THE BOOK OF
ALBERT

*This book is not my writing, my life story,
or my memoirs, but it is an authorized story
about how Park West Gallery became the
world's largest art dealer.*

—Albert Scaglione

By Jeffrey Cyphers Wright

Published by Park West Gallery®

Albert Scaglione, Founder and CEO, Park West Gallery

29469 Northwestern, Southfield, MI 48034 U.S.A

800.521.9654

Copyright ©2020 Park West Gallery.

ISBN: 978-0-9985293-8-7

Library of Congress Control Number: 2020938418

PARK WEST PRESS

29469 Northwestern
Southfield, MI 48034
Tel 800.521.9654

www.parkwestgallery.com

Where dialogue appears, the intention was to re-create the essence of conversations rather than verbatim quotes. While best efforts were taken, there may be errors or omissions.

"Let me not to the marriage of true minds admit impediment."

—William Shakespeare

"To refine… to remove impediments… is that not man's true work?"

—Albert Scaglione

The author wishes to thank:

Jim McFarlin, Tom Burns, Carole Sorell, Lori Ortiz, Seth Wright, Colin Wright, Albert and Mitsie Scaglione, Diane Pandolfi, Jennifer Carey, Brent Plaxton, and everyone at Park West.

Table of Contents

Table of Contents continued on next page

BUILDING THE PARK WEST EXPERIENCE

PARK WEST GALLERY GOES GLOBAL

WORKING WITH ARTISTS

PARK WEST GIVES BACK

CLOSING THOUGHTS

Preface

You're interested in art.

That's why you've heard about Park West Gallery.

You want to own art. You want to see art in your life every day. You may even want to make art.

Learning about art lifts people up. It enriches them. It gives them a deeper understanding of life. The Park West Gallery experience is a whole package that brings art directly into people's lives.

At every event Park West hosts, experts talk about the artwork on display. There can be up to thirty artists shown at any one event. The artists range from the classics (Dürer, Rembrandt, Dalí, Picasso, Chagall, Agam, Max) to recently deceased painters (Kinkade, Tarkay, Pino, Mouly) to the latest hot thunderbolts (Britto, Godard, Wyland, Guyton, DeRubeis, Lebo, Yanke, Glenn, and more).

Art brings joy to the soul. Human beings are wired for art—to look at it—to see into it. To be transformed, delighted, and transported to another place, another time.

Art is mysterious. It speaks to us in broad strokes and secret codes. Each of us has a personal experience with art that's unique. The art that we have around us says something about who we are and what we know.

This book is a tour of the artistry that goes into Park West Gallery, the world's largest art dealer.

More specifically, however, this is the story of Albert Scaglione, the man who created Park West and still leads the company to this day.

Albert's story is remarkable.

The definition of a self-made man, Albert left behind a career in the sciences to pursue his passion. He fell in love with art at an early age, making it his life's mission to bring art down from on high and share it with the people.

Through hard work, Albert transformed himself into the consummate dealer, a force of nature that the art world had never seen before. A visionary, he came up with a method of bringing art to the public that is unmatched. Anywhere. Any time. He then used his acumen and charisma to build a company that shares the joy of art with millions of people around the world.

And he still keeps expanding and refining his ideas. In Albert's words, "I know a whole heck of a lot more than I did when I began in this business, and I'm still learning something new every day."

This is a story of art, artists, Albert, and Park West Gallery. It's historic, spiritual, and unique. It's a testament to how hard work and clear vision can change the world.

THE STORY BEGINS

How does the Park West story begin? It begins with the artist. Albert works with artists as few art dealers can. He develops relationships and gives support. He offers guidance but always respects the artist's creative autonomy.

One of his best talents is finding artists. Albert's ability to recognize talent is remarkable. It was Albert's choice of artists to work with, during his early days as a dealer in the 1960s and 1970s, that laid the foundation and inspired the magic behind Park West Gallery.

In 1970, there was M.C. Escher, then in 1971, Peter Max, and in 1974, Yaacov Agam and Victor Vasarely.

These four artists—who were about to become megastars in the art world—had one thing in common. They all worked with Albert Scaglione and Park West Gallery.

In addition to these contemporary artists, Albert, in the earliest days of Park West, traveled to Europe, seeking out the people who were closest to the masters of twentieth-century art.

It wasn't enough for Albert to acquire a work by Pablo Picasso. He wanted to establish a chain of authenticity—he wanted his clients to feel that link through time, to know that their work came directly from those who knew the giants. If there's one thing Albert knows how to do, it's build relationships. Albert has had close, personal, one-on-one relationships with some of the most groundbreaking art dealers and artists of the twentieth century.

For years, he worked directly with Henri Petiet, the renowned art dealer, who acquired the collection of the legendary Ambroise Vollard, the dealer of Pablo Picasso, Pierre Auguste Renoir, and other masters. (In the 1930s, Ambrose Vollard published one hundred Picasso etchings known as the Suite Vollard. In 1919, Renoir memorialized Vollard's image in the lithograph *Ambroise Vollard*.)

He also worked directly with Maurice Jardot of the Louise Leiris Gallery, the exclusive print dealer of Pablo Picasso; with Alain Mazo and Yves Lebouc from the Bouquinerie de l'Institut, publisher of Marc Chagall lithographs; with Jean Estrade, the artistic director of Les Heures Claires, Paris, the publishers of Salvador Dalí; with Madam Aimee Maeght, the dealer of Joan Miró; and with the legendary master Joan Miró himself.

These dealers were all in Paris, which in the early twentieth century was the epicenter of the art world. These were the prime dealers and, in most cases, the exclusive publishers of hand-signed art made through graphic media for Pablo Picasso, Salvador Dalí, Joan Miró, and Marc Chagall. Paris was indeed good to Albert.

These massively successful dealers both embraced Albert and gave him access to authentic hand-signed works by the masters whose work they represented. They formed a network that connected him to important resources and artists throughout the world.

In turn, Albert met many of these giants—rubbing shoulders with Miró and more—and brought their art to the masses as no other dealer could.

This was how Albert built Park West Gallery. He found the superstars of the era, connecting with artists like Peter Max, who were at the height of their fame, and formed solid partnerships with them. (Max, in particular, was a massive star at the time, appearing on the *Tonight Show,* the *Ed Sullivan Show,* the cover of *Life Magazine*, and the cover of every Yellow Pages in New York City.)

From there, Albert kept going. In 1973, he spent the summer in Japan, selling from Park West's already respectable Picasso collection of hand-signed etchings, lithographs, and linocuts. At the same time, he was developing new Park West collectors and acquiring exquisite Japanese woodcuts. In 1974, he journeyed to Amsterdam, where he gained access to works by classical European masters like Rembrandt van Rijn and Albrecht Dürer.

The stage was set for the Park West engine to start. Its first important VIP event was about to happen. In 1974, Park West clients visited Paris and Amsterdam. In Paris, Albert took them to visit the great dealers and museums.

Albert knew how to keep it personal and help people feel connected to the art. The highlight of the trip was M.C. Escher's wife playing piano for about thirty Park West VIPs in her living room. The clients were enthralled with viewing Escher's amazing artwork in the very rooms where he lived and worked.

It was an intimate event that offered invaluable insights into the life, character, soul, and substance of the art and the artist. For the collectors, it created memories that would last a lifetime and provided them with the most perfect provenance one could imagine.

There was also comic relief and unexpected excitement along the way, as when the whole group, led by Albert, got lost in the subway in Amsterdam after midnight—*welcome VIPs to Park West's adventures in art!*

Albert, who was accompanied by his older sister Marie and his eleven-year-old daughter Lisa, fell in love with the people and the special events each day in Paris and Amsterdam. He knew he needed to develop a system to do it again and again. (What else would an engineer do?) At that very moment, he knew that perfecting that system would become one of the great joys of his life.

Park West now produces more than one hundred events like that one, each one special because of its uniqueness in connecting the art, the artists, and the collectors. Over the past few years, Park West VIP events have been held on all seven continents.

Why did Albert find such overwhelming success as an art dealer? There are many factors—including his unrelenting work ethic—but one of the most notable was how he completely revolutionized the experience of buying art.

Albert wasn't content with just letting his art hang on a wall and wait for admirers. Instead, Albert knew how to make art personal and engaging for his clients.

"All we want to do is please the artist and please the customer," says Albert. "We want Park West to be what brings the art and the artist and the customer together—the marketer in the middle. We want to take people who never thought they could afford art and get them good and great art. When we see our clients with tears in their eyes over how much they love their collections, that's the real thrill for us."

Starting in the 1970s, Park West began to conduct art auctions in fine hotels throughout the world—one of many ways Albert sought to bring art out of the museums and into the lives of ordinary people.

These events enabled Park West to teach, entertain, and bring art to a far bigger audience than had ever been thought about before.

In 1995, Park West expanded by bringing its art programs and auctions to cruise ships sailing around the globe. Now, there are events on almost a hundred cruise ships during any given week. There are thousands of events every year, reaching millions.

Today, in total, nearly one thousand extremely talented fine art auctioneers, gallery directors, and art associates call Park West home as they travel the world. They receive training six to eight times annually at the company's Miami Lakes headquarters and its campus in Southfield, Michigan, where Park West Gallery, Museum, and Foundation are housed. At Park West events, you will find highly trained teams of auctioneers, directors, and associates presenting the Park West art and artists in a unique way that has become identified with the Park West brand. This talented team is accompanied by art educators, teams of art handlers, and hundreds of support staff members working behind the scenes.

The entire enterprise is buoyed by the quality of Albert's collection of classic artwork. Many of these masterworks are on permanent display at the Park West Museum. Other works routinely travel to museums as a part of major exhibitions sponsored by the Park West Foundation, the company's tireless charitable arm.

Recently, a few of the ships have begun sailing with museum collections on board—actual museum collections at sea that allow interested travelers the chance to marvel at works by Picasso or Salvador Dalí while they're on vacation.

This is an enormous service to the public, bringing both classic and contemporary art to eager audiences.

That's something you'll learn about Albert. He likes giving back. He's generous, gregarious, funny, tender, and demanding all at once.

What's the secret formula at the heart of Park West Gallery, Park West Museum, and the Park West Foundation?

In the words of Albert, "Being yourself, making friends, and having a good time."

Introduction

"They may be smarter than we are or have more talent.
But they can't outwork us."

—Albert Scaglione

It's hard to imagine anyone outworking Albert Scaglione. He's a red-blooded American, literally born on the Fourth of July, and his ambition and grit have resulted in the creation of the largest commercial art enterprise in the world. Park West celebrated its fiftieth anniversary in 2019 just as Albert celebrated his eightieth birthday.

Albert is a man of the people. He's a man of his own clan too, coming from a blue-collar enclave of Italian Americans growing roots in New Jersey. Perhaps reflecting his Italian heritage, he is a true Renaissance man. From working as a NASA engineer to running a business, what he has accomplished reflects genius. For the last fifty years, he has married engineering and art more successfully than anyone else on the planet could have ever conceived.

All of his life he's worked eagerly, with the goal of making things better—he strives to make people happier, more educated, and kinder. His enormous success is due to many factors of fortune: including: faith, perseverance, charisma, intelligence, and luck. He has recognized opportunities and seized them boldly.

A deep sense of spiritual awareness and devotion permeates Albert. He is a man with a palpable soul. "It's an interesting thing to be a human… to do God's work," Albert says. Doing God's work shows in everything Albert does.

Park West Gallery provides a huge service to culture. Millions of people have attended one of their art events. The gallery helped its clients collect more than ten million works of art. Sixty percent

of Park West's clients are repeat buyers—once people experience Park West, the majority want to come back for more.

It's that personal touch, the kind that Albert developed as he showed art in M.C. Escher's living room, that has connected with people interested in art all over the world. After much refinement on the original concept, Park West still offers its clients an experience that harkens back to that early intimacy. Today, a special cadre of auctioneers—all trained in Albert's peerless style—meet art lovers face-to-face at their seminars and auctions in hotels and on cruise ships.

Albert is about giving. He is about caring and educating. He is about doing the Lord's work and he quotes Scripture about as often as he makes up a witty pun or profound aphorism.

Now, at a sprightly eighty, this human dynamo has much to celebrate. He is aware of the mixture of talent, background, and focus that has brought him success, and he always looks to those roots. He also explores new paths to move ahead—using his various skills in engineering, management, sales, and artist relationships to actively influence art itself.

The intensity is always there. The quest to be better, to raise others, up is always there, burning away. One of Albert's favorite mottos demonstrates this ongoing, driving spirit.

"We don't stay ahead of the curve. We invent the curve."

True success comes by leading a meaningful life. Meaning is measured in faith and how we have used that faith to improve ourselves and others. Albert has been blessed, and he knows it. So, in turn, he bestows upon the world a model of what full potential can be.

Getting Started: Albert on the Four Pillars of a Successful Career

Before we dive into the origin story of Albert Scaglione and Park West Gallery, let's take a moment to consider the philosophy that helped bring Albert to where he is today.

On December 13, 2008, Albert received an honorary doctorate in commercial science from Central Michigan University in Mount Pleasant, Michigan, and delivered the commencement speech to the winter class of CMU's graduating seniors.

According to Albert, "As I strode up the steps to the dais, I couldn't help but wonder if the words I'd prepared would have any relevance or lasting meaning for these soon-to-be graduates. After all, I had many years on most of them. However, I knew that I possessed one bit of information none of them had and many of them craved: what employers look for in prospective employees."

He told the graduating class, "You're going out into the world and you're going to be perhaps interviewing for a job. The job you end up taking may not be the job you keep. I want to share a few things that you can focus on, that I've learned in these years of life I've had, that may be very useful to you."

Albert then proceeded to tell them in his own words, what he saw, as the four pillars of any worthwhile career—pillars that he calls "The Four C's."

FIRST "C": CALLING:

It's the first thing I look for in our auctioneers, our associates—anyone who aspires to a position at Park West. No matter what job a person is seeking... does she or he

truly feel called to do that type of work? Because calling equates to passion, and if someone is passionate about what they're doing, they will go the extra mile, put in those additional hours, obsess over the details, and be zealously attentive to the client's every need.

As a business owner, who could ask for more than that from an employee?

If an employer is attuned to not only what a job seeker is saying but also how they're saying it, they can identify individuals with true callings. Beware, because people who want or need a job badly enough are not above stretching the truth to get it. It's not enough for them to gush, "This is the job I've always wanted," or "I live for this."

Study their body language. Do they lean forward in their chair when discussing the position? Do their eyes widen? Do their hands gesture excitedly? Those probably are the people you want working for you. Conversely, if someone has to take a job that they don't believe represents what they were born to do, they shouldn't lie and say that it is. That sets up too many false expectations on everyone's behalf.

Instead, keep in mind that everything happens for a reason and give that job—whether it's hauling trash or flipping burgers at the neighborhood fast-food joint—your utmost effort, energy, and respect. Remember, every job is a dress rehearsal for the job to come. I started out hauling industrial waste at the age of eight with my father. I think that turned out pretty well for me.

SECOND "C": CHARACTER:

Why would I, or you, or anybody for that matter, want to work with someone of low character? It is imperative that one demonstrates that character by exhibiting total integrity in both the hiring process and one's employment career. If a

person can't be counted upon to be honest before they land the job, how can they possibly be viewed as trustworthy once they're on the payroll?

Anybody who's ever been called upon to be a witness in court has been told the same thing by his attorney, the opposing counsel, the judge, even the bailiff: Don't lie. Tell the truth, the whole truth, and nothing but the truth! Most of us have enough difficulty remembering the truth, much less trying to keep straight any lies we may have told.

Some years ago, we interviewed a young man for a prominent position who came to us with impeccable credentials. His resume stated he had graduated at the top of his class at the University of Michigan, studied at the Sorbonne in Paris, and held a master's degree in fine arts from UCLA. I guess he figured we wouldn't expend the time or effort to double-check his academic history or contact his references.

It turned out he barely scraped by with a "C" average, didn't complete his master's program, and one of his references had nothing good to say about him! Do I even have to tell you whether he got the job?

Character is what establishes you as a leader, instills confidence in your coworkers and superiors, and ultimately moves you up the ladder to greater responsibilities. Cheating, lying, and stealing may seem like a way to gain an edge in the short term, but they never, ever lead to success.

THIRD "C": CHEMISTRY:

Chemistry is as essential in the workplace as it in a relationship. In fact, since we spend more time at work than we do with our significant others, I might argue it's even more essential. Why on earth would anyone want to work alongside a person they can't tolerate? What do you suppose

that kind of environment does to foster productivity, teamwork, and camaraderie?

Trust me: You'll spend more time, money, and agony trying to correct an office situation with toxic chemistry than by doing whatever you can to prevent it in the first place.

In this era of homeschooling, video games, and social networking, there is a growing and alarming number of young people who haven't developed the interpersonal skills to work with other real-life people.

Sometimes you have to establish and maintain chemistry where it doesn't exist. To do so, I believe it's all a matter of putting the other person first. Again, look to body language; study what the eyes are telling you. Get to know everything about them and get outside of your own head. When you strive to become one with those around you, you're building chemistry.

FOURTH "C" - COMPETENCE:

I saved this one for last. Don't get me wrong. Competence in your job is very important. But there are lots of competent people in the world. These days, every time somebody begins to believe they are indispensable at their job, it seems their company gets downsized, rightsized, outsourced, or restructured, and someone else is taking over their duties.

Competence, in and of itself, is overrated.

As far as I'm concerned, I am not going to hire the most competent person I've ever met if he or she doesn't have the calling, doesn't display character, and doesn't possess the chemistry to "play well with others." Forget it! I'm just not interested.

Although I started my professional career as a mechanical engineer, with visions of assisting NASA to win the space race, I sincerely believe today that the world of art was my true calling all along.

How did Albert learn the Four C's that would serve as the building blocks of his life and career? He first learned them from his family—his parents, mentors, and real-life heroes— who shaped his early childhood in Nutley, New Jersey.

Early Life

CHAPTER 1

A Man from Nutley

"I am a piece of greased lightning."

—Albert Scaglione

Lightning struck Nutley, New Jersey, as the nation celebrated its birthday on the eve of World War II in 1939, when Albert Peter Scaglione joined the world. He was born on a propitious day—the Fourth of July. He was born ten pounds large and he would prove to live large—larger than anyone could have reasonably expected. He would go from a humble beginning to build an enormous life, made possible by a charmed combination of genealogy, willpower, and philosophy. It seems he was born to grasp opportunity instinctively, exude positivity, and bubble with energy.

There are many auspicious people associated with the small town of Nutley. It has been home to senators, musicians, and economists. People like artist Reginald Marsh, sharpshooter Annie Oakley, actor Robert Blake, and business mogul Martha Stewart.

When you look at the wild creativity and know-how of some of Nutley's most notable former citizens, you realize that it's a fitting place for the story of Albert Peter Scaglione to begin.

Albert spent the majority of his formative years in Nutley after his parents, Joe and Agnes, moved the family there, when Albert was two years old, for a shot at the proverbial "better life."

Albert's rise has been, as he puts it, like the "Horatio Alger story. We had nothing. We couldn't rub two sticks together," and yet he remembers his time in Nutley fondly.

"The houses in our neighborhood were not very big but they were big enough, even for a large family like ours," he said. "When I go back today, I'm always amazed at how small they really are, but to me, as a child, our home seemed as vast as a palace. It was an older house and everything creaked—the doors, the floors, everything made noise. This proved to be quite an inconvenience for my brother, my sisters, and me in our teenage years.

"You had to go up two flights of stairs to get into the Scaglione house. There was one short flight leading up to a landing, then another flight and a little front terrace where my mom and dad liked to sit in the evenings. We had a six-room house. You went through the front door and the dining room was on the left, the living room on the right, and straight back was the kitchen. Upstairs were three bedrooms, a tiny bathroom, and that was it, except for what we called the 'little room,' which was really not much more than a storage space.

"In addition to me, there was my brother Joe, the oldest, who was nine years my senior. He shared the same first name as my father, but wasn't named after him—he was Joseph Gerald. I had an older sister, Marie, who, like Joe, was born during the Great Depression, and another sister, Diane, who is ten years younger than I am.

"Joe was my idol and my role model. He was the first member of our family to go to college, St. Louis University, and he went on to become an aeronautical engineer who ran a very important group for the government specializing in fighter-bomber technology. Marie got married at a very young age and left home, so, during that ten-year period before Diane was born, I was raised practically as an only child."

When speaking to Albert's family, it quickly becomes clear that Albert was a decidedly *precocious* youngster.

"Even as a small child, apparently, I was unafraid to strike out on my own and take a calculated risk or two," Albert says. "My sisters love to tell the story of when I was three years old and decided one day that I had to see my grandmother. So, off I went to her house! I knew how to get there; we used to drive there all the time.

"I was on Conover Avenue, and I had to walk past the next house—that belonged to Mr. and Mrs. Holzer, a very nice couple from Hungary. Then take a right on Princeton Street, go past ten or twelve houses, take a left on Hancock Avenue, go up and down a hill, across a field, down another hill, and I was at my grandmother's house. It didn't seem very far to me, but for a three-year-old venturing off on his own, I suppose some people might think it was!

"My mother certainly did when I suddenly disappeared in the middle of the day. After many hysterical moments, she was calmed by a phone call from Grandma informing her, 'Albert's over here. How did he get here?' I honestly don't remember doing it, but my family sure does. It's become our famous family story."

Albert describes his neighborhood in Nutley as "remarkably supportive and surprisingly multicultural." He was blessed with a nearby network of Italian relatives, which provided a support system for his family. His family line goes directly back to Italy. Albert's parents were a complementary blend of type and class. His father's lineage was salt of the earth and his mother's more genteel. He inherited qualities from both sides.

"My father's family was Calabrese, from Calabria, the southernmost part of Italy," says Albert. "Capetosta. Hardheads, stubborn. My mother's family were Guarinos, and her maiden name was Rotunda." Both the Guarinos and Rotundas were from the small mountainside town of Teora, about one and a half hours by car from Naples and three and half hours from Rome. A monument to deaths caused by a recent earthquake had a significant number of Guarinos and Rotundas offered up to the tragedy.

Albert speaks proudly, and with a hint of wistfulness, about his relatives, particularly his uncles and cousins who served during World War II. "They saw the horror... my Uncle Fred Ippolito served in Italy, France, and Germany. His brother Salvador was in the Navy and served in Alaska as a construction builder, learning a trade, and his brother Angelo was a navigator in a flying boat—a Martin PBM Mariner. Cousin Joe was in Iwo Jima, Okinawa, and Saipan. He was a Marine, and they always went in first. Joe's brother was in the Army infantry and served in France and Germany. To a one of them, no one told, right to the bitter end, a single story about their time there. I think those guys, because they'd seen so much death, it affected them very strongly. I think it was a good influence on me, teaching me how precious life is and how true heroes don't need to talk."

As a youngster, Albert had lots of impressive family role models. "Six guys all came out of the war. They were decorated. They volunteered for assignments. Their bravery was almost legendary in the family."

They also helped shape Albert's identity, and he learned the importance of concepts like courage, loyalty, and duty. Later he would join the ROTC (Reserve Officers' Training Corps) program in college and, though he was ready, he never served.

The Scagliones struggled financially during the Great Depression, but, with the advent of World War II, there were new jobs in the wartime economy. Albert's father, Joe, was an independent small businessman who owned his own truck. During the war, there was enough work to enable him to purchase a second truck and make a better living than he had in years.

His trucks served different purposes. One hauled cement blocks exclusively for construction projects. The other, a World War II-era Ford he completely refurbished after it was pulled out of Newark Bay, hauled industrial waste. Not sludge, but all the things exuded by small manufacturing plants in the surrounding area, including plastic, metal, and springs. At the machine tool shops, he would

collect the metal shavings that came off the lathes. At the injection molding plants, he would take the excess plastic debris that ended up on the floor. Joe would collect all that refuse and drive it away to the dump for a fee.

Albert remembers those trucks fondly. "We had a nonattached garage with doors in the front and the back, so Dad could drive in from either direction, and two big lots in the back where he could park the other truck. Often, he would bring the truck loaded with cement blocks for the next day's work and park it at home, in order to get an early jump on the next morning. The people who owned the hardware shop on Union Avenue allowed Dad to drive across their parking lot to access our backyard because it was really the only route he could use to get his big trucks behind our house.

"It was that kind of neighborhood, where people willingly extended courtesies to each other and everybody looked out for everybody else. Those two trucks stayed in our backyard for years and were never touched, much less broken into or stolen. It was a pristine, wonderful time."

"No kidding, I really did have to learn how to work at four. I wanted to work like my dad," says Albert. "But since I was little and couldn't do truck work with my father, which I really wanted to, I was given chores by my mother. Doing the dishes, taking care of the dog (it was Trixie anyway, so I couldn't get away with not doing that), and cleaning up after dinner and making my bed. My dad had a little joke. He would ask, 'You can do that, can't you?'"

And, of course, Albert could. He loved working from the get-go.

Albert's early industriousness included shopping for the family. "I had to learn how to pick out fruit. Until I was eight, I was groomed to be a good mama's boy." Every Saturday, Albert would put on an apron and sink up to his elbows in hot sudsy water, washing the family dishes.

"Every time, my father would look over at me and softly shake his head, his wry smile building to a laugh. 'You know, boy,' he would say, 'One day I'm going to get you out of all this!' He knew the last thing on earth I wanted was to wear an apron, no matter the reason. I would always respond, 'OK, Dad, just say when.' This went on every Saturday for years, from the time I was five until I was eight, our little two-man shtick."

But everything changed one morning when Albert was almost nine.

Albert vividly recalls that game-changing day, when he began to move away from domestic chores and into the work-a-day world. He was helping with the dishes, he recalls, when "My father began to give me his signature line. I interrupted him. 'Yeah, Dad, I know, you're going to get me out of this someday.'

"'Well, guess what, boy?' he asked. (He often called me 'boy.') 'Today's your day!'

"I stood there, stunned. When I finally could fix my mouth to make a sound, I could only say, 'What?'

"'NOOOO!' my mother cried. 'Joe, no! He's too little! He's too young!'

"'He's not too little,' Dad replied. I was a ten-pound baby! I wasn't a huge kid, but I certainly wasn't too little.

"'No, he's big enough. He's strong enough. It's his time. He's going.'

"'NO! Not the truck?'

"'The truck. He's ready.'

"Seemingly out of nowhere, Dad produced a pair of small, pristine new work gloves. 'Here,' he said. 'These are yours.' Somewhere in the back of my mind, I heard a trumpet fanfare. I took the gloves from my father, took my apron off, and carelessly tossed it to the ground, but before I could yell 'Bye, Ma!' I realized what I had

done, carefully picked up and folded the apron, and handed it to my mother, giving her a hug as I left with my dad for my big adventure. I was free!"

Albert jumped into the truck with his father, ecstatic at the thought of learning the family business—a business that would be a huge part of Albert's life every Saturday morning and every summer for the next fourteen years.

"Those were some of the best years of my life, working alongside my father and spending one-on-one time with him on the trucks," Albert remembers. "As a little kid, looking up to my dad, he seemed larger than life, just an amazing guy. I remember one Saturday on the big truck, the cement hauler, we were at a job site and we couldn't get in because the lot was a sea of mud, except for one hardened path. Problem was, the path was blocked by a huge manhole cover.

"Dad leaned out his window and yelled to a bunch of men working on the site, 'Hey, help me move this cover so I can get in!'

"A couple of them yelled back, 'It don't move!'

"My father said, 'Well, let's see.' He jumped out of the truck, walked up to the cover, squatted down, lifted it up on its edge and rolled it over to the side of the path. All the workers in the yard just watched him with their jaws open!

"'It'll move!' he yelled back at them and jumped back in our truck. Another legend about my dad was a story about a time when a jack slipped. Amazingly, my dad lifted the hind quarter of the car with his own strength for just an instant to get the car off the person so he could slide out without causing serious injury.

"He wasn't mad. He just didn't have time to waste. Dad did not suffer fools gladly."

Albert says, of that threshold time, "At ten, you rule the universe.

You fly. You are the king of the world. You know it. Maybe nobody else does. Every now and then, you come back down to Earth, like when you ride your bike down a hill you shouldn't. But you do and it's a thrill."

That freewheeling, industrious spirit, however, was tempered by a life-changing experience when Albert was eleven years old.

"I broke my arm in a pick-up football game and discovered I had a tumor inside my bone… the size of a quarter. It could not be determined from the X-ray if the tumor was benign or cancerous."

The prognosis was grim. If they operated, they would touch the growth center in his arm and his arm growth would be stunted forever, so that was not an option at eleven years old. Albert was told he would have to wait it out until he was about fifteen so the arm would be fully grown. Every three months, they x-rayed the arm. The tumor continued to degenerate the bone in his arm—that's why it had originally broken during that football game. It grew from the size of a quarter to the size of a foot-long skinny banana, filling up the entire cavity of the bone in his upper right arm.

Albert was now faced with three options:

(1) He might die of bone cancer.

(2) He might lose his right arm. If this growing tumor was cancer, removing his arm would be necessary to save his life.

(3) If he was lucky and the tumor was not cancerous, a successful operation would save his life.

He knew that to have this luck he would have to wait out the four years and pray that there was a chance the skinny banana could be removed intact and replaced with bone marrow (from someone else or potentially from his own body if they couldn't find a donor).

"What a formative time to face death," Albert recalls of the trial.

Albert could still work with his father, but he had to hang back when it came to sports. No football for the sports-loving teen.

"I missed four crucial years. That experience was life-forming. I think it was God's way of forming me and connecting me and putting me in the fire and getting me ready for what he had in store. I didn't know my path yet."

Doctors were eventually able to treat and remove the tumor, but facing mortality at such an early age had an enormous impact on Albert's life. "It was a spiritual experience. I set it out of my mind. I was determined to build my own life."

Despite the pride that Joe Scaglione took in his daily work, he never intended for Albert to follow in his footsteps. "He knew his job was thankless, backbreaking work, yet he did it faithfully every day to provide for his family. He didn't want that for me. He wanted something far, far better for me."

"You can do better. You've got a head on your shoulders," his father would tell him, so Joe was adamant that his son stay in school. But, after years of work experience at his father's side, it was often difficult for Albert to see the value in his education. "To say I was a poor student is an understatement," Albert says. "I skipped a lot. A whole lot. The main reason was that I always had jobs. I worked constantly, and I enjoyed it. Anytime I could work, I did—even during school days, if the schedule demanded it."

The Scagliones sent their children to a local Catholic school, St. Mary's. Joe Scaglione had attended the nearby Washington School in his youth, which was just across the railroad tracks. (Albert would one day send his son, Marc, to Washington as well.)

While Albert was always recognized as an intelligent kid, he struggled against the strictures of his early formal education. In his words: "Every day, I would ask myself, 'What am I really learning here in school? This guy's trying to teach me about political science,

something I'm not really interested in. Why do I need to pass a test in political science?' I didn't realize I was smart! The nuns tried to tell me, but I really didn't think so. I didn't believe the nuns!

"However, I did know one thing: If I could get an idea of what a test was going to be about, I only needed the night before to prepare. I never read the book! I'd get my C or D, take my grade and move on. I never flunked a course. As long as I could pass, I figured I was all right. Sometimes I just showed up for the tests.

"My teachers understood the workload I was carrying outside of school, knew I was working all the time. But I was always attentive and pleasant in class, clean-cut, not a discipline problem, and my classmates liked me a lot. In fact, I was voted 'Best Dressed' by the student body, but I later found out the teachers said I wasn't a good example because I was absent from school so much and they gave the award to the fellow who came in second. I didn't mind. I figured that was a small price to pay for having a steady stream of honest, hard-earned money coming in.

"I don't think the teachers necessarily had a bad impression of me. But I'm certain they didn't know what to make of me. I was this guy who came to school (often) in a suit, dressed better than many of my male instructors, sporting a badly broken nose. I got into a lot of, shall we say, scuffles in my high school years. (I had my nose fixed after graduation.)"

While Albert has some fond memories of certain classes and teachers—particularly his history and Latin classes—the rest he describes as a "blur of faces, tests, and grades."

CHAPTER 2

Introduction to the Art World

As Albert continued to press his way through high school, he caught the first glimpse of the "better life" that his parents wanted for him when he was sixteen years old.

The Scagliones had a cousin by marriage from Venice, Italy, who owned an art gallery in Lyndhurst, right across the river from Nutley.

Albert remembers, "One day, my mother says to my father, 'Joe, Albert has been on the truck with you for eight years, and I think it would be nice if he did something different.'

"'What are you talking about?'

"'Paul's got the gallery. He lost his helper. You know Albert's a good worker. I'm sure Paul would love to have him, and it would be nice for Albert because it would be a little change of pace for him. He's in high school now. You want him to go to college. This could give him a new perspective.'

"Dad thought about it for a moment, then to our mutual surprise he said, 'I don't object.' Then he turned to me.

"'I don't know!' I blurted. 'I haven't even applied for the job yet!'

"I got the job, and it was an unforgettable sixteenth summer for me—a totally amazing job.

"I learned to varnish paintings, stretch paintings, frame paintings, hang paintings. I met artists. The experience was just so... different. Not that the work experience with my dad wasn't wonderful, but this was something else altogether. There was another world out there.

"I saw couples stroll through the gallery dressed to the hilt, ladies in elegant dresses, gentlemen wearing impeccably tailored suits. In

my family, we'd wear suits on Sundays, but we were working-class people. I saw money changing hands for paintings, people willing to spend $200, $500 or more for art, which was serious cash in those days. I was thinking, 'Wow! This is amazing!'

"I saw people enjoying the artwork and the atmosphere. More than anything, though, I saw the sheer beauty of the art itself for an entire summer."

Another life-changing event occurred when Albert bought a painting for his parents while he was working at the gallery. He'd seen his parents looking at it and knew they were keen on it. After having his eye on it all summer, he bought it for them for a "substantial" amount of what he'd earned.

"My parents loved that painting."

Albert remembers them talking about the painting to every new person that would come into the house.

"'Look at the painting Albert got us!' And then they would go on talking about the painting in a beautiful way. For me, it was a great and life-changing experience to see what this gift did for Mom and Dad. My dad, a truck driver with no high school education, and my beautiful mom in their glory as art collectors. Mom graduated high school and got a two-year diploma from Coleman National Business College in Newark, which she was very proud of. She did the books for the business as well as the books for her older brother Charles's marble business, but having that painting was the cherry on top.

"At Park West, we make a lot of people art collectors by giving them a free work of art at our events. We do that all the time, we've been doing that for years and years. Because I saw, in my own parents' lives, how even one artwork could have a profound impact on a person's life."

Looking back, Albert regards that first summer working at an art gallery as a "riveting experience."

"Little could I have dreamed it would all come back decades later to influence me at a critical juncture in my life."

CHAPTER 3

Adventures in Education

After that fateful summer, Albert went back to work with his father and back to the daily grind of high school. Unfortunately, during his senior year, Albert was informed that he would not be allowed to graduate with the rest of his class because he didn't have enough days of school attendance to qualify.

"My grades were good enough to graduate, but they hooked me on a technicality," Albert recalls ruefully. "One of the rules of the state of New Jersey was that in order to graduate, a student had to be in attendance a minimum number of hours, and like I said, I didn't actually make it to school often enough. I was not allowed to graduate with my class and had to take additional classes in the summer to increase my hour count before I could get my diploma.

"I remember crying with Diana, my high school sweetheart (who later became my wife) when I received the news I wouldn't be graduating with my class. I wasn't sad for myself as much as for my parents, who I knew wanted dearly to see me walk down the aisle and receive my sheepskin. My father, who was placed in an orphanage as a child because his mother couldn't afford to keep him, only had a fifth-grade education. As I said, my mother had two years of college, which was very rare for women in that era.

"I knew how much they both valued the importance of education. I knew they would be heartbroken. But I tried to make up for that in other ways. I attended summer school and I didn't miss a single minute. I even got to school early! I needed those hours. Somehow, someway, I managed to get through it.

"I graduated from high school in August 1957 after my hours ordeal was completed and my father said, 'You've got to go to college.'"

Yet everything changed when, as the summer of '57 ended, Joe Scaglione suffered a painful double hernia while on the job. Suddenly, the whole dynamic of the Scaglione family shifted. Joe would be down for more than a year, undergoing a difficult recovery process, and it was now up to Albert to operate his father's two trucks by himself to bring in money for the family and pay the mortgage on the new International ten-wheeler with a side-o-matic crane for unloading cement blocks. The larger truck carried loads six days a week. And a smaller dump truck would haul industrial garbage as long as there was light, every day except Sunday. College would have to wait.

"It was a big responsibility," Albert remembers. "We had huge loans on our trucks, both of them: a big International rig and a smaller dump truck for the garbage hauling. (We had upgraded from the old Ford that Dad rescued from Newark Bay.) And these were not big-money days: fifty, sixty bucks a day from the trucks was a fairly sizable take back then, and you had to take gas, tires, maintenance, and bills out of that. I was waking up every morning at four and running until eight or nine at night, six days a week. Our trucks ran out of East Orange, but our jobs were all over the state of New Jersey and as far as upstate New York and occasionally Boston. I was taking all kinds of jobs wherever I could find them.

"I became very popular because, like my father, I liked people and I enjoyed interacting with them. My personality worked. Pretty soon, I had a lot of friends all over the region. I got a job down in Camden, near Philadelphia, landed another in Newark. I even took a short-term job for Liquid Carbolic, because I had my Teamsters card, driving huge tractor-trailers into Brooklyn and back delivering CO_2 containers. Made a ton of money. You were paid by the hour, and the company wanted guys who would bust their asses because unfortunately some of the drivers they had were slugs. I couldn't believe it when I discovered that they actually had guys who would disappear for a while to sleep! Some of the other workers gave me crap, but I'd always be back in the garage from my runs early, sometimes by as much as two hours.

"I took my father's philosophy that there is no substitute for hard work and made it pay off for me. Every place I worked, both customers and bosses always wanted me back. 'I need my load delivered tomorrow, but make sure Scaglione brings it,' they'd say. Or 'Scag,' as some people called me. Or, if they knew my dad, 'Little Scag.' 'Make sure Little Scag brings it. I don't want nobody else!' Now other truckers were starting to get mad at me because I had so much work coming in that I almost couldn't handle it all while they were cooling their heels waiting for their next load. A couple of drivers actually got mad enough to try and jump me, but I'd tell them, 'Don't blame me! I'm just doing my job!'"

Albert relished his role as a breadwinner. If he was busy, he was happy.

"I had to make a thousand a week for my family. I got one thing out of the whole deal. A gold 1956 Oldsmobile convertible with a continental kit on the back. That was my reward. I remember running down to the shore around Labor Day. You couldn't have job sites open that day. Not having a care in the world. Riding in that car like you didn't have a care in the world."

Albert ran the family's trucking business from August 1957 through 1958 and into February of 1959. His father was eager to get back to work, but Albert, who was so much like his father, knew to insist that his dad proceed slowly. "Let's take it one step at a time, Dad," Albert would say.

"I'll know when I'll be ready, but you've got to do your own thing," Joe kept telling him. "You got to get to college. Thank you for helping me with the trucks, but you got to get to college."

In the fall of 1958, Albert agreed and applied to Jersey Prep, a private preparatory school in Newark. Jersey Prep was exactly what Albert needed. The student who had struggled his way through high school was now about to embark upon a surprisingly illustrious academic career—he just didn't know it yet.

COLLEGE DAYS

There was a good reason why Albert sought out a prep school after high school rather than going straight to college. As Albert puts it bluntly, "There was no way any college was going to accept me, not with my high school transcript. I was at like a 1.2 grade point average."

This time, Albert appreciated the education and pursued it with his usual fervor. At Jersey Prep, Albert took forty hours of coursework a week, signed up for accelerated classes, and began studying trigonometry. With his new interested in education, he quickly found himself with a report card filled with As.

The school offered classes to help prepare students for the college entrance board exams. Albert immersed himself in his studies and scored in the ninety-ninth percentile on his boards. "I even shocked myself!" he admits.

Even with his high scores, Albert only applied to one college— Newark College of Engineering, now the New Jersey Institute of Technology (NJIT). When asked why, Albert explains, "Because I didn't want to spend more than $200 a semester! That's what I could afford, and it was coming out of my own pocket. I was going to put myself through college. No way I was going to ask my parents for money or place any extra burden on them after all they had gone through. You had to have exceptional grades and a few other factors to receive that low a tuition rate, and thank the Lord I had all the qualifications."

His undergraduate years passed quickly. Albert was debating his options for life after NJIT when he had a fateful meeting with one of his professors.

As Albert tells it: "A few weeks before receiving my diploma, I was chatting with my thermodynamics professor, Eugene Stampfer. I loved the guy. He was a great teacher, very bright and a very funny, funny man, and I got good grades in his classes.

"He said to me, 'Albert, I think you've got potential.'

"I said, 'Doctor Stampfer, I want to go to graduate school. I'm really excited about education now. Once I wasn't even interested, now I can't get enough.'

"'I think you would do very well in graduate school,' Professor Stampfer replied. He knew my background. He knew how hard I worked, how hard I had to work, coming from Nutley, Newark, the trucks, the city, the streets. I never asked for any slack or special attention. I just asked for a little help every now and then. Maybe the chance to make up an exam if a trucking job interfered.

"Stampfer looked at me with a broad smile. 'I think you would really enjoy the Midwest. The friendly people, the academic environment. You should go to a university there to get the flavor of a midwestern college campus. You will love it!'

"So I applied to Michigan State University in East Lansing, Michigan. I frankly don't remember why I picked MSU. But I think they may have been the first school that accepted me!"

Little did Albert know that one offhand but heartfelt suggestion from a New Jersey thermodynamics professor would lay the foundation of his future career. Because it was in Michigan that Albert would one day found Park West Gallery and where the company remains to this day.

The year 1962 was a major one for Albert. He got married to his high school sweetheart, Diana, and, not long after, the newlyweds packed up all their wedding gifts and worldly possessions to move to Michigan.

Albert began his graduate studies in September 1962 in East Lansing, the small college town in the shadow of the state's capital. The couple was living the semi-spartan life of young faculty families in the appropriately named Spartan Village, which is where they had their first child, Lisa.

During this transformative time, Albert approached his graduate studies with the same ironclad work ethic he had learned while working on the family truck with his father. He also never lost the enterprising spirit that, made him such a successful young businessman.

When he was offered a paying position at MSU, he jumped at it. He was about to get experience in another critical area— instruction.

He remembers, "Midway through my degree, while working as a research assistant, I was approached by the head of the engineering department, who asked, 'Would you like to serve as a graduate assistant? It pays an extra $250 a month.' Oh, heck, yes! By my second semester, he came back and asked, 'Would you be interested in becoming a teaching assistant? It would be $350 a month.' That's for me! And next year, 'Would you like to be an instructor? It'll pay you $600 a month.' Plus, it allowed me to have full faculty privileges! Where do I sign?"

Albert now admits that becoming an instructor "probably did more good for me than the students. The students liked me a lot, and I enjoyed teaching. But what teaching really did was teach me how to communicate. I'm very process-oriented. I'm very much oriented toward having people understand what I have to say and understanding them in turn, so the teaching was wonderful. I could never get it out of my system. To this day, when I'm presenting art, I try to teach rather than sell. I really get into talking to our collectors about all kinds of things I want to teach them about art. I had that same dynamic with my engineering students."

It's ironic that Albert taught for a decade, given his early years skirting school. But, by now, the idea of education was inspiring to Albert. His work ethic became aligned with a cause he believed in. He was happy and enthusiastic. As a professor, he honed valuable communication skills that would later show up in his spellbinding auctions.

Albert describes himself at that time as "a very hard worker. I had the same personality I have now. Inquiring. Engaging. Outspoken. Vocal at faculty meetings, not afraid to speak my mind. I never was necessarily the best at anything. I don't ever remember any situation I was in at MSU where I wasn't surrounded by people who were smarter, stronger, or better in some ways than I was. But I'll tell you this: Among the people I worked shoulder to shoulder with, as well as just my friends, I never found anybody who would work *harder* than I was. As hard, maybe—never harder."

Occasionally, his studies would take him outside of Michigan. During the summer of 1964, Albert had the opportunity to work at Lewis Research Center in Cleveland, which was NASA's Center of Excellence in turbomachinery. Albert recalls, "I had my own wind tunnel. I was learning a lot about how to design a rocket and how air flows. NASA was interested in how thermodynamic flow and magnetic fields interacted. It was kind of joyful for an engineer, because it casts problems, and problems are what you want because it gives you something to work on."

Albert would eventually end up staying at Michigan State for five years, earning both his master's degree and his Ph.D. He left MSU in 1967—all of his coursework was finished but he was still working on his doctoral dissertation. It took three years total of writing and researching to complete. During those years, Albert worked at Wayne State University in Detroit as an assistant professor.

Enthusiastically plowing ahead with his research, Albert found himself once again in proximity to mortality when he was tasked by a professor with what he called a "kamikaze mission."

"I was working in the field of magneto-hydrodynamics, or MHD, where you have fluids that conduct electricity and are magnetic. You have magnetic, electrical, and fluid fields, all interacting in mutually perpendicular directions. Sounds exotic, but for an engineer with a Ph.D. specializing in mathematics and physics, it was an exciting area full of promise and problem solving.

"I was passionate for the work and hell-bent on bringing new insight to the field. This was where I would put a stake in the ground, and I truly believed my doctoral studies would change things. Lofty thinking. So what did I do? Without any prior experience, I built my own laboratory.

"I bought seven hundred pounds of mercury from a government facility in Ohio and built a tunnel out of glued-together plastic where the mercury would be propelled by a special stainless steel motor. This mercury was leaking all over the lab, and although I didn't know it at the time, I was accidentally ingesting fumes like crazy. My brother Joe, who at this time was working at Wright-Patterson Air Force Base in Dayton, Ohio, drove up to East Lansing to visit me on a regular basis. On one trip, he took one look at me and exclaimed, 'Your eyeballs are yellow!'

"I said, 'What are you talking about?'

"'Go look in a mirror.'

"I went over to a mirror. They were yellow!

"I said, 'Well, you know, I'm not getting a lot of sleep these days.'

"Joe stepped into my lab. 'This mercury's all over the place!' he shouted. 'Are you crazy? Go see a doctor. NOW!'

"I took Joe's advice and went to my doctor the following day. I found out that my mercury level was one hundred times what it's supposed to be! Mercury poisoning.

"So I didn't complain, but I came to a realization: I really had to get out of that laboratory. I didn't want to tell anybody. I'm a pretty stubborn guy! I was going to tough it out, do things the right way, and use the work that I already had two years invested in.

"I was thankfully able to do that by carefully working six more months on the project. I found research from another scientist from Greece, and I examined findings from the Atomic Energy

THE BOOK OF ALBERT

Commission. They all had bigger budgets than I had, and fortunately they had done work that confirmed my experiments and offered even more! I raced breathlessly to my professor and blurted, 'I've got great news! They already did it! Look! Here it is! Here are the results, and here is my analysis, and it matches! I think I can finish my thesis on their experiments.'

"He looked up at me and intoned, 'No. You have to do your own.'

"I refused to tell him about my yellow mercury eyeballs. Instead, I said, 'No! That's not right!'

"So I went back and took another six months to complete my dissertation. I still hadn't replicated the experiments. I finished it, returned to his office, dropped it on his desk, and said, 'I'm done. Here's my dissertation.'

"He said, 'You're out of your mind! I'm not even going to bother reading it. You get back in that laboratory!'

"I looked him in the eyes and said, 'I'm not going back to the laboratory. I'll tell you right now, here's what I'm going to do. I'm going to take it to the head of the department and let him deal with it.' I was really enraged by this point.

"I took it to the department chair. 'Here is my thesis,' I said. 'I have experiments that I picked up from the Atomic Energy Commission, and from these sources here. Our budgets are nonexistent, and I'm operating on a shoestring. I have no money, I have no grants, and my professor's not getting me any grants. I've shown him my thesis and he won't even look at it. I'm going to ask you to read it.'

"'I'm going to tell you right now: You can look at it or not. That's up to you. But if somebody doesn't look at it, I'm going to go to the dean, then to the president of the university, then to the president of the American Association of University Professors, and I'm going to put in my complaint formally because this is bullshit!' (Probably shouldn't have used that word.)

"The department head was the nicest guy. I played a little golf and handball with him. Went to Purdue. Fine engineer. He said, 'No, wait, slow down! Slow down. Let me take a look at it. Give me time. Get out of the laboratory. I don't want you in the laboratory.' I think rumors might have been getting out by that time about my mercury. My eyeballs were the color of sunflowers!

"He called me back about a month later and said, 'Albert, we've made a decision. We're going to give you a new doctoral committee.'

"'Thank you very much,' I said.

"'The good news is that they have already read it and like it and are looking forward to serving on your committee. However, they all see great opportunity where the five of you together can do an incredibly good piece of work.'

"So I still wasn't done! It wasn't until another year later that I was finally finished! The committee put me back to work. And I was fine with that. They said, 'We should do this test or that.' Fortunately my doctoral committee of four was handpicked by our department chairman and looked at by the dean and they were technically and analytically experts, so I had the greatest of leadership. Every month for a year, I'd meet with the professors and show them the progress I had made and we together would expand it and develop more work for me to do.

"During this time, I decided I'd grow a beard. It wasn't because I wanted to look more distinguished or professorial. It was because I had come to the conclusion that I might never earn my Ph.D., and as a sign of remembrance, I would wear this beard forever and ever. It would serve to remind me that no matter how hard I tried to achieve this particular goal, I couldn't reach it, and I would never let that happen to me again! One day I might shave, if I actually accomplished something. But this wasn't the time for shaving. And the beard got longer and longer and longer...

"So finally—finally!—I present my dissertation defense. It took three hours, but, by this time, I was ready for anything the professors could throw at me!

"Often when defending a doctoral dissertation the candidate is not notified immediately at the end but waits some time before knowing the decision.

"In this case, the professors told me immediately after my three-hour defense that they'd had ample time to read and study my dissertation, and that I had defended it brilliantly. They told me afterward that I had done an outstanding job. 'You were ready,' they said. 'You were really ready. Congratulations Doctor!' I nailed it.

"It was totally amazing. One of the high-water moments and crowning accomplishments of my life. It took me a total of eight long years and a mountain of hard work to get there, which made the achievement all the sweeter."

It had taken almost a decade for Albert to complete his Graduate work and dissertation, but, in true Albert fashion, he already had his sights set on a much bigger target, one that was literally out of this world.

CHAPTER 4

Mission to Mars

When Albert first starting working at Wayne State in 1967, he had one major area of interest—figuring out how to get a man to Mars.

With the Space Race moving at full throttle, Albert found himself surrounded by opportunities to explore his personal interest in aerospace engineering and space travel. While getting a man to the moon had been an enormous technical challenge, it was exponentially harder to theorize how to safely get someone to Mars and back, compared to the Moon and back.

In 1966 Albert began working under Dr. S.I. Pai, an acclaimed scientist who, Albert notes, "published more than three hundred scholarly technical papers and wrote one of the authoritative books on thermodynamics at the time."

Pai had hired Albert to work as his assistant at North American Aviation Space and Information Systems and Rocketdyne. Together, they pursued a new project designed to get a man to Mars, using some of the theories Albert was developing in his dissertation.

Remembering Dr. Pai, Albert says, "He worked my ass off and I loved it. I felt my thesis was important."

Albert's work proposed to present a solution for keeping a space capsule from incinerating in the martian atmosphere. His thesis concerned heating systems—how to counter them and "cool" the astronaut. Albert describes the shield that was used for the Moon mission that he, in a small way, was part of as a "shield made out of glass like a honeycomb and that shield would ablate. You're going from a solid to a vapor with no liquid phase so you suck up a lot of energy."

Albert had previously worked as part of a team contracted to NASA to help with the Apollo mission, designing space vehicles and heat shields. In 1965 he spent the summer living in Cleveland, Ohio, working for NASA at the Lewis Research Center. After that success, Albert began working on systems that could likewise protect an astronaut going to Mars. But it was well known that the atmosphere of Mars wasn't like the atmosphere of the Moon. The capsule used for the lunar mission wouldn't survive entering the martian atmosphere.

In Albert's words, "The question became, 'How do we get it to work without toasting the astronaut?'" Ever a teacher at heart, Albert still gets excited while explaining this dilemma. "The problem is, the martian atmosphere consists primary of CO_2, which is optically thick, causing a lot of heat on the space vehicle. The heat shield we used for Apollo wouldn't work at all."

It was a massive problem to solve, but massive efforts were being made. The budgets primarily came from NASA, and there were teams of scientists working on different aspects of anticipated problems that would occur in getting a man to Mars and back. It was an inspiring atmosphere of intellect and dedication focused on a worthy outcome and Albert was very pleased with the progress they were making on the Mars mission.

However, things were about to take a dramatic shift.

In the summer of 1967, there were riots in the streets of downtown Detroit, where Wayne State was located, as well as in the Watts district of Los Angeles and in Newark, near Albert's hometown.

Then, in 1968, the U.S. government withdrew their support of the SST, or supersonic transport—a project near and dear to Albert's work.

Finally, in 1969, it became clear that NASA was aborting all plans for manned missions to Mars due to budget constraints. This was a devastating blow for Albert.

"Suddenly, everything I'm working on became meaningless," he recalls. "Nobody was going to fund my research anymore. I had some big decisions to make. If I wanted to stay in the engineering field, all roads led to the Department of Defense."

He wasn't necessarily against that idea. Albert's brother, Joe, was working as a branch chief for the U.S. Air Technical Intelligence Corps. His group developed the black boxes, the computer systems that automated the shooting down of Russian aircraft by F-15s and F-16s.

But, according to Albert, "I didn't see the space program ever being rekindled, and I was right. It was never reinstituted to the level it had been funded and supported in the 1960s. I didn't feel good about it."

What was he supposed to do with his life now? Stay in government engineering? Get another Ph.D.? Pursue his growing interest in environmental sciences?

"My heart wasn't in it," Albert admits. "Even if they were paying me top dollar, I knew I wouldn't be a happy guy.

"Certainly, there is always a hole in your heart not to see a man on Mars. But I did see a man go to the Moon.

"In a way, it was a relief to get away from the Mars project. During my lifetime, it's not going to happen. And I determined that, if it wasn't going to happen, I didn't want to be there. I had to find something new."

And then it hit him.

Entering the
World of Art

CHAPTER 5

Founding Park West Gallery

The year 1969 was momentous.

Music fans flocked to Woodstock in upstate New York, while angry protesters descended on Washington, D.C., to voice their objections to the Vietnam War. Charles Manson and his followers terrified Hollywood as the Beatles held their last public performance on a London rooftop.

The world marveled as man finally walked on the Moon, but, by the end of the Apollo 11 and 12 missions, those working on the U.S. space program could already tell that the nation's once-grand plans for interstellar exploration were being severely scaled back, nearly to the point of extinction.

This was where Albert Scaglione found himself in 1969. His engineering research was no longer being funded, and the Mars mission he'd dreamed of was now called off. A question loomed over him—*what comes next?*

After some soul-searching, Albert realized that his path forward might have begun during that fateful summer working in his cousin's gallery when he was sixteen years old.

What about... art?

Albert had always had a passion for the arts, and his brief foray into the art world had left an indelible impression on him. Looking back, even when he was teaching engineering at Wayne State, Albert admits, "at college, I kept wandering over to where the artists were. I always found myself drawn to it."

Albert made up his mind. He wanted to follow his passion and become an art dealer.

THE BOOK OF ALBERT

It was not a decision inspired by money. With his technical background, he received numerous far more lucrative offers to work for government agencies, Avco Raad, Rocketdyne, North American NASID, and other companies Albert had worked for before, thanks to government contracts funding deep space travel research. He remembers asking the people who wanted to hire him, "'What would I do?' The answer I always got was, they would train me to be a manager."

However, these offers had nothing to do with space exploration, and Albert couldn't see spending the rest of his life doing something he wasn't trained to do and did not understand. After spending twelve years in education, specifically skilled at the research that it would take to be part of the team to get a man on Mars, this just didn't work for Albert.

But Albert now had a new vision of what his future could be. "Getting into art was like a clearing of the brain," Albert remembers. "Pure physics and pure mathematics expressed by someone else."

It was a risky proposition, but one that would pay off handsomely for Albert in the years to come. Perhaps it was a sign that, in 1969, the same year as the Moon landing and Albert's fateful decision, the most popular contemporary artist of the era—Peter Max— appeared on the cover of the September issue of *Life* Magazine in a story titled "Portrait of the artist as a very rich man."

GETTING STARTED

Moving from science to art was a major career shift for Albert. It was a decision that even he questioned, but he didn't let his initial apprehension prevent him from pursuing what he wanted.

Opportunity comes with risk. Willingness to be decisive and try something new is part of Albert's makeup. So he left science—for

the time being. His engineering skills would come back into play once he got the knack of dealing art.

"I thought it might work," he recalls of his career change. "I said, 'I'll give that a shot.'

"I believed in failures. I *still* believe in failure, but I believe in fast failure. I believe fast failure is what builds success. I'm not afraid to fail. But, if you practice properly and do it over and over again, your fast failures will lead to huge success.

"I wanted to be part of the art world, and I needed money to do it. So, I took a second mortgage on my home and borrowed $10,000 from the bank to start Park West."

Now that he had his new mission and his first seed money, Albert started putting together a plan for his yet-to-be-named art company. Fortunately, he was able to find support for his venture in the familiar world of academia.

"I was very aware that I was an ex-college professor, so I used that," says Albert. "My first lawyer was a college professor. My first accountant was a college professor. I went to the universities to seek them out. I sought the best minds that I could find within the departments that had private practices. My lawyer was an adjunct professor at University of Michigan Law School. Wonderful teacher. I could ideate anything to him and, if it was a bad idea, he'd yell, 'Don't ever think that again, that'll get you arrested!' I didn't know the rules, but I was very smart about how I proceeded. We were very proper about everything."

Starting off, all Albert had was a modest, nine-hundred-square-foot gallery space with a frame shop and an office area. He opened it in the city of Southfield, a suburb of Detroit, not far from where he used to teach at Wayne State.

Before long, Albert landed on a name for his new company—
Park West Gallery.

But why call it "Park West"?

Albert explains: "Early on, I ran into this fella who was selling art gallery franchises, and they were called 'Park Lane Galleries.' I was good at researching and investigating things and quickly found out that it was a bunch of hot air—they'd offer these worthless contracts with 'art publishers' who weren't much of anything. I loved the name 'Park' but I didn't like the 'Lane,' so I changed it to 'West.' I liked the sound of 'Park West.' It was a very cool name. I didn't worry about their franchises, because I checked with my lawyer and, anyway, I knew I'd be the better brand. And I was."

Still, Albert describes his early forays into the art market as "primitive."

"When I went out on my own in 1969, I got some pretty decent pictures from my cousin on consignment. I got frames on consignment from a friend of mine, John Abbott. I did my research. I put together some attractive packages."

Finally, Albert sold his first work as an art dealer to a woman for $200. While he was pleased about the sale, Albert recognized that "I still had to pay for the art and the frame out of that $200 (not to mention the rent, heat, and electricity). Unless I sold more pictures there wouldn't be anything leftover. I wasn't going to make a living on that.

"That's when I realized I had to start thinking outside of the box. It wasn't the small markup that was killing me. I just had to sell more pictures. I had to commercialize myself very rapidly or else I was going to go out of business."

For starters, Albert gained access to better art by stressing his connection to his cousin Paul's gallery in Lyndhurst. "I would say, 'Why should you do business with a little squirt like me? Check out

my cousin.' He had become a very important dealer. So there was my backing and, in many cases, Paul got a percentage of my gross sales. I also started selling more graphic works, instead of just paintings."

At this period in history, the art world had several superstar artists who were primarily known for their graphic editions, like Andy Warhol, M.C. Escher, and Peter Max. Carrying these works allowed Albert to ride the wave of his artists' popularity and give his clients a wide range of collecting options.

His next big step forward came from reexamining how traditional art auctions were being held at the time. Albert was about to introduce a new way of selling art to the world.

The concept of traveling with the art and artist, instead of sitting in a gallery, proved to be central to Park West's success. This nascent strategy blossomed into Albert holding about five hundred auctions a week around the world. This strategy's ultimate success is also evident in the international art fairs that have come along since, like Art Basel and Art Miami.

"I looked at everyone else doing auctions," Albert remembers. "And I said, 'I'm going to do auctions, I'll sell at a lower price, and I'm going to get people excited about bidding.' As long as I can cover my costs and make a few dollars, I'll sell the art." A major key to his strategy was falling back on his background as a teacher. "I knew I could talk about art, and I knew I could teach people about art and make it interesting."

Albert was also noticing that traditional brick-and-mortar art galleries just weren't connecting with modern art collectors anymore. "I had my art hanging on the wall of my gallery space, but nobody was buying anything. My head was going a million miles an hour. I had bills to pay. I had a $10,000 loan on my house. I knew I couldn't just sit there and wait for them to come to me."

That was when Albert began experimenting with leaving behind the gallery walls to reach new collectors.

"When I was first starting, do you know what really worked?" Albert says. "I had a little trailer with a light-up sign on the side that said 'Art Auction Sunday.' We'd pull it out in front of a shopping center, and I'd leave it plugged in all weekend. Then, every Sunday, we would hold an auction at the center at 2:00 p.m. I'd make a small amount every weekend… $2,000, $3,000. But, by the end of the month, I'd have over $10,000 just from those Sundays, and a new list of clients."

Albert smiles. "Eventually, it all started to work."

CHAPTER 6

Taking Risks, Reaping Rewards

Uncertainty, experimentation, and risk came with Albert's new model of presenting art, and it began to take its toll on Albert's marriage. Now, Albert and Diana had two children, Lisa and Marc, but it was becoming clear that Albert's new career was a deal breaker for his wife.

"I was a high risk taker, and she was super conservative," Albert explains. "When I wanted to start the business, she freaked out. She said, 'I'm done,' and left me with the kids."

Those were tough years for Albert, launching a business as a single parent, but he was devoted to raising his children, who split their time between living with Albert and their grandparents in New Jersey.

"In those early days, my kids, they grew up in the business," Albert recalls. "Lisa would help with the invoices, and organize them. She was a very strong student. Marc had his jobs—he would load and unload the little pictures and get them organized, He was good at it. I was living the life of being a single father and running a business at the same time. How does that work? Well, God never gives anybody more than they can handle."

Albert would later remarry, but his second marriage ended in only two years. Sharon was a great person, but they were just wrong for each other. What Albert didn't realize was that his ideal partner was already working for him and, one day, she would change his life.

Her name was Mitsie.

When Park West first opened in 1969, Albert needed help, and he found much of it in the local community.

"Mitsie and I met in our neighborhood when I was still teaching. She lived next door. I was looking for somebody to help at the gallery. She seemed like a perfect fit."

"Mitsie was my first employee. She was such a good worker." After years of working together, Albert admits, "I couldn't ignore her forever."

Eventually, in 1985, Albert and Mitsie were married. She had two children from a previous marriage—John and Nicky. Mitsie and Albert were immediately devoted to being parents to all of their children: Lisa, Nicky, John, and Marc.

There was no way for Albert to know it, but finding Mitsie would lay the foundation for, one day, making Park West a true family company.

Mitsie is now Park West's corporate secretary and Marc is the company's president. (Albert is the CEO.) Nicky and John are both executive vice presidents, and Lisa ran Park West's Research Department for a number of years and now lives in Portland (where she remains an outstanding art researcher). Albert and Mitsie's dream of creating a family business became a reality.

But Albert didn't know about Park West's eventual success or the amazing growth of his family at the time. He was just trying to get his new company off the ground.

One of Albert's abilities is to act as a bridge between the art and the audience. He's like a gatekeeper, helping transport a person from one state to another. His vision was (and still is) "to reach people with pictures. I want them to have pictures. How they get them… I'm not so concerned. I want them to get pictures, even if they don't get them from me. Society can't live without pictures. I'm not saying it's revolutionary. There's nothing revolutionary about selling pictures, but we can't survive without pictures."

He just needed to find new ways to reach the people.

ART ON THE ROAD

On the opposite side of the country from Michigan, you can find Park West's facility in Miami Lakes, Florida. In the lobby, several sculptures are displayed. One of them is in the art deco style associated with the artist Erté. Two of the sculptures have Western themes. evoking the ethos of individualism.

One depicting a mountaineer riding a horse, is by Charles Russel, and the other is by Frederick Remington. They echo Albert's sensibility of American ruggedness, determination, and the gumption to get up and go. Albert got them a long time ago when he was still finetuning his vision for Park West.

"That was during a period in the '70s when I was dealing a bit in estates, especially locally, getting things at auctions. I retained the Remington from a local collection."

When Park West first started, Albert knocked on a lot of doors.

"In those 1970s years, I was up to just about anything I could so I could be an art dealer," Albert recalls. It was a time of trying new things and seeing what worked.

"Estate sales were nice but very time consuming, so I focused on signing up more artists, expanding my catalog, getting more auctioneers, and doing more and more events.

"I did events at hotels, department stores, synagogues, high schools, country clubs. One big part of our business at the time was that we would do auctions for charity. Those were very popular. We'd host everything, and the charity would get a percentage of the sales. Now when we do something for charity, we give them 100 percent of the money, which I strongly prefer."

Quickly, however, Albert came up with his winning new concept and began traveling around the United States, selling art with the artist at his side.

Albert attributes the winning formula of his traveling shows to the fact that he's "a people person. I meet people, greet people, love people, and hope they are going to go away saying, 'I learned something.' I was planting seeds."

Albert looks back on those early days with fondness. "I was building relationships with my clients, and I was seeing firsthand how powerful that was. One of my early collectors was a doctor, Newman (Norm) Kopald. At an auction, Norm once bought a Renoir from me for $200. Today, it would be $15,000, $20,000 easy. But Norm wasn't happy with the price he paid, so I said 'Look, I'll give you your money back.'

"He gave me back the Renoir and I sold it to another collector right in front of him for $50 more than he paid me. He couldn't believe it. He said, 'You should've sold that for me and given me the $50.' I told him, 'If I walk into your doctor's office, would you ever pay me to do something for you?' He laughed and said, 'That's a good point.'

"Shortly thereafter, he bought Escher's 'Seven Days of Creation' for $35,000. It was the largest sum of money I'd ever sold anything for. At that time, it was a BIG art deal, particularly for me! That sale happened because of the relationship I'd created with Norm."

Now that Albert had figured out what resonated with his collectors, Park West's traveling road shows expanded. Albert said good-bye to the van and began traveling around the country with tractor trailers full of art.

"It's amazing what we did with so few resources," says Albert. "I was doing all of the auctions and the organizing. Mitsie was taking care of the cataloging. I had a guy that I'd trained to pull together the art for the auctions every week. I had truck drivers and enough art to supply a couple of different trucks. And that was it.

"With the new, bigger auctions, we started locally… Southfield, Ann Arbor, Flint, Toledo. Then Saginaw, Bay City, Petoskey… we hit the state of Michigan hard. Next, we were moving out to Dayton,

Cincinnati, Chicago, Louisville. We went further and further and suddenly we're in Texas." He spins off the names of more cities he visited. "Memphis, New Orleans, Atlanta, Tampa, Jacksonville. When we put on our shows in town, people came."

An example of a 1972 catalog from a Park West auction at the Holiday Inn in Southfield, Michigan is shown on pages 179-182. You can see by the impressive collection of museum-quality art—signed Dalí, Appel, Picasso, Vasarely, and more—that Park West was already on its way to the big time.

The shows grew. Albert had a winning formula.

"At one point, we had eight trucks driving across the country. We would change the trailer, pull up the load, and we were off to the next show. As an engineer, I've always been strong with logistics. I computerized some things on the back end, figured out a plan, and those road shows just took off.

"Remember, I was still the guy up on stage conducting all of the auctions. If I did two shows in a weekend, that was one hundred auctions a year for me alone. It got to the point where I couldn't meet the demand for auctions with just me. So, for the first time, I was hiring other auctioneers too."

But it wasn't just the business that was getting bigger. Albert's clientele similarly grew as he took his moving gallery around the country.

"The clients were letting us talk about art. They were hearing our stories about art. We were teaching them the basics and they loved it. And, when they'd collect with us, they'd love it even more and they'd tell their friends."

Once Albert got in front of a crowd, he was a man on fire, always on the go. During his busiest time, Albert would spend up to three hundred nights a year making presentations.

"The travel sometimes became expensive and problematic, but I was just that busy. I'd do an afternoon event and an evening event. Early

on, the sales were small. If I did an auction for $10,000, that was a good number. But, all of a sudden there were $25,000 events, and at three hundred events, you start to make a little money. We were succeeding because I would see the opportunity, do the research, and make sure that everything we did was impeccably correct. That's how we built our reputation."

ART ABROAD

For a time, Albert tried having another gallery in New York, which had become the art capital of the world. From 1971 to 1974, he had a second-floor space on Central Park West at 79th Street. The location went well with the company name and it was convenient for traveling to Europe.

That was important because not only was Albert going to Paris and Amsterdam more frequently to acquire art, but he was also starting to bring collectors to Europe with him.

"That started very organically," Albert recalls. "There was a small group of our very best clients. Extremely nice people. I wanted to take them to Paris and introduce them to people I knew in the art world. You have to recall that Picasso didn't pass away until 1973, so, because I was dealing in Picasso works, I wanted them to meet the people who spoke to Picasso every day. I wanted them to see where my art was coming from, feel that connection.

"So I organized a trip. I set up tours, found hotels, got everyone a group rate. I didn't make any money on the travel. I just wanted them to have that experience, and they wanted it too. It made those European artists come alive for them. Escher, Picasso, Dalí, Miró. That event I hosted in Escher's home with his wife playing piano— my friend Dr. Kopald was there—*that* really became my model for making those trips valuable and emotional for my collectors.

"I get very close with my clients. Clients are my friends. I don't mislead them. I don't play with them. I sweat really hard to get the best possible situation for them. In the beginning, those trips abroad

were just for my best collectors. They were very spontaneous. There was no schedule. I would do them here and there. It was about quality more than anything."

Today, Park West organizes hundreds of collector trips every year on literally every continent on the planet. (Yes, they have been to Antarctica.) But, back in the 1970s, Albert was still laying the framework for what the Park West abroad experience would one day become.

During those early client trips, Albert developed some essential tricks of the trade. He prided himself on knowing every collector's name. "As they got off the bus, I would come up and say, 'Hey, Jeff from New York. I'm Albert.'" He'd accomplish this by studying a list of names furiously beforehand and even sometimes ducking into the bathroom to give himself a refresher on his list. "I could have my short-term memory kick in for the event and people were so appreciative of the time and effort I put into it."

From the road shows to the international collecting excursions, one thing was clear—Albert's new paradigm for selling art was working.

"My business philosophy was (and is)—help our clients as much as I possibly can," says Albert. "That's the underlying core value at Park West. I don't want anyone collecting with us and not understanding what they're looking at. We slow it down. Let's sit for a minute and talk. That's why I love the cruises or our three-day events today because people have more time to think about what they're buying. It's more relaxing and, as I see it, it's the right way to do it."

Now firmly in the 1970s, Albert and Park West Gallery were starting to have an impact on the art world.

But where was Albert getting the art he was selling to his eager collectors? It came from rising stars and artistic icons. It came from some of the most respected art dealers in history. It came from New York, Paris, and Amsterdam, and everywhere in between.

And here's how he did it…

The Foundational
Artists

CHAPTER 7

M.C. Escher

Many factors contributed to the early success and ultimate longevity of Park West Gallery. One of the major ones was Albert's ability to create meaningful and mutually beneficial relationships with some of the most popular artists of the era.

The first of these art world icons that Albert connected with was the Dutch artist Maurits Cornelis Escher—better known to the world as M.C. Escher.

Even if you're not familiar with the name "M.C. Escher," chances are, you're familiar with his art. His intricate, puzzle-like compositions have become pop culture staples, particularly his multidimensional representations of endless staircases warping back into themselves like a never-ending Möbius strip.

Escher was a draftsman, book illustrator, tapestry designer, and muralist. He even briefly trained as an architect at the School for Architecture and Decorative Arts in Haarlem, but his primary work was as a graphic artist.

In his early works, whether depicting the winding roads of the Italian countryside, the dense architecture of small hillside towns, or the details of massive buildings in Rome, Escher often created enigmatic spatial effects. These effects occured thanks to Escher's unique talent for combining various and often conflicting vantage points—for instance, looking up and down at the same time. He frequently made such effects more dramatic through his treatment of light, utilizing vivid contrasts of black and white.

After Escher left Italy in 1935, his interest shifted from landscape to something he described as "mental imagery," often based on

theoretical premises. This was prompted in part by a visit in 1936 to the fourteenth-century palace of the Alhambra in Granada, Spain.

The lavish tile-work adorning the Moorish architecture suggested new artistic possibilities in the flattened patterning of its interlocking forms. Replacing the abstract patterns of the Moorish tiles with recognizable figures, Escher developed his hallmark "regular division of the plane" in the late 1930s.

The artist also used this concept in creating his "Metamorphosis" designs. The idea of "metamorphosis"—one shape or object turning into something completely different—became one of Escher's favorite themes. After 1935, Escher also increasingly explored complex architectural compositions involving perspective games and the representation of impossible spaces.

Today, you can find clever visual allusions to Escher's "impossible spaces" in comic books, cartoons, and movies of all kinds. For instance, Escher's most famous creation, his perpetual staircase, is directly referenced in director Christopher Nolan's hit 2010 film *Inception*.

In a 2015 article, the UK newspaper *Guardian* argued that "Escher's art at its best… is not just surprising but also surprisingly readable, putting him in the company of the great allegorical printmakers such as Albrecht Dürer."

Escher had been working as an artist since the 1920s, but he became an international phenomenon once his graphic works, in particular, were embraced by the psychedelic art movement of the 1960s. Suddenly, the Rolling Stones were asking him to design an album cover (he declined), and Stanley Kubrick sought him out as a designer for his film *2001: A Space Odyssey* (he declined that too).

Escher didn't want to work on the projects of others. He was proud of his artwork. Albert remembers him as "a man who wanted people to have his art."

That said, Escher was not pleased with how his artwork was being distributed as he rose to fame in the '60s. In the book *Escher: The Complete Graphic Work*, you can find a 1969 letter where Escher complains that "the hippies of San Francisco continue to print my work illegally."

What Escher needed was an art dealer who both respected him as an artist and could bring his art to the people in the best way possible. That dealer was Albert.

Escher was one of the first artists whose work really spoke to Albert. His art fits together in a way that just sings to an engineer. His compositions stimulate the imagination with their impossible, tantalizing proposals.

Albert first got involved with selling Escher's graphic works in the early 1970s, not long before the artist passed away in 1972.

"Unlike most all of my foundational artists, I didn't really get to work directly with Escher," says Albert. "It was my friend and colleague Michael Sachs who interacted with Escher. He would go to Holland to buy the works while I was selling them all over the country."

Following Escher's death, Albert continued working with the artist's family. "In 1974, I went over to Holland along with my oldest daughter, Lisa, then eleven years old, and my sister Marie. It was a collector's trip. Escher's wife was with us. I was able to bring our collectors into the Eschers' home, and there was his wife playing piano in one room while I was showing and selling art in another. It wasn't about being theatrical. It was about connecting people to the art. The market we built for Escher's works was enormous. Demand was high, and now we had a strong relationship with Escher's estate."

The intimate scene that Albert had witnessed at Escher's home became a model for a new way to reach buyers. He added his razzle-dazzle personality and educational components and created a juggernaut.

"We did very nicely with that," Albert remembers. "I only made one mistake—I didn't keep anything.

"Now, it's extremely hard to find original, signed graphic works by Escher at all and, when they come up for auction, they typically sell for tens of thousands. If I'd kept some of the rarer works, they would've been worth a fortune today.

"But, at the time, I couldn't afford to keep anything. We were selling so well, we had to sell them all! Today, as a company, our philosophy is very different. Park West has a fantastic archiving program now. I'm very happy about that. But we had to sell to keep the company growing."

CHAPTER 8

Peter Max—A Winning Ticket

"I wanted the media to be my canvas."

—Peter Max

As Albert gained momentum and was able to look further ahead, he imagined who would be a dream artist to work with. When Peter Max and his cosmic work donned the cover of *Life Magazine* in 1965, Albert was an instant fan. And, when Albert opened his gallery in 1969, he knew this was the artist for him and set his sights on wooing the bright new star.

The ensuing relationship has endured for almost half a century. The dynamic between Albert and Peter is at the heart of Park West's history. No other artist has worked more closely with the gallery. Peter has made hundreds of in-person presentations at Park West auctions over the years. He and Albert were destined to transform the marketing of art.

As a youngster, Max was interested in art and astronomy, and his twin concerns are evident in many depictions of stars, planets, and the cosmos. Likewise, Albert had a deep interest in astronomy and space, having spent years working on rocketry systems.

Unlike Albert, though, the iconic artist had an unusual, dangerous, and exotic childhood. Born of Russian immigrants fleeing oppression, he spent time in Japanese-occupied Shanghai. Watching monks paint calligraphy was instrumental in inspiring his line and technique. His colors were free and vibrant. He then spent time in Israel before moving to Brooklyn in the 1950s. In the midst of uncertainty, art was Max's constant companion. He learned how to incorporate his kaleidoscopic life into his work.

"When I approach a canvas, the only thing I anticipate is being... surprised!" Max once tweeted.

When Park West was founded in 1969, it would've been hard to imagine a more popular living artist than Peter Max.

Max was EVERYWHERE.

Though he was already an accomplished artist, during the 1960s, Max's surrealistic pop art propelled him into the stratosphere. Few other artists had so perfectly captured the spirit of the era, and critics referred to Max as "the visual counterpart to the music of the Beatles."

In 1961, fresh out of art school, Max established a graphic design studio. It found almost overnight success in the design industry. Around this time, Max began experimenting with a more abstract and colorful style. He expressed this new, psychedelic style through posters, advertising, and graphic works.

The look he achieved quickly became sought after by companies across the globe. Agencies, magazines, and national publications all commissioned Max's trademark style for a wide variety of projects and campaigns.

Posters of his cosmic designs hung in almost every college dormitory in the United States, and, in 1970, New York City printed millions of their Yellow Pages telephone directories, all with Max's art featured on the cover.

The same year Albert started Park West, Max appeared on the *Tonight Show with Johnny Carson*, the *Ed Sullivan Show*, and the cover of *Life* Magazine. Max was so popular that, for his *Tonight Show* appearance, they completely redesigned the talk show set, surrounding Johnny Carson in reproductions of Max's art. Max was the definition of an art world celebrity.

Albert was a fan of Max's designs and, like many dealers of the period, had great success bringing Max's graphic works to his collectors. Albert could see that the public had an almost insatiable hunger for Max's artwork, but Park West was still a new and

relatively small gallery. How could a gallery that size partner with, arguably, the biggest artist in the world?

"I knew I needed to find a way to work with Max and that was not easy for a guy without money," Albert remembers. "It worked out because of perseverance."

Part of perseverance is preparation. Albert did his due diligence, respectfully learning everything about the artists with whom he wanted to work.

"When I'm prepared, I'm ready. I read about Peter. I studied him before we met."

In a short period of time, Albert was able to sell so many of Max's graphic works that it led to a fateful meeting between the two men—a meeting that would change the course of both of their lives.

Albert told the story of how they first met in an introduction to the artist's 2013 memoir, *The Universe of Peter Max*. Here's what he wrote:

"In the fall of 1971, I was invited to New York to act as the art auctioneer for a charitable benefit. At the time, I had built a reputation as a capable auctioneer with a broad knowledge of Peter Max's work, and Peter had built a reputation as a dynamic, innovative artist, who had uniquely woven his iconic imagery into the fabric of American culture.

"New York's mayor, John Lindsay, was present at the event, along with prominent labor lawyer Theodore Kheel. Immediately after *NBC Tonight Show's* co-host Ed McMahon introduced me, I began to sell every piece at the auction, with the proceeds going to the charity. Peter and I instantly became good friends."

In the Park West archives, there is a video of Max appearing at a 2012 event where he tells a packed audience all about his first meeting with Albert:

"My favorite person in America, Albert Scaglione. He's so smart, he's so fabulous, he's so nice to me, I can't believe it. And I was introduced indirectly through… Ed McMahon… Ed McMahon had me come to some event and this gentleman was giving an auction and then I became a big fan and followed him and then we became big friends, and now he owns the art world!"

Following that charity auction, Albert began representing Max as his art dealer. Since that day almost fifty years ago, no dealer on Earth has sold more Peter Max art than Park West.

But it initially took some convincing for Max to start expanding the scope of the art he was making available to the public.

"You have to remember, Max was very successful as a young, young guy," Albert points out. "Max did not have a need to sell his paintings in those days. He had licensing, he was a designer. Galleries were not really his cup of tea. He liked having control."

However, around the same time that Park West was getting off the ground, Max was becoming less and less interested in his corporate commissions and graphic design work.

Max wrote in his memoir, "I had been so busy managing a studio that I had taken very little time to paint and draw for myself, without any project commitments."

In that 2012 Park West video, Max tells the rapt crowd about that early time in his career. After leaving behind his first studio, Max recalls, "Somebody came to me and said, 'Peter, you have these amazing images, we would love to put them on shirts and so forth.' So I allowed that to happen… In three years, I went from one T-shirt line to seventy-two product lines and did almost two billion at retail in 1971 dollars, if you can imagine. Today, that would've been ten times as much. And I gave it up painfully because I loved it so much, but I knew that if I continued, I'd become Pierre Cardin, Dior, Ralph Lauren, you know, and I didn't want that to happen."

Instead, Max embraced painting and, as he wrote, "Slowly I returned to my core self, and my creativity began to flow, inspiring a series of drawings with a totally different look than my cosmic 1960s style."

Albert recalls the change in Max's style during that era. "Peter always had many things going for him. He was a great colorist. He was using really modern colors, paint, techniques. His drawing was fluid and relaxed and, in a sense, almost like Picasso."

Max was moving away from his pop graphic roots and toward abstraction.

In his memoir, the artist remembers, "Throughout this transition period, I gravitated to a whole new expressionistic style, embracing minimalism while I continued to create drawings and paintings in my cosmic 1960s style. Then I met a master silk-screen printer and created a new series of limited-edition graphics. The colors and color blends were pure and vivid. I fell in love with the whole art of printmaking and created numerous editions, employing a vast diversity of art styles."

Max's move toward fine art became apparent when his first one-man museum exhibition, "The World of Peter Max," opened at the M.H. de Young Memorial Museum in San Francisco in 1970. The show attracted tens of thousands of visitors and, as a result of its success, forty-six additional museum exhibitions were scheduled around the United States by the Smithsonian Institute Exhibition Services.

That ushered in a whole new chapter of Max's career, where he developed a new neo-expressionist style, and where he truly began to bridge the gap between critical and popular acclaim in a way that few artists ever have.

In the following decades, Max designed his own postage stamp, held more museum exhibitions, and published books of his art. He almost single-handedly inspired the campaign to renovate the

Statue of Liberty in the 1980s, and he celebrated the end of the Cold War with a sold-out retrospective at Russia's Hermitage Museum.

He painted six sitting U.S. presidents, was the official artist for the 2006 U.S. Winter Olympics team, and created art for Woodstock '99, World Cups, U.S. Opens, and Super Bowls.

In 2000, Continental Airlines commissioned Max to paint the fuselage of a $600 million Boeing 777 Super Jet. Albert remembers one of the few times Peter was really unhappy with him was when he told Peter, because of scheduling, he couldn't travel with him on the inaugural round trip of the "airplane painting." It took Peter nearly a year to stop mentioning to Albert how disappointed he was that Albert didn't make the trip.

Over a decade later, Max was the first artist ever invited to paint the hull of an entire cruise ship. His designs decorated all forty thousand square feet of the Norwegian Breakaway, one of the largest cruise ships in the world. Rest assured that Albert was happily with Peter, arm in arm, at the ship's inauguration.

It's further evidence of the simpatico relationship between Albert and Max that, while Max was painting the outside of a cruise ship, Albert was establishing a network of galleries on dozens of cruise ships around the world.

Throughout it all, for more than forty-five years, Albert and Max worked together, creating art and appearing together at hundreds of Park West events around the world. Not many people can point to such a successful friendship or a partnership that goes back so far.

"Peter's exponential, man," says Albert. "I mean, we go back a long time. I used to go to the studio, he put on the music, we'd hang out all night. I couldn't last with him. I mean, he starts when I'm starting to wind down… that's his time. And then it just goes, he's got his colors… he thinks exponentially. He would've been a great scientist."

In turn, Max admitted in 2012, "Whenever I'm painting, every day when I paint, I always think of Albert."

Looking back, it makes complete sense that Albert and Max developed such an affinity for each other. They're only two years apart in age and, though Max's family lived internationally when he was a child, Max eventually settled in Brooklyn—barely twenty miles from Albert's home in New Jersey. And, interestingly, Peter still maintains a warehouse and studio in Lyndhurst, New Jersey, the small city where Albert first worked at his cousin's gallery.

Also both men share a true affinity for astronomy and space. Max found himself drawn to stories of the cosmos in his youth. When Max was eleven years old, his family moved to Israel where his "childhood fascination with space was reignited."

In his memoir, Max recalls that "[m]y parents, ever supportive, arranged for me to sit in on special classes in astronomy at the Technion, the Israel Institute of Technology. After several classes and countless hours spent poring over astronomy books, I came to understand space—not in a scientific way but in a manner that spoke to my inner being. Somehow I could intuitively perceive the vast distances of space by visualizing immense vistas in my mind that could never be seen with the eye."

With that in mind, how could there ever have been a better art dealer for Max than a dealer who actually worked on the Apollo program and spent years trying to make a mission to Mars a reality?

From the beginning, Albert and Peter were an ideal fit, destined to be together.

"We had a special sauce," Albert says of their half century together. The two were a perfect pair and sold hundreds of millions worth of art together—more than any other artist Albert has worked with to date.

Albert bonds with the people he chooses as partners. He stands by them. There were times when Peter needed Albert's help financially. Peter liked the good life and his first wife liked jewelry and on a couple of occasions Peter got in over his head. When Peter got in trouble with the IRS in the 1970s, Albert loaned him a large sum.

"Peter—we've got a fifty-year history. Peter has thirty stories— twenty-eight positive, two about going to jail."

Peter and Albert have an unbelievably history together. It's probable that the two of them have sold more art than any other team of artist and dealer in history.

CHAPTER 9

Yaacov Agam

In those first years of Park West, Albert pursued relationships with a select group of well-established, living artists whose works spoke to him. He connected with the sublime engineering of Escher and the cosmic boldness of Max. A third artist he pursued brought together those same qualities, while introducing the dimension of time.

That artist was Yaacov Agam, one of the most influential artists of the past century and, arguably, the founder of the contemporary kinetic art movement.

Unlike the op art of Vasarely, which is characterized by the illusion of motion, kinetic art is drawn to *real* motion. For his entire career, Agam has been fascinated by the possibilities of movement in art—its potential to create new and more interactive relationships with the viewer and wholly new visual experiences.

Discussing Agam, Albert says, "He's the kind of artist that if you can dream it and imagine it, he can do it."

Born in 1928, Agam began his ambitious art career studying in his home country of Israel. After leaving art school, Agam moved to Switzerland in 1949 to study color theory under the mentorship of artists Johannes Itten and Max Bill.

Renowned architecture critic and historian Sigfried Giedion helped shape Agam's artistic path while the artist took courses at the ETH Zurich University during this time, inspiring Agam to transform the concept of static paintings.

"In life, you look at art and it doesn't change, but everything changes. But you don't know how it will change, so you have to go

beyond the visible," Agam once said in an interview with Park West. "You have to get the notion that what you see can at any moment disappear to be replaced with something else."

In 1951, Agam moved to Paris. He held his first solo exhibition two years later at the Galerie Craven in Paris. According to legend, when gallery owner John Craven first saw Agam's works, he told Agam, "Don't show your work to anybody, otherwise, they may be copied!" Following his show at Craven's gallery, Agam quickly grew in fame for his innovative approach, encouraging spectators to actively participate in art during a time when this was rarely expected.

The noted art critic Michel Seuphor wrote in a 1954 issue of *Art d'Aujourd'hui* that Agam "does not impose upon the spectator his point of view but invites him into the game of choosing his own viewpoint."

In the essay "Dancing with Janus," scholar Luis R. Cancel further noted that Agam "was cognizant that his work was inserting *time* as a new variable that viewers had to assimilate in order to appreciate and comprehend his work." Agam's introduction of time as art's "fourth dimension" remains as one of his most valuable contributions to the world of art.

Only one year after showing at the Galerie Craven, Agam featured three of his large mobile paintings at Paris's Salon des Realities Nouvelles, followed by an acclaimed exhibition at the Galerie Denise Rene in 1955 titled "Le Mouvement."

This led to additional exhibitions in Tel Aviv, Stockholm, and locations around the world. In 1963, the Sao Paulo Biennale in Brazil created a special award just for Agam called the "Prize for Artistic Research."

The international art world was embracing Agam with open arms, and in no place was that affection more evident than in France.

Agam had been splitting his time between Israel and Paris since the 1950s. However, it was the development of Agam's Élysée Palace Salon in the late 1960s that truly showed France's love of Agam on a national level.

It started in 1968, when Bernard Anthonioz, the principal arts inspector for Paris's Centre National d'Art Contemporain (CNAC) was reviewing their latest acquisitions with Georges Pompidou, the current prime minister of France.

The acquisitions included a work by Agam titled "Double Metamorphosis III," which had been commissioned by CNAC after Agam's previous "Double Metamorphosis II" received remarkable acclaim at New York's Museum of Modern Art.

Not long after his meeting with Pompidou, Anthonioz called Agam and told him, "You know your work has caught the prime minister's eye, and for the last quarter hour he has been pacing up and down in front of your picture."

Later, in 1969, after Pompidou was elected as the president of the French Republic, the French government once again approached Agam.

According to the book *Agam: The Élysée Salon*: "Deeply interested in art and culture, Pompidou decided to make big changes at Élysée Palace [the official residence of the French president], particularly in introducing contemporary works of art." At first, an Agam sculpture was procured for the presidential office, but soon Pompidou was asking Agam to transform an entire salon in the palace into an immersive work of art.

Agam worked on the salon from 1971 to 1974, turning the room into a "seven-hundred-colored kinetic environment" involving groundbreaking design, a special kinetic carpet, and a moveable sculpture. (Unfortunately, Pompidou would pass away in April 1974 before the room was finally completed later that year.)

The French media and critics lauded the Élysée Palace Salon, further raising Agam's already-huge esteem in the art world. In 1979, Agam's salon was moved to Paris's Pompidou Centre, the massive arts center named after the salon's original patron, where it is still on permanent display today.

It was during the creation of the Élysée Salon that Albert first met Yaacov Agam.

"I actually met Agam on my birthday," Albert remembers. "July 4, 1974. I was in Paris with a gallery owner, Blanche Fabri, her husband, Jacques Tésé, and their daughter Vicki, who was a good friend of mine. Blanche owned Gallery 22, which was at 22 Rue Bonaparte in Paris.

"On that day, we were all hanging out with I.M. Pei, the world-famous architect. He designed, among other things, the glass pyramid entrance to the Louvre. It was a huge honor, spending my birthday with this great man. So, at one point in the day, Blanche says to me, 'I'd like you to meet Yaacov Agam. Let's go to his studio.'

"I, of course, knew who Agam was, but I'd held off on meeting him. I wanted to be ready. But Blanche arranges this group of people to go to Agam's studio, and I stayed quiet. He didn't even know I was there, because it was a big group and he got groups all the time. I stood back, I watched, I studied, I listened. I paid attention because Agam was a really big name, a high-level guy at that time, and I wanted to be prepared before I tried to work with him. Agam loves to tell that story now."

It's easy to see why.

Who could have predicted that, after their innocuous first meeting, Albert and Agam would eventually start working together in what would become one of the most fruitful partnerships of their lives?

Albert became a major force in Agam's career not long after his fateful birthday visit to Agam's studio. He quickly became one of Agam's most prolific dealers and played a significant role in

organizing Agam's unforgettable 1980 exhibition at New York's Guggenheim Museum titled "Beyond the Visible."

As Agam developed the concept of the Agamograph, which represented one of the most remarkable contributions to any graphic medium in history, Albert became the dealer who would sell them. More than 90 percent of the Agamographs sold in the world have been sold through Park West.

Sayako Aragaki, the author of the 1997 book *Agam: Beyond the Visible*, describes Agamographs as "the combination of a precise lithographic printing process and a surface mounted-lens." The lenticular lens causes Agam's imagery to shift and change when viewed at different angles—making every person's experience interacting with an Agamograph unique.

Collectors around the globe quickly fell in love with Agam's artwork. Through his limited-edition works, Agam was able to fill the world with his artwork and, at the same time, revolutionize traditional methodologies of printmaking. He not only made his work more accessible to the public through his multiples but he also envisioned an extension of art's traditionally static print medium into the fourth dimension.

Agam further brought his innovative concepts to his large-scale sculptural installations throughout the world. In 2009, he created a monumental sculpture for the World Games in Kaohsiung, Taiwan. He also created the world's largest menorah in New York City and has many other public and private monuments in major cities around the globe.

One of the most significant is his "Fire and Water Fountain" in Tel Aviv, Israel's Dizengoff Square. Originally dedicated in 1986, it's one of his most dynamic kinetic sculptures, bringing together the elements with color and motion to create a singular experience.

During a visit to Dizengoff Square with Agam in 2010, Albert said, "Agam saw this place, and he said it needs to have something for

the people. Tel Aviv is a city of life. Tel Aviv is the city of action, movement, Tel Aviv is the city of water, it's on the sea, Tel Aviv is a city of light. At night, the fountain has fire and music. So, it contains so many elements of art that have never been done by any other human being."

While watching Agam sign autographs near the fountain, Albert pointed out that "Agam is an icon here in Israel. I can't think of another artist that represents his country better." (Agam is, to this day, the best-selling Israeli artist of all time.)

Albert remains deeply protective of Agam and his legacy, which led to Albert pushing Agam in a wheelchair through the streets of New York just a few years after their Dizengoff Square trip.

In 2017, *The Algemeiner*, one of the foremost Jewish newspapers in the world, selected Agam to be the recipient of their prestigious "Warrior for Truth" Award. The award ceremony would take place at the newspaper's annual J100 Gala in New York, a celebration of the top one hundred people in the world who are "positively influencing Jewish life."

Albert and Mitsie flew into New York for the gala but were concerned to discover that Agam had been checked into a local hospital. The artist's pulse had dropped dangerously low following his flight to the United States. (Agam was eighty-nine years old at the time.)Albert rushed to Lenox Hill Hospital, where he found Agam in good spirits but anxious to leave.

That left Albert and Mitsie to figure out the logistics of getting Agam released in time for the J100 Gala. Papers were signed, bills were paid. They were on their way until they encountered the most New York City problem of them all—the impossibility of finding a taxi in the rain.

Undaunted, Albert got Agam into a wheelchair and pushed him three blocks through the rain toward the artist's hotel. "There was no way I was going to let Agam miss receiving that award," Albert

said. "Even if it meant running through the streets of New York, pushing him in the wheelchair in the rain."

But even this short journey wasn't without its complications. During their short trip, Albert and Agam were briefly stopped by the U.S. Secret Service—the president was in town—but the agents eventually sent them on their way. Shortly thereafter, they finally reached Agam's room at the Carlyle Hotel.

A few hours later, noted art world manager Gene Luntz arrived at the hotel to take everyone to Cipriani's 25 Broadway location, where the event was taking place.

It was a fantastic night. In his introduction for Agam, Abraham Foxman, president of the Center for the Study of Anti-Semitism at the Museum of Jewish Heritage, noted how difficult it was to convey the impact of Agam's work using only words.

"Words alone cannot do him justice," Foxman said. "His creativity, his form of expression, is in the image. It is the eye rather than the ear that appreciates Yaacov's genius."

Albert concurs. "His artwork is both universal and proudly Jewish, and I'm so grateful that people recognize what an unquestionably positive influence Agam has had on the world around him."

That positive influence has found yet another expression in the world through the opening of The Yaacov Agam Museum of Art (YAMA) in Agam's hometown of Rishon LeZion, Israel.

When a museum features a painting or a sculpture by an artist, it's considered a tremendous honor. However, few artists in history know what it's like to have an entire museum dedicated solely to their works.

The museum was in the planning and construction stages for nearly two decades. It finally opened its doors in October 2017. The fact that the museum is a publicly funded institution—supplemented

by generous donations from the Park West Foundation and dozens of contributors—shows how passionately Israel regards Agam as its greatest living artist.

"Agam has been so influential to generations of Israeli artists and his work needs to be experienced in person," Albert remarked at the opening.

The museum is one showcase for Agam's amazing creativity. Park West Gallery is another. Through their partnership as artist and dealer, Albert and Agam have been spreading Agam's message around the world together for almost fifty years.

And they're still going strong.

As recently as June 2019, Agam and Albert were happily leading groups of Park West collectors through the artist's Élysée Salon in the Pompidou Centre—the groundbreaking work of art that Agam was in the process of creating when Albert first stepped into his studio in 1974.

CHAPTER 10

Victor Vasarely

Albert can't help but smile when he remembers **Victor Vasarely**.

"Vasarely. For flair, style, nostalgia. He was something else."

Those familiar with art know Victor Vasarely as the founder of the op art movement. Op art is a form of abstract art that typically employs patterns composed with a stark contrast of foreground and background—often in black and white—to produce effects that confuse and excite the eye.

Vasarely's mind-bending art fit Albert's personal taste for precision and order in the same way that Escher's did. "I met Vasarely through my friend Wilfredo Arcay, one of the greatest silk-screen printers in the world," Albert recalls. "I had projects with him with Yaacov Agam, which inspired Arcay and I to become great friends."

Albert knew that Vasarely's kinetic artwork would connect strongly with collectors and developed a strong relationship with the artist, visiting him often. The pair even filmed an interview together in 1982. (Albert says, "I still love showing that video to people to give them a sense of our history.")

Today, Vasarely is recognized as an important artist of the twentieth century. His innovations in op art, color, and optical illusion had a profound influence on generations of artists to come.

Born in Hungary in 1906, Vasarely studied art in Budapest, where he became familiar with the contemporary research in color and optics by Johannes Itten, Josef Albers, and the constructivists Malevich and Kandinsky.

After his first one-man show in 1930, at the Kovacs Akos Gallery in Budapest, Vasarely moved to Paris. For the next thirteen years,

he devoted himself to graphic studies. His lifelong fascination with linear patterning led him to draw figurative and abstractly patterned subjects, such as his series of harlequins, checkers, tigers, and zebras. During this period, Vasarely also created multidimensional works of art by superimposing patterned layers of cellophane on top of one another to attain the illusion of depth.

In 1943, Vasarely began to work extensively in oils, creating both abstract and figurative canvases. His first Parisian exhibition was the following year at the Galerie Denise Rene, which he helped found. Vasarely became the recognized leader of the avant-garde group of artists affiliated with the gallery.

In 1947, Vasarely vacationed in Belle-Isle (off the Brittany coast in France). A mature artist already in his forties, Vasarely experienced an artistic epiphany. He wrote, "The pebbles, the sea-shells on the beach, the whirlpools, the hovering mist, the sunshine, the sky… in the rocks, in the pieces of broken bottles, polished by the rhythmic coming and going of the waves, I am certain to recognize the internal geometry of nature…"

This experience marked the beginning of the most important artistic phase of his life—the "Belle-Isle Period"—in which Vasarely came to the understanding that "pure form and pure color can signify the world." As he spent more time studying, he discovered that he could comprehend more of humanity and the mysteries of nature.

In 1965, the Museum of Modern Art in New York mounted an exhibition called the "Responsive Eye" which included Vasarely's works. The exhibit centered on a new artistic concept that focused on the optical *suggestion* of movement without actually creating movement.

From this exhibition, the term "op art" was coined, and Vasarely became the movement's most famous exponent. From 1968 on, Vasarely's work centered on his own "universal structures" where

illusions of forms escaping, swelling, and protruding emerged from entirely flat surfaces. His other works offered perceived shapes resolving into completely different shapes and forms as the eye moved over them—a similar concept to the works of M.C. Escher.

Vasarely also became adept with color, taking full advantage of color juxtapositions. He created astonishing kinetic effects through subtle shifts in chroma, which required rigorous calculation, exhausting experimentation, and careful preparation.

As he grew older, Vasarely became more interested and involved in developing a worldwide aesthetic. Much like Albert, Vasarely believed that art should be for *everyone,* and he worked tirelessly in his later years to achieve this goal.

He famously said in 1960, "The end of art for a sophisticated elite is near, we are heading straight towards a global civilization governed by Sciences and Techniques. We must integrate visual sensibility into a correct world. … The art of tomorrow will be a collective treasure or it will not be art at all."

In his 1982 interview with Albert, Vasarely stated that people always have two distinct reactions when they encounter a work of art.

"The first is a reaction of feeling that takes place in the heart, in the stomach. The second movement is in the brain.

"First feeling… one sees a painting. Suddenly, the colors enchant you, you are touched by the colors. You feel something that comes from the painting and you begin to think, 'Why does that interest me so much?' Purely and simply, because, bit by bit, you have occupied a specific place in general human thought. That place is what we call 'humanism.' That means one mustn't believe that the 'me' is something important.

"The individual is a minuscule part of a huge life of billions of individuals, that is to say, humanity. One mustn't make art for an individual or individuals. Art must be made for the entire world."

This belief in the universality of art is yet another reason why Park West Gallery made such a perfect home for Vasarely.

During their partnership, Park West was the publisher of hand-signed serigraphs featuring some of Vasarely's most defining and riveting imagery.

The technique of serigraphy was particularly well suited to Vasarely's work as it expertly captured the subtle coloration modalities, precision of shape and form, and nuances of gradation so important in achieving his kinetic effects.

Later, Park West acquired a significant number of Vasarely's paintings, serigraphs, and sculptures when it purchased the art dealer known as Circle Fine Art—making Park West's collection of Vasarely's works one of the most comprehensive in the world.

However, similar to what happened with Escher, Vasarely's intense popularity with art collectors resulted in Park West quickly selling out of his works. While Albert regrets not having archived more of Vasarely's work, the collection is still one of the gems of the Park West archives.

"I loved Vasarely. He was a neat guy. Clever and Hungarian to the core."

Traveling the World,
Acquiring the Masters

CHAPTER 11

Testing the Waters—Tokyo

While those four iconic artists—Escher, Max, Agam, and Vasarely—played an enormous role in the foundation of Park West Gallery, they weren't the only factors that transformed Park West into an art world phenomenon.

In the '60s and '70s, Albert was set on working with the most exciting artists of the day, but also developing a world-class collection of art from some of the greatest artists of all time. But he couldn't acquire those classic masterworks from his home gallery location in Michigan. So, Albert packed his bags and began years of nonstop international travel, hunting down significant works of art that would make his collectors go crazy.

After a chance encounter at his gallery in Southfield, one of Albert's first stops was Tokyo, Japan.

"A man happened to walk into the gallery one day. It was 1970,

I had just started the business. Tatsuo Takeii was a scrap-iron dealer from Tokyo, but he knew the art scene. He was incredibly impressed by how many Picasso works I had acquired. He was shocked that a Detroit gallery had such a collection."

That got Albert thinking about Japan as a potential new market for his art auctions. "I had started dealing art in New York, and so many of those sales were going to Japanese collectors. So I figured I might as well go to Japan."

Albert began working on a plan for entering the Japanese art market. He found his Japanese partner, Murakami—a gallery owner whose father-in-law was Kiyoshi Saito, known for a style that blended modernism with traditional Japanese woodcuts. Now Albert just had to decide what kind of Western art would appeal to Japanese collectors.

He landed on one name: Picasso.

"What I'd learned from Takeii, and the dealers, auction houses, and galleries I was dealing with in New York was that the Japanese had a high appreciation of Picasso, and I had a keen interest in Picasso too."

Through his contacts, Albert was able to put together a substantial Picasso print collection. Even though Park West was young, it had very good credit and a strong reputation. Albert and Takeii put together a plan and, within months, there were two containers full of Picassos headed for Japan.

It was a smart move on Albert's part. "In Japan, I was being begged to display my Picasso inventory. With the program we put together, we were way ahead of the curve."

Albert organized auctions while living out of a hotel in Tokyo. The public quickly embraced both Albert's Picasso collection and his flair as a showman. "I was doing very well holding auctions in Japanese department stores," he remembers. "Collectors were buying the Picasso prints like candy."

Soon, Albert had become a kind of local celebrity, and the fact that he was a tall, well-dressed American made him hard to miss. "I had so many people taking my picture, I was getting a suntan from the flashes," he laughs.

However, not everyone was happy with Albert's newfound success. "I had an incredible run in Japan, but it was short. The Tokyo dealers didn't like my success. Within a matter of a few months, as I was hitting my stride, a new law was passed regarding art auctions in hotels, department stores, and shopping centers. They didn't try to outlaw art auctions but governed those who were allowed to buy by forcing them to become members of the auction society. Only members of the auction society were allowed to buy at auctions. The problem with that was it cost the equivalent of $10,000 to eventually become a member. As soon as the law was passed, the auctions were over."

In response, Albert's Japanese partner began selling the Picasso works at his own gallery, an arrangement that didn't last long when Albert learned that Murakami only intended to pay him in prints by his father-in-law Saito or in Japanese woodblock prints.

"It had a bit of a tale. Murakami ran out of money and he had to sell the prints. They kept my Picassos and I took their woodcuts. I took the logical way out, which was to accept what was happening, maintain the relationship, and head home," Albert admits.

The woodblock prints were known familiarly as *ukiyo-e*, or "pictures of the floating world." Japanese woodcuts traditionally portray "worldly pleasures and earthly delights"—a type of escapism inspired by the frustrating ancient class divisions between Japanese nobles and warriors.

Fortunately, Albert had good reason to suspect these woodcuts would be popular with Western collectors.

Claude Monet once explained his artwork to an art critic by stating: "If you insist on forcing me into an affiliation with anyone else for the good of the cause, then compare me with the old Japanese masters; their exquisite taste has always delighted me, and I like the suggestive quality of their aesthetic, which evokes a presence by a shadow and the whole by a part."

Other collectors of Japanese woodcuts included renowned artists like Toulouse-Lautrec, Edgar Degas, James Abbott McNeill Whistler, and Vincent Van Gogh.

At the very least, Albert knew that the art he was leaving Japan with had inspired many of the European masters he'd spend much of his life collecting. Albert wasn't upset.

"They kept my Picassos and I took their woodcuts," Albert states matter-of-factly. "I learned a lot."

His time in Japan had been a success. He'd proven that there was a hungry international audience for his style of art auction, and he was leaving with an impressive collection of Japanese art.

"I left Japan full of confidence, thinking how great it would be to return home," says Albert. "My time there was part of a whole picture that was developing as I was coming into my own as a dealer.

"I knew how to sell in Japan. Japan was my world. Then Paris became my world."

CHAPTER 12

My World Became Paris

"A prudent man must always follow in the footsteps of great men and imitate those who have been outstanding."

—Nicollo Machiavelli

Albert's first international foray gave him experience and courage. It was another step in creating the complex events that Park West has become famous for. The Picassos had sold in Japan and made the trip a success. Now, Albert concluded it was time to go to Europe and begin dealing directly with the best dealers. Gay Paree was the next step.

One of the earliest lessons that Albert learned after opening Park West Gallery was that, with art, whenever possible, you always should go directly to the source.

Albert wanted the pedigree of his art collection to be impeccable and that meant always being able to clearly establish *provenance*— the direct line of ownership that could take a work of art back to its original creator.

At the time, there was no better place in the world to find authentic artwork than Paris, the city where many of history's finest artists lived and worked for centuries.

New to the art game, Albert didn't have any contacts in the Parisian art world, but he did have one thing going for him.

"I knew a little French," he recalls. "I needed a language in order to complete my Ph.D., so I took technical French, even though most engineering students take German or Latin. So I had a pretty good technical knowledge of French and that's what I needed."

Albert first visited Paris when he was in his midthirties, but he was eager and ambitious to make his mark in the city's art scene.

"Fortunately, I was with my friend Michael Sachs, who I knew from Ann Arbor, Michigan. He has a Ph.D. in psychology and was very resourceful," Albert remembers. "His French was better than mine, thankfully, but we were always planning together, playing to our strengths.

The two Americans had complementary attributes and made an effective team. "We had the ability to absorb knowledge—my ability to teach and sell, my business sense, and, with Michael, his own expertise in art history and particularity in research and making connections. We truly respected each other."

Albert's initial visits to Paris kicked off a productive cycle—he would arrive in the city, buy as many signed, authentic works as his budget allowed, return to the United States, and sell enough of his new acquisitions to fund another trip to Paris.

Fairly quickly, Albert decided that he wanted to get more ambitious with his collecting trips. He just needed more access to better works of art.

What he needed was Henri Petiet.

Petiet was a legend in the contemporary art world. According to a February 2018 ArtDaily article, "[t]he vast ensemble of modern prints gathered by this giant of the 20th-century art market was indeed considered to be the largest in the world in private hands."

But Petiet didn't deal with the public and Albert didn't have an entrée to him. Ultimately, it took some rudimentary sleuthing for Albert and his partner to locate the king of prints.

"Michael and I called every 'Petiet' in the Parisian phone book." Albert smiles as he remembers the story.

Michael would call and ask if the person was Henri Petiet, the art dealer. Finally, he got a "Yes" and an abrupt hang-up. But they now had his address. Their cunning and determination had led them to Petiet's doorstep.

THE BOOK OF ALBERT

Now, Albert was able to arrange a meeting with Petiet, who slowly began to trust Albert and reveal to the eager American dealer some of his legendary collection.

Petiet's life story is incredible.

Petiet came from a long line of French politicians and soldiers—one of his ancestors was the French Minister of War. Young Henri was fiercely intelligent with a passion for cars, model trains, and art. He began collecting art in his twenties after meeting Ambroise Vollard, the masterful art dealer who gave Picasso his first solo exhibition in Paris.

In 1925, Petiet set up shop as an art dealer at Paris's Rue d'Assas at the age of thirty-one. He swiftly acquired works by Maurice Denis, Édouard Vuillard, Bertrand Redon, and Pierre Bonnard. He also began collecting art direct from Vollard, including Picasso's "Les Saltimbanques" drypoint series.

As his collection grew, so did Petiet's ambition. He collected works by Mary Cassatt, Georges Rouault, Pierre-Auguste Renoir, Toulouse-Lautrec, Paul Gauguin, and Georges Braque, among many others. He arranged to purchase etchings and lithographs from Henri Matisse through Matisse's daughter. He began buying artist books and even published his own.

Petiet was a genius when it came to developing collections of prints and graphic works. He played an essential role in building the print collections for institutions like the British Museum, the Brooklyn Museum of Art, and Boston's Museum of Fine Art.

In the art world, however, Petiet was perhaps most famous for acquiring almost all of Ambroise Vollard's exalted art collection after Vollard was tragically killed in an automobile accident in 1939.

Petiet was exactly the kind of source that Albert had been looking for. He had an impeccable reputation, fantastic connections, and an unbelievable collection of authentic art.

Fortunately, Albert and Petiet hit it off.

"I was extraordinarily curious. I would ask a million questions," Albert remembers. "One time, we got so engrossed in being together, that Petiet canceled his meeting that afternoon with one of the curators of New York's Metropolitan Museum of Art! When he told me, I felt rather guilty, but he told me, 'No worries, he scheduled for another day.'

"His style of dealing was what I'd call 'down home.' We would meet in his apartment. He didn't have any real place of business. He had his antique trains there he was very proud of. He would bring out prints and just spread them across his piano. I couldn't believe he didn't have any gloves on!

"Petiet was very fair. He had very fixed prices. Whether it was me or the curator of the Met. I would buy things from Petiet and sell them in months. That's because I only bought what I considered to be the best images. I also had Petiet advising me, which was invaluable."

Petiet not only gave Albert a fantastic source for art in Paris, but he also provided Albert with that link, that direct line back to the master artists that Albert had wanted.

To give you a better understanding of that direct connection from classic artist to modern collector, let's take a look at one of Henri Petiet's greatest acquisitions—and later amongst Park West Gallery's most important acquisitions—the full collection of Pablo Picasso's famed "Vollard Suite."

COLLECTING THE VOLLARD SUITE

Pablo Picasso's Vollard Suite ranks among the greatest graphic achievements of the twentieth century. In fact, many consider it the masterpiece of Picasso's work with etching.

The one hundred etchings in the groundbreaking suite were created during the 1930s, a particularly turbulent period in the artist's life.

Picasso received the commission for the etchings from famed French art dealer and publisher Ambroise Vollard, an early champion of Vincent Van Gogh, Paul Cézanne, Pierre-Auguste Renoir, and many other legendary artists.

Vollard had given Picasso one of his first major breaks, hosting an exhibition of his work in 1901, when the artist was still trying to make a name for himself in the Parisian art world.

However, Vollard was not a fan of Picasso's more experimental Cubist paintings and stopped representing him in 1910. (Following Vollard, Picasso was represented by the art dealer Daniel-Henry Kahnweiler.)

But Picasso and Vollard's relationship changed in 1931. That year, two books were published featuring multiple etchings by Picasso—"Le Chef-d'œuvre inconnu" by Honoré de Balzac and "Les Métamorphoses" by Ovid. Both were critical and popular successes.

This acclaim ignited Picasso's interest in etching and caught the attention of Vollard, who saw an opportunity for his art publishing business. Vollard ordered one hundred new etching plates from Picasso, paying the artist for his work with original paintings from Cézanne and Renoir.

The majority of Picasso's plates from the Vollard Suite are line etchings (occasionally with drypoint), a technique that Picasso had mastered. On several of the plates, Picasso used "sugar-lift" or "lift-ground" aquatint, a variation on etching that allowed him to paint his design directly onto the plate.

It took the artist six years to deliver all of the final etchings to Vollard. The resulting plates open a window into Picasso's dominant preoccupations between 1931 and 1937.

These included meditations on Rembrandt and the artist at work, wild depictions of the mythical Minotaur, and, perhaps most famously, Picasso's rocky relationship with his "muse" and mistress, Marie-Thérèse Walter.

Picasso met Walter in 1927, approaching her in front of the Galeries Lafayette in Paris when she was only seventeen years old. Picasso was married at the time to Russian ballerina Olga Khokhlova.

The forty-five-year-old artist and the teenaged Walter began a passionate affair, inspiring Picasso to include images of Walter in his artwork. She makes several appearances throughout the Vollard Suite etchings—often lounging in his studio, offering visual commentary on the relationship between the artist and his subject.

In 1935, Walter became pregnant with Picasso's child, resulting in Khokhlova leaving her husband and taking his son Paulo away to the South of France. However, that same year, Picasso was won over by a new "muse"—French artist Dora Maar.

Picasso worked feverishly on the neoclassical etchings—particularly throughout 1933—but did not deliver the final plates to Vollard until 1937. The suite includes three portraits of Vollard himself.

Tragically, Vollard died in a car accident two years later in 1939 before the plates could be printed.

Enter Henri Petiet.

Following Vollard's death, Petiet moved quickly to acquire as much of the legendary dealer's collection as he could, but he was particularly interested in obtaining a complete set of Picasso's Vollard Suite. Petiet's urgency was escalated by the onset of World War II. The Nazis were less than one year away from occupying Paris, and the city's art community was in the process of fleeing either the city or storing and hiding their art collections from the approaching invaders.

It is estimated that Vollard's collection ranged from five to ten thousand works of art, and many of those works were dispersed, were sold, or vanished during the German occupation.

Eager to buy the Vollard Suite, Petiet approached Vollard's brother Lucien, who sent him to meet with the key negotiator in the

dispersal of Vollard's estate, Martin Fabiani. Petiet was insulted that Lucien wouldn't meet with him personally, which soured the relationship between the two men.

Now, the estate was willing to sell Petiet the one hundred etchings from the Vollard Suite, except for the three etchings of Ambroise Vollard. Lucien Vollard is reported to have said, "As long as I live, the portraits of my brother will not belong to Henri Petiet!"

With those three images now off the table—Lucien sold them to another dealer—Petiet set his sights on acquiring the rest of the Vollard Suite.

By the start of 1940, Petiet has acquired more than eighty-six prints from the suite made between 1930 and 1934. Now, through Fabiani, Petiet was granted access to an attic on Paris's Rue de Maratignac where the rest of the Vollard Suite was stored—thirty-one-thousand prints total, most of them unsigned.

Fabiani extracted a very high price for the suite. (Petiet was excited by the prospects of owning them and wanted to keep them out of the hands of occupying German collectors.) By 1950, Petiet was able to acquire the missing etchings that Lucien had prevented him from collecting, now making his Vollard Suite complete.

However, many of the prints were still unsigned.

For over a decade, Petiet followed Picasso from place to place in southern France to get him to sign the etchings—from Vallauris where Picasso lived with Françoise Gilot to Cannes where the artist lived with Jacqueline Roque.

This went on for years with Petiet visiting Picasso in Mougins from 1961 until his death.

Albert recalls Petiet telling him stories of getting Picasso to sign the Vollard etchings. "He would go to Picasso with a whole bunch of sharpened pencils and he would pay Picasso to sign them. He

said to me, 'Remember, all of the best-selling images are the ones I had signed by Picasso. Also, the pencils always started very sharp and got dull, so you will see a great variation in the thickness of the lines of the signatures.'"

Petiet finally had his complete Vollard Suite collection, fully signed by Picasso himself. And, not long before Picasso's death in 1973, Petiet would show that collection to a young and hungry new art dealer named Albert Scaglione.

"Once when I visited his apartment, he had an entire Picasso Vollard Suite laying on his piano," Albert remembers. "I was so overwhelmed by the whole thing."

That's an understandable reaction. Today, Picasso's Vollard Suite is regarded as one of the artist's crowning achievements.

In 2017, Petiet's estate sold a complete set of the suite at auction for $2.2 million. Institutions that own complete editions of the Vollard Suite include the British Museum, the Bibliothèque nationale de France, the National Gallery of Canada, the Philadelphia Museum of Art... and Park West Gallery. (Park West actually bought two!)

Albert's early meetings with Petiet fostered a fascination with Picasso's Vollard Suite that the dealer continues to pursue to this day. In fact, visitors can today see selections from Picasso's Vollard Suite on permanent display at the Park West Museum—the free-to-the-public museum Albert established adjacent to Park West's corporate headquarters in Michigan.

So, that fabled suite of etchings, which began as an idea by Ambroise Vollard in 1931, made its way from Picasso to Albert in just a few decades.

OTHER PARIS ACQUISITIONS

Not all of Albert's time in Paris was spent pursuing Henri Petiet, however.

"When I first got to Paris, I walked the streets, the art districts, and I stopped in every spot and met every dealer I could. From 1974 through 1984, I would be there as many as three or four times a year."

Albert was a welcome guest in the heady Parisian scene—from art stalls to auctions, from salons to apartment suites. He began focusing on collecting the works of specific artists: Joan Miró, Marc Chagall, Salvador Dalí, and, of course, Picasso.

He was able to forge a relationship with Yves Lebouc from the city's lauded Bouqinerie de l'Institut (often referred to as "Lebouc"), who were the exclusive dealers for Chagall's graphic works. To this day, Lebouc is the only art world expert accepted by the estates of both Picasso and Chagall, and they remain the preeminent authorities when it comes to verifying the authenticity of works by Picasso and Chagall.

With Joan Miró, the acclaimed twentieth-century Spanish surrealist, Albert was able to meet the artist himself and work with his dealer, Madam Aimee Maeght for the Maeght Gallery, Paris.

"I bought the best aquatints of Miró," says Albert. "I would be offered many of them when they were just released. I got to meet Miró at openings. I enjoyed him. He was good to me. Miró was always dressed in a suit. Looked like a banker or an accountant. Not as expressive as others. He was totally pleasant. I spoke just enough French and a little Spanish to talk to him about his art and what he was doing." Albert also has fond memories of his dealer, Madam Amiee Maeght. "She loved me and I loved her. She enjoyed my personality. She really helped me build a top-tier Miró collection."

"I never got to meet Picasso," Albert notes regretfully. "He died before I could meet him."

Fortunately, Albert *was* able to meet many people who knew Picasso, including Maurice Jardot, the director of the Louise Leiris Gallery, one of the artist's final dealers. Louise Leiris was the daughter of Daniel-Henry Kahnweiler, who represented Picasso

after Vollard. The Louise Leiris Gallery was Picasso's exclusive print dealer at the time.

According to Albert, "Back then, Picasso was already so famous that the prices for his paintings were out of reach. With Picasso, you were going to deal with prints."

Albert developed a working relationship with Maurice Jardot, which led him to acquiring works from Picasso's "347 Series," a stunning collection of etchings Picasso created over a seven-month period when he was eighty-seven years old. Each of the plates was etched or engraved by the hand of Picasso *alone*. There were only 67 of each of the 347 works made (50 numbered and 17 annotated epreuve d'artiste). The *last two* complete sets of 347 hand-signed Picasso works known to have come to market were both purchased by Park West.

In her 2000 book, *Picasso, Suite 347*, art scholar Brigitte Baer describes the 347 etchings as one of the rare points in Picasso's career where "he looked, not at his anxieties and deepest states of being... but rather at what he perceived of the outside world."

During those early Paris days, Albert recalls acquiring "originals as well as one-of-a-kind prints by Joan Miró. Plenty of Marc Chagall paintings. Plenty of Renoir paintings. Picasso color drawings, black-and-white drawings. It was the greatest art by the greatest artists."

Albert also began collecting works from Salvador Dalí, who was alive and active in the Paris art world at the time, but Albert "avoided him like the plague."

"Dalí has a genius, had a remarkable sensibility," says Albert. "But I'd heard stories of his depravity. I wasn't a holy roller, but I knew this man's not for me."

In that case, Albert worked with the dealers who knew Dalí, pursuing the artist's graphic works and watercolors.

These included Dalí's "Biblia Sacra" and "Divine Comedy." The "Biblia Sacra" is a series of watercolors and lithographs illustrating the Bible that Dalí was commissioned to create in 1963. Dalí's "Divine Comedy" suite is comprised of one hundred etchings and watercolors based on Dante's classic epic poem.

(A complete set of Dalí's "Divine Comedy" illustrations are currently on display at Park West Museum.)

As Albert's Parisian collection grew over the years, he was also acquiring something else—frequent flyer miles.

"I started out flying coach to save money," Albert recalls. "After a while, I was going to France so often that I started taking the

Concorde because it saved me time and I could prove that saving time made me more money. I'm a very efficient person. I saw a lot of celebrities on those back-and-forths on the Concorde. Richard Gere, Cindy Crawford… I was a regular. I must've flown it fifty times."

While Albert still travels to Paris regularly to this day, he has warm memories of his early days in the City of Lights, working the streets as an up-and-coming dealer.

"I was in a suit and tie every day in Paris. When artists and dealers saw me coming, they saw a professional. After a while, they would say. 'Albert, come here. Let me show you something.'

"Mitsie and I made a very nice picture as we traveled around the city. We went to so many auctions, we would wind up in the French newspaper. There were photographs of us, a nice American couple, at the auction. I was the man of the hour.

"In Paris, at that time, it was a partnership of people who were making things happen."

Paris became the center, Europe became the place.

Albert would go anywhere, including Africa, searching for art, artists, and dealers, establishing his footprint as a global art dealer.

His next stop?

Israel.

Israel—A Tapestry of Artists

"They came there for the fight of Israel."

—Albert Scaglione

As Albert traveled the world, establishing the relationships that would sustain Park West for decades, one of the most important countries he visited was Israel.

"Park West has a rich history in Israel," Albert says proudly. It began in 1978 when Albert partnered with the Pucker Safrai Gallery of Boston to bring clients to Israel and raise funds for the Israel Philharmonic Orchestra. Zubin Mehta was the conductor at the time.

"Our total group was about thirty collectors. Each one of them purchased a sculpture especially cast for the occasion by the Spanish artist Gradiega Kieff, who traveled with us. We provided round-trip airfare, the itinerary, and all accommodations. It was a week long and it seemed like we covered all of Israel in that week. We visited everywhere from Tel Aviv to Jerusalem to Haifa, and spent time on more than one kibbutz. That began my love of Israel. From then on, I visited Israel regularly and got immersed in the world of Israeli art and culture, building many friends there over the more than fifty times I visited."

While Yaacov Agam was the world's most famous Israeli artist in 1978—and still holds that title today—Albert quickly learned that the art community in Israel was thriving. It was a country rich with artists and artisans, including several who would, one day, become recognized by the international art world as "masters."

One of those singular artists was Itzchak Tarkay.

ITZCHAK TARKAY

Tarkay was born in 1935 in Subotica on the Yugoslav-Hungarian border. In 1944, at the age of nine, Tarkay and his family were sent to the Mauthausen-Gusen concentration camp by the Nazis. They remained there until the Allied Forces liberated the camp in 1945. When his family returned to Subotica, Tarkay developed an interest in art.

In 1949, his family immigrated to Israel, where they were sent to a transit camp for new arrivals at Be'er Ya'akov. In 1951, Tarkay received a scholarship to the Bezalel Academy of Art and Design in Jerusalem. After leaving school due to financial hardship and up until he was mobilized into the Israeli Army, Tarkay studied under Yosef Schwartzman, a well-known art teacher.

After Tarkay's military service ended, he traveled to Tel Aviv and enrolled in the prestigious Avni Institute of Art and Design. At the institute, Tarkay worked under some of the important Israeli artists of the time, including Moshe Mokady, Marcel Janko, Yehezkel Streichman, and Avigdor Stematsky.

Tarkay abruptly stopped painting for years—finding himself devoid of inspiration—but his love of art was rekindled after he held a one-man exhibition in Tel Aviv in 1975. After that, Tarkay sought out mentorship from fellow Israeli artist Moshe Rosenthalis and began developing his signature style.

That style led to Tarkay being recognized as a leading figure for a new generation of figurative artists. The inspiration for his work lies with impressionism and post-impressionism. He held artists such as Toulouse-Lautrec, Paul Cézanne, Camille Pissarro, Pierre-Auguste Renoir, and Henri Matisse in high regard. One can see the color sophistication of Matisse and drawing style of Toulouse-Lautrec in Tarkay's compositions.

Tarkay believed in beauty, letting aesthetics and human psychology drive his art. As a result, the artist created visual poetry from the

aura of his city cafés and intimate settings. He enjoyed juxtaposing surface planes, patterns, and materials. Instead of focusing on minute details, his expressive paintings allow the color, plane, and line to establish an emotional mood.

In the early 1980s, Tarkay was breaking new ground, but he had yet to get his artwork in front of a global audience. That all changed when he met Albert.

But their first meeting didn't take place in Israel. It took place in New York City.

In 1986, Tarkay traveled to New York to showcase his work at Artexpo, a famous annual trade show that previously had hosted artists like Andy Warhol, Robert Rauschenberg, Keith Haring, and LeRoy Neiman. According to Artexpo's promotional materials, "Each year thousands of art industry insiders flock to Artexpo New York in search of the art and artists that will shape trends in galleries worldwide."

Here's how Tarkay remembers his first encounter with Albert:

"The exhibition was only five days. The first day was for the collectors and galleries. Albert came by with his gallery director, and I heard him say, 'It's the first day—you watch what is in his booth.' The next day—Albert came again—nothing. The third day—he bought everything. All my paintings. That was the beginning."

According to Albert, "We were actually there to look at a different artist, but I thought Tarkay was better for us. He had great color. I've not seen it before or since or seen anyone exactly try how he approached it. He had an exclusive with another gallery, but he didn't renew it and signed with us. For about seventeen years, every single work of art he did came through our hands.

"His work is timeless. It's ageless. I knew it the first time I saw it. I knew it would survive."

A few years after that first meeting, Tarkay would be considered one of the most famous figurative artists in the world. His success was, in part, due to his active, industrious spirit. Tarkay was always working, always challenging himself to try something new.

"I remember going on vacation with him once," says Albert. "It was Mitsie and I with Tarkay and his wife. We were in the South of France, and he was painting watercolors. He was just obsessed with creating these watercolors. I had to leave for a while to take care of some business. After a couple of days, I called Tarkay to let him know I'd be back soon. I asked him how many watercolors he'd finished and he said, 'Oh, about four hundred.'

"Four hundred?! I thought he'd do ten! I said, 'What the heck are you doing? Don't you want to relax with your wife and Mitsie?' And he said, 'Oh, they're fine. They're very happy.' That was just who he was. Always working. And I bought all four hundred of those watercolors from him."

Tarkay primarily worked in a studio in Rishon LeZion, Israel. The building itself was a kibbutz with an interesting history. It was originally constructed by the Germans in the nineteenth century, who built it as a school for Christian Arabs. The facility was later commandeered as a base of operations for English troops who occupied the region in 1917 under the command of General Edmund Allenby.

That studio space would eventually become a landmark for the Israeli art world. While Tarkay worked there, he shared the space with an astonishing lineup of major Israeli artists, including Yaacov Agam.

Tarkay remains to this day the only artist who has ever been invited to paint a collaborative painting with Yaacov Agam. In 2010, the two Israeli icons collaborated on a painting that brought together both of their unique styles.

There's actually a video showing Albert, Agam, and Tarkay together in that studio, as the two artists work out the details of their joint project.

Albert tells the camera, "Tarkay is the first artist Agam has ever chosen to say, 'Let's paint together.' So the two of them are on the same canvas working together, what a wonderful thing. And we see Agam taking Tarkay under his wing and loving Tarkay, loving his talent, loving his energy, loving his beauty, loving his way of painting."

Agam gestures to one of Tarkay's works hanging nearby. "This is two dimensional, I am multidimensional, but there is an affinity between the form."

Albert smiles, re-envisioning the film. "I'm excited about this painting but I'm more excited about the energy and enthusiasm." He looks at Tarkay. "Agam was telling me how he's got a glow and how energized he is with you being here."

"Because I love you," Agam tells Tarkay.

"I love you too," Tarkay responds. "I never painted with anybody before. It goes together, our different art, it goes together."

In addition to Agam, Tarkay also shared his studio space with acclaimed, established artists like Anatole Krasnyansky, Igor Medvedev, and Linda Le Kinff and a younger generation of Israeli artists who regarded Tarkay as their friend and mentor—artists like Mark Kanovich, Yuval Wolfson, and David Najar.

Albert recalls, "David Najar is a fantastic artist, and he was originally Tarkay's physical trainer. When Tarkay first saw his works, he told David, 'What are you doing?' He wanted David to pursue a full-time career as an artist. He pushed him to paint. What a gift."

After that, Najar and Tarkay were inseparable—Najar became Tarkay's regular traveling companion to auctions and exhibitions all over the world.

Tragically, it was during one of those trips that Tarkay passed away unexpectedly. In 2012, Tarkay and Najar were in Detroit visiting Park West Gallery and some of their collectors. After an auction one night, Tarkay began experiencing chest pains and was admitted to a local hospital.

"We knew it was bad," Albert recalls. "There was a tear in his heart and the doctors couldn't fix it. So, David goes to Itzchak's bedside in the hospital, and Itzchak looks right at him and says, 'So... how did you do? How many paintings did you sell?'

"David can't believe it. He's like 'Itzchak, what are you talking about? Why are you worried about that now?' Itzchak looks at him and says, 'I survived the concentration camp, I didn't know if I was going to survive. I got hit with this, I don't know if I'm going to survive. But what difference does it make? You're here now. I'm going to need you to sell. Let's get going.' And he died not long after that.

"But that was such a beautiful moment. He went out so elegantly. He was concerned about his friend and that's all he was worried about. He lived his life to the fullest."

EXPLORING ISRAEL'S ART COMMUNITY

As Albert established his reputation as a dealer in Israel, many of the country's top artists began signing with Park West. That included some of the artists who shared studio space with Tarkay as well as artists like Anatoly Metlan, Slava Brodinsky, Michael Kachan, Slava Ilyayev, Maya Green, and Michael Milkin.

Another discovery that Albert made during his frequent trips to Israel was that the country had some of the most skilled ateliers and printmaking workshops in the world.

In the 1970s and '80s, Park West was starting to not only sell art but also act as an art publisher, signing deals with artists to produce their graphic works. While the company began to build partnerships with acclaimed graphic studios in Paris and London, Albert was also

suitably impressed by the level of craftsmanship he found in the Tel Aviv area.

One of the best ateliers Albert found was the Romi studio in Rishon LeZion. The studio is owned by Ran Bolokan. The studio craftsmen are themselves talented artists, specializing in the serigraph medium.

Serigraphy is a form of silkscreen printing, coming from "seri"— which is Latin for "silk"—and "graphos," the Ancient Greek word for "writing." The word "serigraphy" was coined early in the last century to distinguish the artistic use of the medium from its more common commercial purpose. The medium's roots lie deep in ancient history, originating in China and Japan as a technique for applying stencils to fabrics and screens.

Serigraphy came fully into its own in the 1960s with the advent of pop art and op art. It was embraced by artists like Andy Warhol, Robert Rauschenberg, Josef Albers, and Richard Anuzkiewicz.

Typically, art serigraphs are made by starting with a special reproductive camera to produce a few color separations.

A 4x5-inch transparency of the painting is only the starting point. The Romi studio makes a screen for each hue—not just the primary colors, but every nuanced variation. In effect, the transparency is dissected into color planes much like geological layers. Each layer is hand-painted by a craftsman. There can be literally dozens and dozens of screens, perhaps as many as a hundred or more. Any or all screens—actually photographic film—may be divided into two or more color areas so that a single image can have as many as 250 individual tints. The inks must be as transparent as possible, unlike those in color lithographs.

Although the process makes use of technology, it is anything but mechanical. A great deal of trial and error experimentation requiring numerous proofs is needed in order to achieve the intended effect in the serigraphs.

The technical virtuosity of Romi studio is undeniable and, today, many top artists still use the studio to create their graphic editions—and not just Israel artists.

"I introduced Peter Max to their studio," Albert points out. "He loved how they could capture his colors, and that's been the only serigraphic studio in the world that he's used for the past twenty years."

Albert still travels regularly to Israel. In November 2017, the Celebrity *Constellation* cruise ship docked in Israel's Port of Ashdod, south of Tel Aviv, having set sail from Athens, Greece.

A large group of Park West collectors disembarked and were met at the dock by Albert, Mitsie, and other members of the gallery team. They boarded buses, which took them to the Yaacov Agam Museum of Art in Rishon LeZion, where Agam himself met the group at the entrance and personally invited them in.

He greeted them warmly, encouraging them to notice the contrast of colors on the pillars leading into the museum. The bold designs on the pillars transform the museum itself into one of Agam's works of kinetic art.

Inside the museum, the group was treated to a personal tour by the artist, who walked them from work to work, giving them insights into each of his creations.

After a talk by Agam—and at Agam's insistence, a vocal performance by Albert—the Park West delegation left the museum to take a private tour of the Old City of Jaffa, one of the most historic districts of Tel Aviv. Later that night, they returned to the cruise ship and, after setting out to sea, Park West hosted an auction of Agam's works.

"That was a wonderful day," Albert recalls. "It was so gratifying to show our clients what Agam is like when he is truly in his element."

Tokyo. Paris. Israel.

While all significant, they're just a few of the places Albert traveled while establishing himself as a world-class art dealer. From Europe to Asia and beyond, Albert has tracked down masterworks and found new art to offer for the ever-growing and eager audiences for his art auctions.

However, it took more than globe-trotting to transform Park West into the world's largest art dealer.

The first years of Park West Gallery were spent building a foundation. However, once that foundation was laid, Albert took the next step of refining and expanding his original idea of what an art gallery could be. And he did it in ways that no other dealer had ever attempted.

Albert once said, "I want to create a new paradigm in how art is presented to the public."

That paradigm started with the creation of a new gallery space back home and the development of an incredible new network of destination galleries around the globe.

Building the
Park West Experience

CHAPTER 14

Park West Gallery Expands

When Albert opened his first brick-and-mortar location for Park West in 1970, it was a modest affair—a 20' x 60' gallery space at 24916 West 9 Mile Road, in Southfield, Michigan, less than a mile from his home.

However, within a year, Albert realized he needed more space. He recalls the scene. "My little trailer sign that said, 'Art Auctions Sunday'... that trailer that I would drag out to the front with my own hands... it was such a success that we got too big for the building. We had started doing our roadshows, too, so there wasn't room for our trucks either."

After searching for a better location, in 1973 Albert signed a lease to move Park West to a new facility about a half mile away at 23415 Telegraph Road.

"Oh my god, I was in heaven," Albert remembers. "The new place was very cool. I can still visualize it in my head. I did a lot of the build out myself. We lined the walls with this white carpet and this great rosewood imitation paneling. You could drive nails into it to hang the art without damaging the actual walls. To decorate, we hung burlap on the walls from India that we fireproofed. I did all that myself, took me about a week or two. I also built a partition to make room for a 20' x 20' frame shop in the back.

"Next, I built this mezzanine, so I could look over the business and screen things, and it connected to our offices on the second floor. There was a warehouse in the back that we shared—there was a wall down the middle. We had space for galleries and a big auction room. And now we could get our trucks in and out easily because at the time we were operating as far away as Texas."

By now, Park West, as a business, was thriving. "We were really doing well," Albert says. "By 1975, we were doing more than $5 million a year. We were getting to be an operation. People were hungry to buy our art and we were in the right place at the right time."

But Park West's growing success began presenting new challenges too.

"When our lease came up for renewal on our Telegraph location in the late '70s, our landlord suddenly told us that he's going to triple our rent." Albert shrugs. "He didn't like that we had been very smart with the building. I'm good at doing everything legally, everything by the book. I'm a Boy Scout. I had worked with the city to get us food and alcohol permits—we were hosting events there for our clients. And the landlord wanted to charge us the rate you'd charge a banquet hall."

Albert wasn't about to pay a new astronomical rent for the gallery, but he didn't want to move far. He liked the area and he liked operating Park West close to his home in Michigan.

"So I looked around for the most beautiful place I could find nearby," Albert remembers. "And I landed on McInerney's Restaurant, just a short drive away on Northwestern. I went there for eggs in the morning sometimes. It was surrounded by woods. This cool 1930s-style building surrounded by willow trees on a three-acre lot with some wetlands in the back."

This gave Albert an idea. He would build his own building.

He would buy the plot of land that McInerney's sat on and construct a sixty-thousand-square-foot retail plaza where he could have enough space for Park West, but also have tenants as well. The tenants' rent would pay the mortgage (and give Albert some profit too), all while he continued to grow Park West as a global business.

Albert brought his idea to his appropriately named lawyer, Harold Helper. The lawyer's response was, "This is *crazy*. What do you know about building a building?!"

But Harold couldn't talk Albert out of the idea. They began setting up meetings. Albert got an architect to draw up a plan for free by giving him a sculpture by the artist Kieff.

Next, he met with a local builder, Jimmy Jonna, who introduced Albert to his brother, Eddie Jonna, founder of the extremely successful Merchant of Vino wine company, which was eventually sold to the Whole Foods Corporation in 1997.

Jimmy would build Albert's new shopping center and Eddie would be one of Albert's first major tenants. "I gave Eddie a really fair rent," Albert says. "He built one of the best food and wine stores in Detroit right next to us. For our other tenants, we had the Tina dress shop and some really great businesses."

There was one other initial tenant, however, that had special significance to Albert—L'Uomo Vogue Men's Clothing. "That was me," Albert admits. "We needed another tenant for the bank loan, so a partner and I put that business together. I eventually sold my stake, but it's still in business today."

With his tenants in place, Albert just needed to finalize the financing. "I needed to get the loan closed. It was 1979 and interest rates were skyrocketing. But, to get our loan closed, we needed to be occupying the building. We broke ground on March 23, 1980, and we were in the building by November 30 that same year. We built everything in *six months*.

"You have never seen work happen like that in your life. Seven days a week, nonstop. We put the floors in ourselves. I went to New York City and found these very cool white oak floors. All exposed and very different looking. Jimmy, our builder, gives us the best price by far but everything got finished on time and suddenly… we're in this beautiful building that didn't exist even six months before."

The address—29469 Northwestern in Southfield, Michigan—is where the Park West Museum and Gallery can still be found today.

While the location was fairly rural back when it was McInerney's Restaurant, Northwestern has grown to become a bustling thoroughfare, packed with thriving businesses and commuters.

The grand opening of the "new" Park West Gallery was held on December 6, 1980, with an exhibition by the Hungarian artist Laszlo Dus.

The invitation to the gala opening read: "You are cordially invited to attend the premier public opening of the new Scaglione/Park West Galleries and the inaugural one artist exhibition featuring 76 works by Laszlo Dus."

The two-story gallery space was packed for the event, with Albert working the crowd in a smart tuxedo. The attendees were surprised when Dus added his signature to the décor by spray-painting his name and the title of the show ("An Art Experience") onto a blank wall.

The opening established the location as Park West's new home. Though the retail plaza would grow and evolve over the years as Park West expanded, Albert slowly began hosting fewer and fewer tenants—his gallery operations needed the space. Albert said good-bye to his last tenant in 1999 when Park West finally took over all of the complex that Albert first imagined twenty years earlier.

Today, Park West Museum and Gallery command all sixty-three thousand square feet of 29469 Northwestern, and Albert purchased a second nearby building to house the Park West Foundation at 29621 Northwestern. The Park West campus is a beautiful five-acre site, including a natural pond and sculpture garden in the back.

While there have been many renovations since 1980, one of the most significant happened in 2001, when Albert asked Anatole Krasnyansky to provide a new design for the museum.

Krasnyansky was an auspicious choice for the job. He was not only a celebrated visual artist, but he was also an accomplished architect

who had personally worked on the restoration of Russia's Potemkin Palace, the Marble Palace, and the Hermitage Museum.

The Park West Museum redesign evokes that same tradition, while also accounting for the fact that thousands of vehicles drive past the gallery every day. The museum is well lit, it is alarmed, and the windows are bulletproof. According to Albert, "Praise the Lord, in almost forty years, we have not had even one robbery attempt. Also praise the Southfield Police department, which is super-outstanding, and our own security with Dale (an ex-Detroit Lion)."

But, back in 1980, many of those innovations hadn't happened yet. Albert was still years away from taking over all of the Northwestern location, not to mention building a free-to-the-public museum for his private collections. (More on that later.)

On that opening night in December 1980, those projects were still just a glimmer in Albert's eye. The important thing was that Park West now had a new home base—a headquarters where Albert could create his plans to take Park West to new heights in the 1980s.

ASSEMBLING THE PARK WEST TEAM

Park West's headquarters wasn't the only thing that was growing. By the end of the 1970s, the company was expanding at an exponential rate. In the early days, Albert could get up in front of a crowd and sell the art himself at hundreds of events all year. But, with the success, Albert had new challenges—he had to operate a thriving business.

He knew he had to run the company, but he also knew it was vitally important to spend more time with his artists. Those relationships were the lifeblood of the company.

With that in mind, Albert began growing his "team."

"I started with the 4 Ms," Albert remembers. "Mitsie, my wife;

Marc, my son; Maureen, my controller; and Morry, my principal auctioneer and soulmate.

"Mitsie was my first employee fifty years ago and has never been matched. Marc, at sixteen, stepped in and ran our entire print department under emergency situations thirty-five years ago. He came full time to Park West after getting his degree from the University of Michigan and has earned his way to the presidency of Park West. Maureen Dipaola came to us as an accountant right out of Walsh College the same year Morris Shapiro joined us over thirty-five years ago. None of us have ever looked back.

"Mitsie and I have four children together. Our oldest, Lisa, was the director of our research department for a number of years and works for us off-site from her home in Portland, Oregon. She lives with her husband, Paul Thacker (a photographer who over the years has provided services to Park West). Their daughter, Maria, is now doing excellent work in our restoration department. Nicky Yanke, our executive vice president of human resources, graduated with her bachelor of science in business administration from Central Michigan University. She lives in Huntington Woods, Michigan, with her husband, well-known painter Tim Yanke, who has studios in Berkley and Kewadin, Michigan. They have two sons, Roman and Angelo.

"John Karay, our executive vice president of cruise ship operations, lives with his wife, Ann Karay (who has provided services for Park West), in Plantation, Florida. They have two sons, Michael and Matthew. Michael is now our associate vice president of merchandising and Matthew has joined Park West as an art associate. Marc Scaglione lives with his wife, Ann Marie Zetelski-Scaglione, along with their two children, Annabelle and Augustus in Santa Monica, California. Ann Marie is still an associate with Park West.

"All of our children have celebrated over twenty-five years in the business. As you can see, spouses work for Park West as well. We

love each other, we love being together, we love traveling together, we love working together, and we love being with our clients."

Albert takes pride in how Park West events are staffed. "At our auctions, I always tried to have one educator and one auctioneer. That's important. That you do your best to communicate to people all the information that you have. I've never been the best salesman. Never will be. I forget to sell it. I get so into talking about what I think the customer really wants to know. Morry is a bit like that too."

Morris Shapiro remembers first meeting Albert at an auction in Chicago, where he was immediately impressed with Albert's knowledge, passion, and vision. "I believed I could learn a great deal from him," Shapiro recalls. "So right then and there we discussed my joining the company."

"That's when I brought Morry on as our gallery director," says Albert. "And it was a great fit. He's still with us over thirty-five years later."

Marc, meanwhile, would become an integral part of Park West's management team. He started on the ground floor, working in almost every department of the company—gallery operations, auction coordination, inventory, framing, the print shop, even the mail room.

As a result, few people know the business as well as Marc. He rose through the ranks, from merchandising manager to vice president, and, today, Marc serves as the president of Park West Gallery.

When Albert speaks about Marc's role in the organization, the pride in his voice is apparent. "Marc is a good fighter," says Albert. "He understands how to protect the company."

While Park West would continue to evolve as a family company throughout the years, with the hiring of key staff like Morris Shapiro, Albert was assembling a team ideally suited to position the company for its second decade.

Another critical component of Albert's winning strategy occurred during this era too—Park West was becoming a prolific art publisher.

Albert's early publishing partners included Stèphane Guilbaud, a master printer from Paris. "Stèphane has the biggest lithograph press in existence," Albert says. "He owned the biggest lithograph shop in the world and he was booked years ahead. We began working with him and other ateliers in different countries, including the Romi studio in Israel."

Getting started as an art publisher was, as Albert recalls, "a lot of work." However, it was a decision that was "completely, totally, 100 percent driven by our artists."

"Artists have needs," Albert notes. "As their dealer, I want to fill those needs and, inevitably, most major artists want to make editions of their works. Lithographs, serigraphs, whatever medium they want. It gets them wider distribution and, once they decide to create editions, we want to make that happen.

"Our program was built around whatever the artist demands. They all have their own preferred mediums, and they all have their own locations where they want to work, so we became a global publisher. We had one French artist who only wanted to work in France. Wouldn't touch an edition if it came from anywhere else, so we connected him with Stèphane. Whatever they wanted and whatever worked best for their art.

"Ultimately, this isn't just a commercial venture. This is a venture of our lives, this is a venture for art. The editions have to look perfect. If the public rejected the editions we published, it wouldn't work very well. But they love them, and our artists do too.

"Now, decades later, Park West is not only the world's largest art dealer but we're also certainly the world's largest art publisher. Nobody's even remotely published the number of editions that we have.

"And, in the complex art world of the twenty-first century, we have continued to develop relationships with some of the world's leading experts. For example, Bob Wittman, former head of the FBI's Art Crime Team (ACT), who, for the past two decades, has provided invaluable services to Park West. His previous partner, Atty. Robert Goldman, former U.S. Assistant Attorney, has also been an important part of the Park West team of experts.

"We've additionally built fantastic relationships with people like Daniel David and Stèphane Guilbaud of Les Heures Claires, Paris and Caroline Ashleigh, formerly with *Antiques Roadshow*, who is one of the country's finest appraisers of fine art."

What started in a small 1,200-square-foot art gallery was now a major player in the international art world—an organization with the infrastructure to serve artists and collectors in ways that no other art dealer could.

NEW ART, NEW ARTISTS

As the 1980s progressed, Park West greatly expanded their network of artists. Early in the decade, in addition to their core group of original artists, they began representing new names like Tarkay, Robert Kipniss, and Harold Altman.

In 1982, Albert was able to forge a mutually beneficial relationship with the famed Erté after meeting the influential art world figure on his ninetieth birthday.

Erté is often referenced as the premier proponent of art deco, the style that came into vogue internationally in the 1920s. Erté defined art deco as the fusion of nineteenth-century art nouveau with the cubist, constructivist, and geometrical designs of modern art.

Albert remembers Erté as "the artist who got us to recognize how wonderful art deco was, how wonderful that era was. I remember discussing that with him. He turned to me and said, 'Albert, if I was the father of art deco, I had many brothers.'"

Erté was influenced by Persian miniatures and would often use a brush with a single hair to complete his gouache paintings. His imagination was limitless. Along with his paintings, Erté designed costumes, stage sets, jewelry, objet d'art, sculpture, and ceramics. Unlike many artists who work freely before a canvas or sketch pad, Erté developed his own unique process—he would visualize the entire work of art in his mind until it was completed to every detail and then create the work from his "mind's eye."

Erté was world famous for his work with the magazine Harper's Bazaar, where, over twenty-two years, he created more than 240 magazine covers. In fact, at the time of his death at the age of ninety-seven, Erté was considered one of the most influential artists of the twentieth century.

Only a few years earlier, he found himself sitting with Albert at his ninetieth birthday party. There's actually a photograph of the two men sharing a warm moment at the soiree. "I was very friendly with Erté," Albert recalls. "David Rogath was his dealer. I had bought a 347-Picasso set from David that he fortunately had just acquired from the family of Picasso. Erté liked me so much that the day after his ninetieth birthday, he invited me to breakfast alone, and it was a wonderful day that I will never forget. After Erté passed, I acquired many works from his estate at an auction at Paris's George V Hotel."

As the '80s marched forward, the list of Park West artists grew.

But there were many artists who, for one reason or another, never made their mark on the world of art.

Albert was a savvy judge of talent with impeccable taste, but not every Park West artist broke through, even despite his best efforts. The ones that did, however, left an indelible mark on the world, and Albert's batting average for finding those artists was outrageously better than most.

In many ways, Albert resembles a modern-day version of Ambroise Vollard. Both had a knack for building relationships with significant artists at the right times in their careers.

Albert built one of those foundational relationships in the 1980s with an artist who had a direct connection back to masters like Picasso. He was one of those rare figures who linked Albert back to the kind of dealers who walked with the greats, the dealers like Vollard, Henri Petiet, and Louise Leiris.

That artist was Marcel Mouly.

MARCEL MOULY

Mouly was pretty much the last of the old-time artists to have known Picasso and Chagall. He was "a link to art history in the modern world… an international link." By knowing Marcel Mouly, Albert also carries the flame.

"I become a little anchor of flesh and blood," is how he puts it.

With his boldly colored, semi-abstract work, Mouly earned a reputation as an important modern artist of the late twentieth century and the early twenty-first century. Whether it was his still lifes, landscapes, interiors, boats, or port scenes—his distinct style shone with the influence of Matisse and Picasso.

Mouly was a student of Picasso beginning in 1946 when Picasso's nephew, Jose Fan, took him to meet his famous uncle.

"It was an amazing privilege to work with Picasso in his studio," Mouly once said. "At the time, [Picasso] was working on his kitchen stills. They were large, graphic paintings predominately in grey and ochre. In the interlacing of black lines, he introduced plates and service ware. It was really fun to watch him do it. Picasso's studio was extraordinary! Objects were everywhere. African masks were lying all over the place. … The walls were covered with paintings and ceramics."

That same year, Mouly was invited to display his art in a now-famous group exhibition at Paris's Salon du Mai. Mouly's works were being shown alongside works by Picasso, Georges Braque, Matisse, Fernand Léger, and other luminaries of the day.

Mouly found inspiration in Picasso's trailblazing work, which he used to blaze his own trail throughout his artistic career. Numerous contemporary artists cite Mouly as a profound influence on their work.

After their first meeting in Paris, Albert developed a strong relationship with Mouly. There are many videos in the Park West archives of Albert visiting the artist, touring his studio, or sharing a laugh with him.

When Mouly died in 2008, Albert's wife, Mitsie, composed a touching remembrance of Mouly that wonderfully conveys the kind of relationship Albert sought to develop between artist and dealer.

Here's what she wrote:

"For years, Albert and I have traveled here and abroad and have had the good fortune to meet with many of our artists, not only on a business level, but on a personal level. It was always a pleasure to visit with Marcel Mouly and his wife Maguy at their home/studio in the suburb of Paris. From the beautiful flowers adorning their front porch to the heartfelt welcome at the door, we always felt special.

"As you entered their home, you took a right to Marcel's studio where, usually on the easel, there was a work in progress, basking in the sunlight from the many windows. He was always eager to show us the many souvenirs they had purchased from their travels to exotic places—India, Greece, Israel, to name a few. He lived life to the fullest and was always captivated by the colors and hues of the different countries, with Greece being a particular favorite.

"Marcel was also happy to play the host by wheeling out his beverage cart so we could be properly welcomed by aperitif. Then onto the business at hand—looking at the collection. And what a collection!

"We were honored to have Marcel and Maguy at our gallery for an event in September 2004. It was a magnificent show. Then, at a dinner at the Ritz Carlton Hotel, Marcel was honored where he received a standing ovation that deeply touched him. Unfortunately, that was Marcel's last visit to us."

Mouly's legacy is still being felt today, both at Park West and beyond. In 2019, the prestigious Monthaven Arts & Cultural Center held a museum exhibition highlighting the connection between the work of Pablo Picasso and that of Marcel Mouly—contrasting Picasso's ceramic works with Mouly's original paintings.

The exhibition, which will be traveling around the United States, was organized by Albert and the Park West Foundation.

KEY ACQUISITION: CHAGALL

Throughout the '80s, Albert continued to grow his stable of artists, his management team, and the gallery itself. He was also growing his reputation as an exemplary art dealer—the same reputation he built on the streets of Paris while acquiring works by Picasso, Dalí, and Miró.

If anyone had any doubts about Albert's ability to track down masterworks while running an international corporation, those doubts were proven wrong when, in 1988, Albert was able to acquire the entire collection of one hundred hand-watercolored etchings from Marc Chagall's renowned Bible series.

To put this acquisition in context, in a 1956 essay, noted art historian Meyer Schapiro said, "If we had nothing of Chagall but his Bible, he would be for us a great modern artist."

Now considered a pioneer of modernism, Chagall risked damaging that lofty position when he created a graphic series based on one of art's most ancient subjects: the Bible. The end result, however, was a series of 105 etchings and engravings that many art historians consider one of the greatest artistic achievements in modern times.

The idea of Chagall, a Russian-Jewish artist, taking on the monumental task of illustrating the Bible actually originated with Ambroise Vollard—creating yet another connection between Albert and the famed art dealer.

Vollard had previously worked with Chagall on illustrating a Russian novel and a collection of fables. In 1931, Vollard once again approached Chagall, who was living in Paris, this time with the idea of creating a series of etchings based on the Bible, specifically the Old Testament.

In preparation for the commission, Chagall traveled to Palestine in the spring of 1931. The two-month trip became a life-altering experience for the artist, who had always been fascinated by the Bible and religion.

"Ever since my earliest youth, I have been fascinated with the Bible. I have always believed that it is the greatest source of poetry of all time," Chagall said. "I have sought its reflection in life and art. The Bible is life, an echo of nature, and this is the secret I have endeavored to transmit."

Upon his return to France, Chagall immediately began working on the series, choosing etching and engraving as his medium. His passion for the project even led him to Amsterdam, where he intently studied the biblical art created by Rembrandt van Rijn and El Greco.

Between 1931 and 1939, Chagall completed sixty-five plates for his etchings and engravings. Unfortunately, calamity would strike before he could complete the series. In July 1939, Vollard died in an auto accident. This tragedy, coupled with World War II spreading

across Europe, forced the Bible project to a halt—similar to what happened with Picasso's Vollard Suite.

But the encroaching war did more than threaten Chagall's progress on his Bible series—it also threatened his very life. As Adolf Hitler and his Nazi party gained power in Germany, they began to enact public campaigns against modern art, labeling art that was abstract and nonrepresentational as "degenerate." This also included works created by Jewish artists, making Chagall a target.

However, when Germany invaded and occupied France, Chagall remained, refusing to leave the country he loved. France soon became dangerous for Jews like himself. In October 1940, the government began approving anti-Semitic laws, and Chagall and his wife realized they needed to flee. They could only go to the United States, but they were unable to afford the fees necessary for passage to New York.

Thankfully, an American journalist named Varian Fry was operating a rescue network within France. Chagall's name was added to a list of more than two thousand other prominent artists whose lives were at risk. Chagall and his family left Europe in May 1941 and arrived in New York a month later.

During their time in the United States, Chagall's wife, Bella, died due to illness in 1944. Grief-stricken, Chagall stopped painting for months. Despite these personal tragedies, Chagall's fame in the art world continued to grow. By 1946, he had become internationally recognized, inspiring an exhibition at New York's Museum of Modern Art that showcased his artwork from the preceding forty years.

Chagall returned to France in 1948, and in July 1952 married his secretary, Valentina "Vava" Brodsky. That same year, Chagall finally resumed his work on the project Vollard had commissioned twenty-five years before. He continued working on the Bible series for another four years, completing another forty etchings by 1956.

The etching plates were first printed in the studio of Maurice Potin, and later at Raymond Haasen's studio. Once the process was complete, the copper plates were canceled and given to the Musee National Message Biblique in Nice by Chagall and Vava. The results were 275 signed and numbered portfolios and twenty hors commerce portfolios. An additional one hundred sets of etchings on paper featured hand coloring and were initialed by Chagall in pencil.

Park West Gallery is the only gallery in the world currently in possession of the complete collection of Chagall's Bible etchings and engravings.

There are several reasons why this was such a significant acquisition for Park West. Chagall is, undeniably, one of the masters of twentieth-century art, and many consider the Bible series to be one of his greatest works.

But it was also particularly significant for Albert due to his deep and abiding personal faith.

He was raised Roman Catholic, attended Catholic schools for eight years, and was an altar boy. Though he still practices with his wife as Greek Orthodox, Albert attends daily Catholic mass at a local monastery, where, weather permitting, he walks the mile back and forth each morning.

Every day starts with prayer. "I live for one purpose—for the Almighty," Albert states with confidence. "And there's a great peace and power that comes with that belief, that power, that insight, that grace."

With that in mind, you can see how Chagall's Bible series is a perfect fit for both Albert and Park West, an ideal amalgamation of faith and art.

CHAPTER 15

Redefining the Art of Collecting

Park West's second decade proved that Albert's innovative program of bringing art direct to the people was extraordinarily powerful. Collectors around the globe were eagerly responding to his thoughtful, personal way of connecting them with art.

He had built a gallery that was welcoming and accessible to new and established collectors alike.

It wasn't long before Park West was being called "America's number one art dealer."

People now knew the name "Park West Gallery." The media began to profile the company. Advertisements for Park West appeared in newspapers and magazines. One popular ad from that era stated, *"Just as an interior designer helps you put together the right environment, we help you build an art collection."*

In the Detroit area, the main Park West location was now a well-known destination, and Albert was becoming a bit of a local celebrity.

One of the best examples of that newfound fame was a popular series of radio interviews Albert did with Detroit media icons J.P. McCarthy and Paul W. Smith of News/Talk 760 WJR. For decades, McCarthy and Smith have been fixtures on WJR, the area's premiere talk radio station, and Albert often offers his art insights and knowledge on Michael Patrick Shiels's radio program "Michigan's Big Show."

Albert quickly hit it off with these radio personalities and, as a result, provided an enormous number of timely and highly popular interviews, making Albert the voice of art in the state of Michigan.

Many of these interviews paint a picture of Park West as a company on the rise and, perhaps more importantly, offer a compelling portrait of Albert's personal philosophy as an art dealer.

Here are a few excerpts from some of Albert's radio interviews with Paul W. Smith, in which Albert explains what makes Park West so unique in the world of art:

Paul W. Smith: Albert, the feeling one gets upon stepping into [Park West] is really something special.

Albert: Well, we believe that we've developed an art of collecting and we share that with everyone who comes into Park West. It begins the moment you enter the gallery.

Paul W. Smith: A gallery which is designed like a beautiful and magnificent space, almost like a museum.

Albert: Very much a museum-like feel. I think the thing that's best about it though is that it's still very friendly, very comfortable.

Paul W. Smith: Albert, no pun intended, but is there an art to collecting art with Park West Gallery?

Albert: Absolutely. We believe that we've developed an art of collecting. It begins the moment you enter the gallery with your pleasant surprise at finding yourself in a place that's kind of like a museum.

Paul W. Smith: But the art of collecting is more than that. You really want to educate every visitor who comes to Park West.

Albert: The art of collecting has to do with collecting with an institution that's devoted to bringing art to the public. We believe we're educating and informing in an entertaining and nonthreatening manner, and we're giving you the opportunity to buy art at extremely competitive prices. The art of collecting is a total experience that we will provide for you.

Paul W. Smith: How do you think you became America's number one art dealer?

Albert: By selling more pictures than anybody else.

Paul W. Smith: But what does this mean to me as an art buyer?

Albert: Selection. Because we sell more pictures than anybody, we have the biggest selection of anybody. We have an extraordinary selection. We don't tell you what to buy. You tell us what you want to buy. It's a real difference.

Paul W. Smith: How often do you rotate the art on the gallery walls, and how many pieces would you have on display?

Albert: On display, there'd be over one thousand in any given exhibition, and we would be doing a complete turnover once a month. On a daily basis, there's some turnover done, because people come in and buy things.

You're going to see new art. You're always going to see new art. I'll tell you the other part. If you don't see something that you really like, ask. You're going to be shocked at how much we can show you. Or, if you see things you like and you'd like to see more of that, ask.

Paul W. Smith: You really have something for everyone.

Albert: We really put our best foot forward. We put wonderful things and great values on the wall that, if you're in the market at all, you may well find something that you're interested in.

Paul W. Smith: I think another reason for your success, Albert, is that shopping for art at Park West is such an enjoyable experience. I don't know how you created such a friendly and relaxed environment, but you have, and your people are very knowledgeable without being threatening.

Albert: I think every single person I have working for me is a collector—many of them used to be our customers. Just used

to buy from us and then they moved over and now sell for us. They've been in the position of being the customer and they have a good idea of what the customer needs and wants.

Paul W. Smith: What is it that makes Park West so accessible to art buyers?

Albert: It's the way I want you to feel. It's my place so you'll feel very welcome. You'll feel very relaxed, and the good part is you'll have somebody to talk to who really does know their stuff. Our sales staff is customer-focused on satisfying your needs. Now, don't get nervous, there's not many high-pressure sales presentations from us. Never have, never will.

If, in fact, you're interested in buying some art and you get turned onto the art, we'll get you enough information to let you make that decision properly. I think you're going to find it a great experience and it's one that you're going to want to make over and over again.

Paul W. Smith: Plus, with world-class art, unsurpassed values, and outstanding customer service, you've really made a name for Park West Gallery.

Albert: It took us a million pictures to develop our reputation. It would only take one to hurt it and we're not going to let that one happen. And you know what our job is going to be? To maintain that forever and ever and ever.

In 2019, years after those interviews were first recorded, Paul W. Smith found himself giving a toast at Albert's eightieth birthday party. Albert and Mitsie had arranged for a select group of friends and family to join them on Michigan's idyllic Mackinac Island for the long fourth of July weekend.

As he rose his glass in a toast, Smith said to the assembled crowd, "Do you know what Albert did that's so very important and that will last forever? Albert taught me and thousands, *no*, hundreds of thousands of other people that art is to be enjoyed.

"Albert, you brought art to the people, to average people like me and so many others. You taught us just to enjoy art and, for that, I will be forever grateful. And thousands of other people who have had joy brought into their homes and into their families and into their lives through art have you to thank for it."

Park West Gallery
Goes Global

Bringing Art to the Seven Seas

When you talk to art collectors today and mention the name "Park West Gallery," at some point, the conversation will inevitably turn to cruise ships.

That's because, in the twenty-first century, Park West's auctions on cruise lines have become so popular, so ubiquitous in the art world that there are generations of art enthusiasts who now also associate the gallery with the experience of collecting art on luxury ocean liners.

Park West had already become a massive success long before the cruise industry came into the picture. As Albert told Paul W. Smith during one of their radio interviews, "Even when we were never on a single cruise ship, we were America's number one art gallery." But the cruise industry did offer an enormous opportunity.

Albert is quick to point out that, despite being America's largest gallery, Park West was always an international company. "We could not have built our business without the international market. The only reason we favored events in the United States was because the majority of our clients were from the United States."

Thanks to those traveling events, Park West grew tremendously during the 1980s and early 1990s. "Park West had a specific identity back in 1990," says Albert. "It was not a particularly corporate identity. It was a very good brand. We were very well respected for our brand. We got that respect because of what we did with Escher, Picasso, Chagall, Renoir."

As Park West's third decade was beginning, the company had annual revenues in the tens of millions. Albert had forged a very good partnership with Ritz-Carlton to hold art events and auctions at their hotels.

Park West was featured in an issue of *Architectural Digest*, and new artists—including Anatole Krasnyansky, Igor Medvedev, Charles Bragg, and Linda Le Kinff—continued to join the gallery's roster.

Peter Max had also recently come out of a long, self-imposed exile and was creating art again, with Park West serving as his primary dealer.

"Things really changed for Peter when he started working with Gene Luntz in 1990—Gene was the best thing that ever happened to Peter Max," says Albert.

Luntz is a legendary manager who works with such major talents as John Cougar Mellencamp and Bob Dylan. "Peter was one of the greatest painters in the world, but he needed management," Albert recalls. "Gene was a very tough negotiator for Max's studio, but slowly, we started doing deals—a serigraph here, a new edition there—and over time these deals soon added up to the tune of over one-hundred-million dollars! When Gene came into the picture, everything just got better and better."

Park West was growing as a family company too. Marc Scaglione rose through the ranks from merchandising manager to vice president in the 1990s. The '90s was also when Nicky Yanke and John Karay officially joined the company as well, bringing their great talents to human resources and operations, respectively. Business was booming.

And, yet, few could've predicted the seismic impact that the cruise industry would have on Park West Gallery when the company first explored the idea of holding art auctions on cruise ships in 1995.

"After our first year in business, Park West took off like a rocket," Albert remembers.

"When we started on cruises…" Albert smiles broadly. "Well, that was the second rocket."

STEPPING ABOARD THE CRUISE INDUSTRY

Looking back, many people are quick to take credit for Park West's move toward the cruise industry.

"I remember Yaacov Agam in the 1980s telling me that we should be on ships," Albert laughs. "So I'll give him the credit for saying it, but saying it and doing it are two different things and, at the time, it just wasn't ready yet."

However, the idea became a reality in the '90s when Albert received a call from two businessmen—Philip Levine and Jerry Chafetz.

Those familiar with politics will remember Philip Levine as the mayor of Miami Beach from 2013 to 2017. He also famously ran for governor in Florida in 2018. (Albert was one of his supporters.)

In the 1990s, however, Levine was focused on finding business opportunities in the cruise market. A July 10, 2018 *Miami Herald* article described Levine at the time as the "president of three cruise line marketing and retail companies, managing relationships, seeking out deals, and negotiating contracts while longtime business partner and former jeweler Jerry Chafetz oversaw operations."

Levine and Chafetz had seen Park West's auctions and wanted Albert to bring his special way of presenting art to cruise ships around the world.

There was only one problem—Albert wasn't completely sold on the idea.

In a July 19, 2007 interview with the *Detroit Free Press*, Albert admitted, "I was skeptical. I thought it looked too unregulated, too odd, not a serious art market."

Today, Albert still understands why he was so hesitant to expand onto cruise ships. "I had a good business. I was knocking them dead. We didn't need the cruise ships, and I wasn't sure I wanted to do it. We'd built our headquarters. I was in my fifties. At fifty, you start thinking about what you want to do with the rest of your life. You think about retirement. I initially said 'I don't think so.'"

After much debate, Albert reconsidered Levine and Chafetz's proposal and finally made a deal in 1995 to try out Park West auctions on two cruise ships—Celebrity *Zenith* and Crystal *Harmony*.

"On just those first two cruises, we did $270,000 in sales," Albert recalls. "$140,000 on one ship, $130,000 on the other. When I found out, I said '*What?!*' It was insanity."

Albert knew an unmissable opportunity when he saw one. "As an engineer and problem solver, I recognized that this initial success could both be replicated and scaled up."

The demand for more cruise auctions was "immediate," according to Albert. "There was this limitless horizon in front of us. An untapped market with little competition and enormous potential. From the start, my role was to limit the number of ships we were on, not grow it. I only let us grow when it made sense because the pace was just too rapid."

However, that doesn't mean that there weren't any early missteps.

"I lost $18 million in the jewelry business," Albert admits with a shrug.

"All out of my own pocket. We started a company to sell jewelry on the ships too, but we just couldn't compete with the established players in the market like Louis Vuitton Moët Hennessy.

"But, when it came to art, it was a whole different world. No one can compete with us when it comes to selling art."

As Park West's cruise art business grew, Albert eventually bought out Levine and Chafetz. "It was all very happy," Albert says. "I just wanted complete freedom. It was difficult for me to have partners or any kind of restriction in the art world. When you're an art dealer, you have to be alone in a way. Park West is a very strong corporate entity, but, at the end of the day, someone has to be in charge. A single person has to take responsibility."

That person was Albert.

Soon after those first test voyages, Park West's auctions spread across the cruise business like wildfire, becoming one of the most popular onboard events in the industry and a profitable vendor for their cruise partners.

Park West Gallery currently has a presence on nearly one hundred ships sailing worldwide, appearing on top-flight cruise lines like Royal Caribbean International, Celebrity Cruises, Norwegian Cruise Line, Carnival, Princess Cruises, Holland America, and MSC Cruises.

As a result, Park West's art holdings went from tens of millions to hundreds of millions to into the billions at a pace Albert never could have anticipated.

"I'm a very step-by-step person," Albert says. "My mission has never changed—expose people to art. Now I had this wonderful opportunity beyond the galleries and the hotels. We were bringing art directly to the people in a new way, and they loved it. They still love it."

WHY SELLING ART ON CRUISE SHIPS WORKS

It's not immediately obvious why a cruise ship would be a good place to get people interested in art. The people on board are on vacation. They've signed up for a voyage filled with swimming, dining, and day trips to exotic locations. Many of them have probably never attended a live auction before or didn't even know that there was art for sale on the ship.

Many ships nowadays also offer art lovers a very sophisticated atmosphere with museum-worthy collections on display. On Celebrity Cruises, for instance, each ship has a curatorial theme that centers around the ship's name. Cruising and art collecting go together well, and it's a topic that Albert has given a lot of thought. Ultimately, he believes the success of the arrangement comes down to how Park West presents its art.

"I think a cruise is one of the best opportunities I've seen to teach people about art. Our specialty is teaching. We really teach a lot. We like to take things slow, answer questions, make sure people understand us.

"On a cruise, you can have three days, five days, fourteen days or even more to build a relationship with your collectors. If we have the opportunity to spend more time, we will. When people who spend time with us leave at the end of the cruise, whether they bought anything or not, they are enriched, and that's our goal.

"There isn't an art dealer anywhere who wouldn't want the opportunity to interact with their clients in a relaxed setting, during multiple visits over many days. It's a tremendous experience because, at sea, the dealer can almost step away to allow the bonding that occurs between the artist and the artwork and the client.

"We also make things fun. People love our live auctions and seminars. We've turned our cruise program into a highly developed form of educating, and selling is really the by-product. People buy because they get into it. They're making educated purchases

because we've spent the time with them. They know about the art, they know about the artists. They know exactly what they're getting.

"We know they're happy because more than half of the people who collect with us on cruise ships have collected with us before. It's well over 60 percent. They've gone through the experience already, and they want more. We've helped them develop a passion for art.

"There's nothing else like it."

"Park West is almost like a secret club," Albert notes with a smile. "When people encounter us for the first time, they go, 'Oh my God, you guys have been in business fifty years and I didn't know you existed!' We're a wonderful discovery for people who love art, and a cruise ship is just a great place to be discovered."

Albert also appreciates the exacting standards of the cruise industry, which he feels are a perfect fit for the Park West philosophy. "The cruise lines are just like us when it comes to wanting everything to be *perfect*," Albert says.

"You always have to remember that you're not the only game in town, so you better put your best foot forward every time. That attitude is part of our company's identity, and our cruise partners recognize that. It has caused us to have long lasting relationships."

Park West takes its commitment to excellence incredibly seriously. Once their cruise programs took off, Albert dramatically increased the size of the company's compliance department, reviewing onboard auctions to audit everything. Now fleet managers and secret shoppers conduct regular spot reviews, and customer feedback drives changes and improvements across the company.

But Albert's strictest standards are reserved for the integrity of the art. "No one can argue with our authenticity. *No one*," Albert declares strongly. "Park West has never, ever knowingly sold an inauthentic work of art. We are painstakingly accurate. Over the

years, with over three-million clients Park West has had only a very few people attempt argue that something wasn't authentic. In each and every instance we were able to unquestionably demonstrate that the art was authentic and we were correct."

One reason that Park West is so confident about the origins of their art harkens back to Albert's days in Paris, acquiring works from Henri Petiet and Maurice Jardot. "We know where our art comes from," Albert says. "That's because we only get it from reputable sources. I always prefer to acquire from people who have a direct link to the artist."

However, while that strategy works for collecting masterworks from historical artists like Picasso and Rembrandt, Albert has another, even-more-accurate way to authenticate the vast majority of the art Park West carries—he gets it right from the artist.

"More than 95 percent of the art we offer comes from living artists, or the estates of those artists, whom we represent directly—artists whom we consider part of our Park West family. I know our paintings from Peter Max or Yaacov Agam are authentic because Max and Agam delivered them to us themselves.

"It somehow defies the imagination that a company can sell ten million works of art and never knowingly sell one that was not authentic. But that's the very business model of Park West Gallery. We buy from the artists, eliminating all middle men. When we deal with masters, we deal with the estates of the artists or the world's foremost experts for the relatively few like Picasso that may require such expertise."

The uncompromising quality of Park West's artwork and onboard events is a major factor in why the company has been a dominant force in the cruise industry for over twenty years.

In the words of Albert, it all comes down to building relationships. The cruise lines trust the caliber of Park West's art and their proven track record. Vacationers trust Park West's service and selection, which is why the company's return-customer rate is so high.

Cruising and art collecting may seem to be an unlikely pairing, but Albert recognized early on that a relaxing ocean voyage just might be the ideal environment to get people excited about art.

The simple fact is that selling art on cruise ship *works*. But that doesn't mean that it's easy.

CHAPTER 17

The Incredible Logistics
of Selling Art at Sea

Now that Park West could see the almost-limitless potential of bringing their art auctions to cruise ships, only one question remained—how could they pull it off?

It was a logistical nightmare, even for someone with Albert's analytical background. The company would need to scale up on a monumental level. They needed staff, resources, facilities. They could no longer rely solely on a core team of auctioneers and Albert's fleet of trucks crisscrossing the nation.

Essentially, cruise ships are floating cities with their own laws, regulations, and space limitations. Not to mention that each ship is constantly traveling between various sovereign nations and international waters all while dealing with everything from passengers to hurricanes.

Albert's test runs on the Celebrity *Zenith* and the Crystal *Harmony* had proven that cruise travelers wanted to collect art, but getting that art to them was going to be a challenge.

"It took every bit of my skill set as an engineer, as an art dealer, and, frankly, as a politician to make it all happen," Albert admits. "We had to work with our cruise partners, business partners, banks, governments. We got very successful at working with customs. We've been able to get art in and out of over one hundred countries. Everything on our end had to be note-perfect or else all of those agencies wouldn't work with us.

"At the end of the day, I credit our ability to make the logistics work to the fact that we're very upfront with our partners about our

mission. Our mission is supplying art to the public in a way that's never been done before. We are performing a service for the public, and nobody's ever done it like us. It's an ambitious goal, but we made it happen."

With the wide expanse of the new cruise market before him, Albert came up with a multiyear plan of attack. His first step would be expanding Park West's operating base by acquiring a select group of competing art companies—Fine Art Sales, Inc. (FASI), London Contemporary Art, and Circle Fine Art.

According to Albert, "Fine Art Sales, Inc. had no gallery presence whatsoever but was already operating on the second-largest number of ships in the cruise ship art auction business. And, with its talented young president, Albert Molina, it was by far the best of the three. London Contemporary Art—based in London, England—was run by Anthony Stancomb and had a significant gallery presence internationally but ran a weak second to Molina's Fine Art Sales, Inc. Circle Fine Art had workshops, buildings, and a lot of overhead and was a company in trouble. We bought it because of the artists it represented.

With its contracts on cruise ships, management, and infrastructure, Fine Art Sales was an obvious choice for the first acquisition.

"That was key because it gave us a base near Miami," Albert notes. "It was a tough chore running everything out of Michigan from 1995 to 1999 when we were growing like that, so buying FASI worked out perfectly. It gave us a warehouse and full infrastructure within thirty miles of where many cruise ships we were serving were operating out of."

Next, Park West acquired London Contemporary Art. "We operated in London for only a brief time, but the deal was well worth it because of the art auction contracts and because it gave us some good art and artists," Albert recalls.

"Circle Fine Art, the last of the three, turned out to be a wonderful acquisition. The benefits of all the knowledge we gained were invaluable—we got to analyze the flaws of the company that was the largest art publisher in the world at the time, operating more than fifty galleries all over the world ranging as far as Tokyo."

By bringing those three companies under the Park West banner, Albert dramatically increased Park West's distribution, framing, and shipping capabilities.

More than ten years later, in 2013, Park West would come to acquire its last significant competitor—Global Fine Art, whose parent was Carnival Corporation. Global Fine Art operated the art programs on Princess Cruises and P&O Australia under the name Princess Fine Arts. In 2013, Princess Fine Arts became a Park West company.

"But, after those first three acquisitions, we had absorbed all of the work and insights of the best companies in the business," Albert states proudly. "We had grown significantly, yet we still needed a new hub, a new operations center to handle our scale and everything we were doing with the cruise industry."

As the 1990s came to a close, while Albert was buying companies, he was also looking for land in Miami.

THE BOOK OF ALBERT

CHAPTER 18

Building Park West a Home in Miami

Albert found the perfect spot for the company's new home in Florida in 2000, just as Park West entered its fourth decade in existence.

It was a ten-acre plot of land in Miami Lakes, ideally situated for air freight and shipment to cruise ships.

Construction on the new facility began in 2000, but it wouldn't officially open until 2002. The reason why is apparent at first glance—Park West Miami is *enormous.*

Albert has jokingly compared the building to the endless warehouse at the final moments of *Raiders of the Lost Ark*, and it's an apt comparison. Park West's Florida operations center takes up over 222,000 square feet—it is the size of six football fields.

Sitting in front of Lake Karen, the largest inland lake in the area, Park West Miami is situated in a pastoral and welcoming environment. The building's cream-colored exterior and meticulous landscaping make it look like a modern office building, albeit a very, very large modern office building.

"Considering that our previous framing operation consisted of a twenty-five-thousand-square-foot facility we rented in Florida and sixteen thousand square feet in the lower level of our Southfield headquarters, I was pretty ecstatic the first time I looked at that structure," Albert admits.

Upon entering Park West Miami, visitors are greeted with a warm reception area that opens onto a series of offices for the company's Florida-based executives and staff. There are meeting rooms, kitchenettes, gallery spaces ... everything a corporate office needs.

As visitors work their way further back into the complex, they enter a vast maze of cavernous rooms humming with activity.

When Albert works out of the Miami location, he rides around in a green golf cart adorned with a Spartan sticker—a tribute to his college days at Michigan State University.

As he drives through the expansive facility, he passes individual quarters where people prepare art for distribution. He zips past warren-like alleyways where storage bins rise to the ceiling, filled with artwork.

Framers, shippers, art handlers, and cutters pass by in the narrow passages. Hellos and smiles are exchanged. Forklifts reach up four stories to get artworks that are stacked on palettes. They're headed for the loading bays to be trucked out to the cruise lines and hotels.

Deep within the center of the complex, Albert has a special three-sided sanctum, with two rows of shallow shelves running along the walls, where he can review prototypes of new artwork from his family of artists.

Both the Michigan and Miami buildings have a nerve center affectionately known as "The Albert." It resembles a war room or an operations center for a hi-tech military film with enormous digital screens covering the walls.

This is where Albert works with Park West's merchandising and inventory teams and keeps his finger on the company's pulse.

In an instant, Albert can bring up intricate spreadsheets, allowing him to see what's selling and what's not. He can see how many editions have been made, and how many have shipped. The tables and reports are precise—Albert created special software to give him exactly the information he's looking for and he uses that data to shape the company's future.

But that's not all he does with that data. He also shares it with his artists.

Albert's a strong believer in artistic autonomy. He never attempts to direct his artists and what they should paint, but he's found over the years that artists appreciate the ability to see how they and their art are connecting with their audiences. Albert just supplies the information. It's the artist who gets to decide what they want to do with it.

After a long session in his operations center, Albert often heads over to another area in the Miami complex that he's particularly proud of—Park West's framing center.

TAKING FRAMING TO THE NEXT LEVEL

It's been established that Park West is the world's largest art dealer and the world's largest art publisher. But it's a lesser-known fact that Park West Miami is, arguably, the largest custom framing operation in the entire world.

"Framing is essential," Albert notes. "I don't believe that framing should compete with the artwork. It should be the finishing touch, the enhancement that draws your eye to the work, makes it 'pop.' That's why we devote so much care—and so much space—to our framing process."

When the facility first opened, they discovered that, while operating only one shift, they could produce as many as ten thousand individual custom-framed works in a month. (That represented an enormous increase in capability. Now it's not unusual for Park West Miami to run three shifts to meet demand.)

About 130 artisans accomplish this remarkable mixture of craftsmanship, packaging, processing, distribution, and shipping every day.

All Park West artwork that originates in Southfield is sent to Florida in wooden crates, accompanied by a liquid "Tip and Tell" device in each carton that can alert the people in Miami Lakes immediately if the contents have been turned over or potentially damaged in

transit. The company gives explicit instructions to their freight forwarders that all packages *must* be handled with extreme care, but it doesn't hurt to have a fail-safe system.

Upon arrival, each item is double-checked against the packing list to make sure the artwork has arrived in pristine condition and that its registration numbers are correct. Then the works are separated and routed to various departments.

Works on canvas are sent to their own department. There, you will find almost every shade of linen imaginable and highly trained staff carefully wrapping every matte by hand. When they say a matte is "hand-wrapped linen," it's because a piece of acid-free foam board is cut to measure, sprayed with an acid-free glue, then covered with linen by hand.

For all mattes on paper, the company utilizes programmable, computerized matte cutters. These cutters are extremely useful for complicated and detailed matting tasks, resulting in great efficiencies in volume when many mattes are cut to the same size.

Park West uses American-made machines for cutting their moldings, but the computerized units that control them were manufactured in Italy. Albert points out, "It has nothing to do with my heritage, but the Italians always have shown a flair for art, clothing, fabrication, and design. I mention this because we have spent years traveling the world to find the best equipment available, and we're always willing to upgrade in order to provide a better quality, price, and service to our customers."

Everything is programmed and automated, synchronized to function in harmony. In the old days, Albert's crews used to do every one of these functions by hand.

The company purchases large quantities of their molding from efficient U.S. manufacturers who utilize the latest equipment and technological advances in picture frame production. However, Park West also imports molding from South America, Europe, and Asia as well.

At the Miami facility, they often have as much as *seven million feet* of molding on hand at any given time—enough to stretch from the Florida building to the Park West headquarters in Michigan. That's because Park West offers thousands of different frame styles with hundreds of different molding, matting, and framing combinations.

Some collectors are surprised to learn that Park West doesn't frame with glass. They instead work with Plexiglas because they're shipping artwork all over the world and want to do everything they can to eliminate breakage, and, most importantly, prevent damage to the art. "Most people assume Plexiglas is cheaper than glass," Albert says, "It's actually *four times* more expensive, but it's worth it."

Albert used to employ twelve people who cut Plexiglas to size all day long. Now, they have computerized equipment that not only cuts the Plexi but also mathematically figures out the exact sizes needed from a single sheet and the most efficient way of cutting them so that waste is kept to a minimum.

"That really appealed to my analytical, left-brain engineer mentality," Albert admits. "The initial capital investment paid for itself in less than a year through labor and material savings. What I'm most happy about, however, is that we retrained all of them and they now have much better paying and more interesting jobs with us. Everybody won."

After the matting, molding, joining, and Plexiglas placement, every work receives a final inspection to make sure it's as perfect as humanly possible. This is the most important function in the entire operation. Each employee who is part of the framing process has his or her own individual identity tag that is placed on the part of the work they complete.

If the inspectors see something wrong—*anything* wrong—they immediately walk the work over to the appropriate worker and the imperfection is corrected that same day. Once the artwork is flawless, inspectors slip on protective bubble-wrap corners, place the wire on the back of the artwork, and move it to the shipping department.

SHIPPING TO THE WORLD

Every Park West shipping box is customized to the particular artwork being shipped inside it, and every work is shipped individually to clients. A few years ago, Park West invested in new packaging equipment making it easier to ensure that every work shipped out is packaged to the highest standards and shipped in immaculate condition.

That equipment includes a machine called the IntelliPack SmartBAGGER, a foam-in-bag packaging system that uses a chemical reaction to expand and custom fit foam L-brackets around each corner of the artwork with the press of a button. Thanks to the custom foam, the artwork is literally floating in air inside the container.

Fleets of FedEx and UPS trucks are parked in the facility's shipping docks nearly twenty-four hours a day. Albert proclaims that "we have become experts in packing those trucks to eliminate damage and increase cost-effectiveness. That's an important detail—Park West staff packs the FedEx and UPS trucks, *not* the drivers. That's how committed we are to making sure our deliveries get to our customers safely."

Every artwork that goes through the operations facility has a special tracking code, which allows Park West's information technology team to give clients constant updates about their purchases. Notification emails are sent out when the work is being framed, when it is being shipped, and when it is scheduled to arrive at its final destination.

It's estimated that Park West ships between six thousand and seven thousand framed works of art *every week*.

In contrast, when Albert first started Park West in 1969, he was getting his frames by consignment and often hand-delivering the works he sold.

Decades later, Park West fulfills their orders with the efficiency, scope, and customer focus of companies like Amazon or Zappos. While collecting with Park West is still personal and intimate, Albert has constructed an infrastructure that allows him to deliver his works of art—framed to perfection—to anyone in the world.

It was all part of Albert's multiyear plan, his road map for being able to serve the new cruise market. He acquired all the right companies, he built a powerful new logistics hub in Miami Lakes, and he created the largest custom framing operation on the planet.

Now, he just needed a small army of the right auctioneers to head out onto the high seas to deliver the Park West "experience."

CHAPTER 19

Training a New Generation of Auctioneers

Fortunately, Albert had been training auctioneers since his earliest days on the road.

What was he looking for? Remember "The Four C's" that Albert laid out in his commencement address at Central Michigan University: *Calling, Character, Chemistry,* and *Competence.*

Park West's expansion into the cruise market presented a new challenge. While the company's auctioneering staff had grown significantly over the past three decades, Albert now needed to grow his pool of auctioneers *exponentially.*

It helped that, at his core, Albert never stopped being a teacher.

Rigorous training had always been a priority for staff at Park West. Now, Albert just needed to expand his existing educational programs to meet the new demand *and* cover the unique aspects of living and working at sea.

"I was always training new people. In-person, through catalogs, and especially about our style of presentation, which is essential to Park West," Albert says. "But, once we moved down to Miami and moved onto more ships, that training program had to become a lot more formal.

"When you're on a cruise ship, there's protocol. There are inspections, regulations, safety drills. Our people always need to be ready to go. Well disciplined, well organized, well trained. That's been our mantra from day one."

Miami Lakes quickly became the epicenter for Park West's training program. The company holds multiday training events there every six to eight weeks. The students are a mixture of new recruits—who must endure a rigorous interview process before they're invited to training—and established auctioneers—who refresh their skills on a regular basis.

According to Albert, "Our trainees come from many different backgrounds and countries. They typically hold a college degree—often, but not always, in the arts. The common denominator is a passion for art, hard work, dedication, and integrity. And, of course, they all must possess an abundance of the 'Four C's.'"

During training, the candidates are provided with resources and reference materials about art, artists, and art movements. They attend seminars focused on everything from how to run an auction to how to conduct themselves on board a ship. The candidates role-play interactions with clients, and they're tested on their art knowledge. Artists fly in from all over the world to give lectures. The students even break into teams to hold a raucous "Battle of the Gavel," where they compete against each other in mock auctions.

Every aspect of the business is covered, which is valuable for both the recruits and Park West. "During those training days, we have a much better chance of finding out whether the candidates are truly called to our field," says Albert. "It gives us the opportunity to see whether they are of good character, whether they have the interpersonal skills—the chemistry—to adapt to and bond with each other. And, through our testing, we can determine whether or not they have the ability to develop the high level of competence our company demands."

When the new recruits successfully complete this ten-day process, they are offered the position of associate: level 1. Every ship has an art team of varying sizes, depending on the vessel. The roles on that team can range from the more physical and logistical art handlers

to the more sales-focused associates to the more managerial gallery directors and auctioneers.

For those just starting out, there are three levels of associates. To proceed through each level requires a certain amount of time and testing. If the auctioneer successfully passes from a level 1 to a level 3 associate, they may next attain the position of gallery director. This usually takes a minimum of one year. After gallery director, they may achieve the level of auctioneer. This usually takes from eighteen months to two years. There are exceptions—some take longer, some less.

The training is facilitated by current staff members, all of whom previously worked on ships. The company's executive vice president of sales, national sales managers, and regional sales trainers were all once onboard auctioneers for Park West. They know the training process intimately because they've gone through it themselves.

This mentoring and training program is the reason why Albert has been able to staff over one hundred cruise ship galleries around the world in addition to the hundreds of land events the company holds annually as well. It's also the reason why Albert gets weekly letters and emails from happy customers complimenting his staff for their professionalism.

Albert won't allow just anyone to represent Park West Gallery. Instead, he has heavily invested in an expansive educational initiative that ensures Park West auctioneers are only the best and brightest. "From the start, I want these recruits to understand that they will be going through a very intense training program based on ethics, morality, propriety, and values. It's an experience that they will carry with them for the rest of their lives.

"But what a time they will have. We teach them how to be right with people, how to put on a show, how to represent our art properly and ethically.

153

"And these skills can be applied to *any* field. We're not just teaching about the business of art. We're teaching about the business of people."

A LOOK INSIDE THE PARK WEST TRAINING PROGRAM

There's definitely a buzz in the room during a Park West training week. One of the essential jobs of auctioneers is to get their audiences excited about art, and they learn that skill by getting themselves excited about art first.

That excitement is apparent in early 2019 as Albert watches a packed room of bright-eyed recruits prepare to end their final day of training in Miami Lakes. There are over eighty new faces in the crowd side-by-side with almost forty long-time auctioneers back for a refresher.

With a smile on his face, John Karay, the executive vice president of operations, motions for the assembled crowd to quiet down. He calls out some of the returning training graduates and asks them to tell the room where they come from.

Korea. Namibia. Zimbabwe. South Africa. The United States. Canada. India. China. Romania. Jamaica. The United Kingdom. Serbia. Azerbaijan.

Park West's auctioneers truly do come from all over the globe.

Karay gestures to a nearby wall adorned with plaques. These are awards won by past auctioneers during previous training competitions. "It takes a tremendous amount of effort to get your name up there," he informs the team. On this day, a new auctioneer, Megan, will have her name immortalized on the wall twice—once as the winner of the Battle of the Gavel contest and once as a member of the training session's overall winning team.

A practice session begins as different trainees hustle up onto a stage and give their best in mock auction scenarios. As the novices try out their skills, their unique personalities shine through. The

atmosphere is intense, critical even, yet unquestionably supportive.

Leif, one of Park West's national sales managers, runs the trainees through some question-and-answer drills. He even gives practical advice for nervous auctioneers who can't stop pacing across the stage.

Leif talks about educating clients before ever approaching a sale, stressing that, with the right information, the customer will organically grow their own interest in a work of art—if it's the right work for them.

To illustrate his point, he uses one of Park West's most popular artists as an example: Thomas Kinkade.

He wants to get the recruits comfortable talking about Kinkade. He runs through a sample presentation:

"Thomas Kinkade's works are in more American homes than any other artist and, looking at his work, it's easy to see why. He is known as 'The Painter of Light,' as he uses techniques borrowed from the Luminists of the nineteenth century. Many of our collectors love Kinkade's works because of the way his art reflects light—they look brighter in the daylight and more subdued at night.

"Kinkade was also a family man. He would hide 'love notes' within his works in the form of the letter 'N,' representing the name of his childhood sweetheart and wife, Nanette. On top of being more collected than any other artist in America, he was also selected to commemorate the 2002 Salt Lake City Olympics as well as the 2002 World Series.

"If you're looking for an award-winning and widely-collected artist whose work will turn your house into a home, Thomas Kinkade might be the perfect artist for you."

Leif stresses that the trainees need to educate their clients not only on the facts about Kinkade's art, but also on how Kinkade makes them feel.

He points to a Kinkade painting on a nearby easel and asks the room, "Give me one word that describes the way you feel when you look at this work of art."

Voices ring out.

"Serenity." "Energy." "Magnanimous." "Peaceful." "Freedom." "Tranquility." "Calm." "Tumultuous." "Adventurous." "Ambrosial."

Ambrosial?

The crowd laughs, but Leif is pleased that they're understanding what he's getting at. He strings together their words in a new litany about the painting.

"That was a cornucopia of emotions. In two minutes, you gave me the gamut of emotional responses… it gave you a sense of peace, calm, energy, tranquility, freedom. That makes me imagine the dynamic world this painting could create in someone's home. After one week. After a month. Imagine this work of art as a family heirloom. Imagine something that would make your soul grow."

The trainees nod, making notes in their training materials. Now that the auction practice is over, it's time for the day's main event— Albert's address to the class.

Albert prides himself on speaking to training groups. Like any good educator, he enjoys sharing knowledge. A playful enthusiasm shines in his eyes as he talks about Park West's newest offerings.

As he takes the stage, Albert clearly can't wait to show off a new artwork—the first example of a new medium. In the moment, Albert is actually practicing what he preaches to the class. He tells them, "Always show what you want to show first. Share your excitement."

The new work is brought onstage. It's a vibrant and attractive composition covered in butterflies created by artist Tim Yanke.

The colors pop off the canvas, but it's not just the colors. The work itself has an unusual depth, with some butterflies rising up from the two-dimensional plane into the third dimension. But all are soon to find out that the butterflies leap off the surfaces and fly into the fourth dimension.

Is it a painting or is it a sculpture? It's both. It's the first example of sculptograph™, a new medium exclusively created by Park West artists.

Albert beams, "It's a sculpture you can hang on your wall." But it's more complex than that. The sculptograph process enables artists to work in a digital format with special 3-D technology, allowing them to choose different paintbrushes, do color separations, and completely control the creation of every aspect of their work in real time.

The end results are fantastic sculpted artworks with amazing variations in hue and depth. With the new process, artists can bring together different colors, textures, and layers into one solid sculpted work of art.

The crowd murmurs appreciatively, noticeably impressed. It's a meaningful moment for several reasons, not least of which is that Albert has a personal connection to the art and artist. Tim Yanke is married to Nicky, Albert's stepdaughter. Tim and Nicky have been together for over thirty years of marriage.

Yanke titled the new sculptograph "Peta Louthias," the Greek term for "butterfly," as a loving tribute to Nicky's Greek heritage.

As the assembled auctioneers begin to snap pictures of "Peta Louthias," Albert, ever the showman, motions them to pause.

The smile on his face tells the room, *"But wait, there's more!"*

"We are committed to getting our new art out to the market faster," he tells them. "Because we're the real deal, we're doing cutting-edge things at Park West. The sculptograph is big on its own, but we wanted to do something even bigger."

Albert nods, and trainers start moving around the room, handing out tablets and instructing the recruits to download a new app onto their smartphones. When the room is ready, Albert has them open the app and look at "Peta Louthias" through the app viewer.

The room collectively gasps. *"What?!" "Wow!"*

"Peta Louthias" is not only one of the company's first sculptographs, but it was Park West's very first example of augmented-reality art.

When the training class looked through their smartphones, the butterflies on Yanke's "Peta Louthias" took flight, rearranging themselves into configurations specially designed by the artist.

Albert wanted to introduce the new artwork to the next generation of auctioneers personally—both to show them Park West's commitment to innovation and to help teach them how to present this new style of art. No other gallery has anything like this currently on the market.

It's thrilling new technology, but, ultimately, Moving Canvas is just another extension of Albert's trademark approach to art dealing: "Don't leave art passively hanging on the gallery walls. Bring the art directly to the people in fun and exciting ways they won't expect."

As the appreciative comments about "Peta Louthias" flood in, Albert looks pleased. He tells the crowd, "Remember, we do the unheard of every day."

Not every training class is lucky enough to witness a new product launch, but Albert still addresses them all, imparting his wisdom to each group of recruits. His topics can range from his early days as a dealer to his personal philosophies on art, business, or faith.

Albert's known for quoting inspirational passages from Scripture, but today, he's opted for one of his favorite anecdotes.

"I like to tell a story about the now-deceased Ted Arison, founder of Carnival Corp and the former owner of the Miami Heat. The story begins back when Ted Arison hired Pat Riley as head coach for the Heat, which was huge for the team. In the job interview, Riley was giving Arison all of his ideas about what it would take to make the team a winner. He then asked Ted, 'Mr. Arison, now that I've told you what it takes to make a winner, would you mind if I asked you the same question?' And Arison just looks at him and said, 'The guy who works the hardest wins. That's it.'

"I remember telling that story to my friend, Micky Arison, Ted's son and CEO of Carnival Corp, at a dinner party one evening and was surprised at his response. Micky said, 'Albert, I've heard that story over and over again and I don't know if it's a fact or not, but it doesn't change the beauty of the story and, if you want to keep repeating it, it's fine with me.'"

Albert's words are both challenging and reassuring. "Don't make yourself too crazy here, but know that this is a tough job. It's a demanding job. It's a constant, burning job. But it's a fun job."

Albert ends his rallying speech with heartfelt personal advice. "Care about your personal heart and not your pride. Everything you do... selling art or tying your shoe, you're doing it for God— not for man. You do that, and you'll succeed here. God will bless you. Bless you all."

With that, Albert leaves the stage to a standing ovation.

CHAPTER 20

Heart of the Game: "The Park West Experience"

While every student in the Park West training class aspires to become an auctioneer in one of the company's onboard galleries, only a select few will ever become what's known as a "VIP auctioneer."

Those auctioneers conduct the auctions, presentations, and events that go into what's become known as the "Park West Experience." It might range from three days at one of America's finest resorts to a cruise ranging anywhere from seven to twelve days.

"The Park West Experience" is one of the company's crowning achievements, and it first began back with those early collector trips Albert organized for his best clients.

When Albert brought that small group to M.C. Escher's home in 1974 or traveled with his collectors to Israel in 1978, he had no idea it would one day evolve into a vibrant program of annual collecting events at five-star locations worldwide.

"Originally, our collector trips were spontaneous," Albert recalls. "We might go a few months without doing any. Then we might do two or three in a single month. It all depended on what came up. Now, it's a very organized, extremely well coordinated affair. We do multiple events every single month, and the demand keeps growing.

"Marc Scaglione manages more than one hundred Park West Experiences a year, a logistical challenge that he relishes and few others could handle. After Marc accepted responsibility for operating the entire program about ten years ago, the program exploded. It also led to the starting a new family, since his wife Annie was an associate auctioneer and that's how they met.

"It's very typical of the Park West business model. In more ways than one, we truly are a family business. We now have Marc, Annie, and their two children Annabelle and Augustus, traveling together as a family to auctions already!"

On the surface, the infrastructure of Park West's VIP program is reminiscent of the rewards programs run by major airlines or high-end hotels: the more you collect, the more access you get to higher and higher tiers of benefits. However, while Delta SkyMiles might upgrade your seat or Ritz-Carlton Rewards might give you a bigger room, Park West offers its VIP clients something that's one-of-a-kind.

From day one, the program's mission has remained the same— provide Park West's clients with unique combinations of art, artists, and places that create unforgettable collecting experiences.

Park West collectors receive invitations based on their level of collecting. They might be invited to an exclusive auction event in the closest nearby metropolis where they'll be presented with art that Park West doesn't make available to all of their collectors.

They might be invited to a meet-and-greet with one of their favorite artists. Or they might get invited on a trip of a lifetime.

The variety of "perks" in the VIP program is impressive, and it fosters a real sense of loyalty and family amongst Park West's collectors.

Albert is quick to point out that, "We're so good at providing an exceptional experience that our clients are just knocked out at how flawless it is. That's because there's an auctioneer and team, putting their hearts and souls into it, working behind the scenes solving a million different problems that are thrown at almost every event."

To illustrate that point, Albert shares a story about one of their VIP events where almost everything went wrong at the last possible moment.

"One of my fond memories in life was being a Boy Scout," Albert says. "I only got to the level of Star Scout and always looked up to those Life and Eagle Scouts. But earning my five merit badges to get to Star taught me the Boy Scout motto: *Be prepared.* It has stuck with me all my life and has become part of the Park West culture. We are prepared. We have been in this business long enough to have an excellent Plan B and even Plan C, although sometimes we have to implement Plan D and if we need to we will even go to X, Y, and Z.

"In 2012, we had a VIP group come to our gallery in Michigan. Not only did we have a power outage but a water main also broke—all on the same weekend. We didn't quite get to Plan Z, but we were approaching it. We contacted the local police and fire departments and got permission to operate without power and water.

"Each client came in and was handed a Star Wars–like necklace with a colored light on it and their own individual flashlight. There were high-powered flashlights all over the gallery, illuminating the art; porta-potties in the back; and hundreds of gallons of water in the bathrooms and just about everywhere else. The show went on, dinner was served, and a live band played music. Without our local fire and police departments, both of whom were amazing, it would have been impossible. God bless them.

"One of the clients asked me how we were able to stage such a magnificent event and actually wanted to know if I arranged to have the power fail just to present them with this great experience! This was an exercise approaching Plan Z, but our mantra was the same: never give up.

"The whole experience, for us and our clients, became very special and an art unto itself. Like in show business, the show must go on, and it did. I am quite certain that for every single person, client, and staff member, it was an evening that will stay with them for the rest of their lives."

TRAVELING WITH COLLECTORS ACROSS THE GLOBE

These singular VIP events take place all over the world, and that's no exaggeration. Park West has recently taken VIP clients on excursions to Paris, Antarctica, the Canary Islands, Rome, Israel, Egypt, Croatia, Russia, England, and China… and those are just a few examples.

While these events revolve around auctions and artist exhibitions, the collectors all find themselves experiencing a true luxury vacation. They stay in fine hotels or on first-class cruise ships, and they eat at the best restaurants. Park West arranges live entertainment and takes the collector groups on tours of international cities or acclaimed museums—and they're often joined by some of Park West's biggest artists.

Yaacov Agam has given Park West collectors personalized tours of his museum in Rishon LeZion, Israel, and his permanent installation at Paris's Centre Pompidou.

Clients have traveled to the Florida Keys to spend time with marine wildlife artist Wyland and participate in an auction at the artist's own home.

Park West has arranged special after-hours tours for its collectors at the Hermitage Museum in Saint Petersburg, Russia—the second-largest art museum on the planet.

Park West frequently holds exclusive events in California's Napa Valley, where, in addition to great food and great wine, their guests find themselves treated to truly unique experiences.

One of those experiences began thanks to rock 'n' roll legend Gary Puckett. With his band, the Union Gap, Puckett had six consecutive gold records and sold more records in 1968 than any other artist, including the Beatles. He's responsible for world-famous songs— "Young Girl," "Woman Woman," "Lady Willpower," and more.

Puckett and his wife Lorrie gravitated toward art collecting because, as he puts it, "We just wanted to start adorning our walls with cool stuff." The musician still performs all over the globe and, while traveling on a cruise ship years ago, he visited a Park West gallery for the first time and began collecting in earnest.

Once Puckett started collecting, he "discovered all of the great artists that live and work in this world" and quickly became a Park West regular.

"Meeting Gary—that was a beautiful accident," says Jason Betteridge, one of Park West's long-time VIP auctioneers.

While collecting, Puckett developed a friendship with acclaimed photorealist artist Scott Jacobs, who introduced Gary to the Park West team. "That introduction gave us an amazing idea," says Betteridge. "We thought it would be fantastic to also have a live performance by a music industry titan, who loves art collecting just as much as everyone there."

Puckett liked the idea and, in 2014, he performed for the first time at a Park West event. The collectors were completely knocked out by his performance, but Puckett and Betteridge had another surprise up their sleeves.

Puckett notes that there's a natural connection between art and music—in his words, they're both "expressions from the heart and soul"—and Betteridge knew that several of Park West's top artists were also accomplished musicians.

Imagine the shock of the VIP collectors when the artists who were exhibiting their work throughout the event picked up their own instruments and joined Puckett on stage.

Artist Scott Jacobs sat behind the drums, Patrick Guyton grabbed his bass guitar, Tim Yanke shook his tambourine—even Betteridge and Park West Gallery director Morris Shapiro joined in on percussion.

Since 2014, Gary Puckett has performed for Park West VIP collectors across the globe. In February 2018, on a Napa collecting trip, Puckett and his artist band were joined by famed French artist Duaiv, an accomplished classical cellist, who opened for the group with a stirring performance.

"We love having Gary in the Park West family, both as a musician and as a collector," Betteridge says. "He's this musical genius, who really gets art and loves collecting with us."

"Having someone at Gary Puckett's level performing at our events really brings home how special our VIP events are," Betteridge continues. "We're not just serving wine and cheese. We connect our collectors with our artists, we display the absolute best works of art we can offer, and we create these once-in-a-lifetime vacation experiences too.

"You get to share your love of art with people who are just like you, in some of the most beautiful places in the world, and sometimes a rock star shows up and sings 'Woman Woman.' How great is that?"

THE PERSONAL SIDE OF BEING A VIP

When collectors bring home a painting or sculpture from one of Park West's VIP experiences, more often than not, they bring home an incredible story along with it.

Gloria and Steve Miller could write a book about their collecting adventures with Park West. Since their first VIP art cruise in 2013, they have traveled to the Mediterranean and East Asia with Park West and have filled their home with art from these trips.

Many of their artworks have an interesting tale behind them. There's the hand-painted tie that artist Alexandre Renoir (great-grandson of Pierre-Auguste Renoir) created for Steve one night on a dare and the painting that international art icon Romero Britto renamed "Glorious Freedom" after meeting Gloria.

Their experiences extend beyond the art itself. There was the time they went dancing with Korean artist Sam Park or the time they shared martinis with famed Miami artist David "Lebo" Le Batard.

Every work in their collection is tied to a memory.

But their most memorable experience might have been meeting Michael Godard on a 2016 cruise to Asia. During the voyage, Godard spoke to the Park West collectors about how losing his sixteen-year-old daughter to brain cancer in 2006 impacted his life and work. In turn, the Millers shared with him their experience of raising their daughter who has special needs. This formed an immediate connection between Godard and the Millers and, in the end, how they looked at Godard's art was irrevocably transformed.

"Michael poured his heart out to us, and we couldn't help but fall in love with him and his art," Steve recalls. "He is just an amazing person. We got to see the way his mind works, and it makes the artwork we bring home and hang on our walls all the more meaningful to us."

Another experience the Millers will never forget was taking a private tour of French artist Paul Cézanne's workshop in Toulon, France during their honeymoon cruise with Park West. Led by the VIP team, the Millers walked in Cézanne's footsteps, setting eyes on Sainte Victoire Mountain and the Aix en Provence landscapes he so often painted.

It was awe-inspiring for Gloria. "You hear about Rembrandt and Picasso and see their paintings in museums," she explained. "But it's different when you see it right there in context."

The Millers have many lasting memories they attribute to the VIP program. "When I look at the works in our home, it brings me back to when we met the artists who created them. I remember the conversations and experiences. It means so much to me."

While reflecting on the legacy of the program, Albert offers this insight: "At our VIP events, I think we give people the opportunity to win. Not just win a bid, but win a day, win a friend, win new knowledge. They get to put themselves into an elite group of people in a custom environment where they have access to this world that's normally not available to them.

"That's why you take art off the walls. That's why you not only bring art to the people but you bring the people with you to where the art lives. That might be in a museum in Paris or that might be standing next to an artist, sailing on a ship together. Taking the collectors with you is a powerful thing."

CHAPTER 21

Park West's Lasting Impact on the Cruise Industry

Park West has become an indelible part of modern cruising's DNA and perhaps the best example of that is painted along the side of one of the largest cruise ships in the world.

In 2012, Norwegian Cruise Lines decided to do something unprecedented. They wanted to find an iconic artist to paint the hull of Norwegian *Breakaway*, which was in the process of being built in a German shipyard.

But this would be no ordinary mural. The art would cover approximately *40,000 square feet* of the ship's hull. It was a massive undertaking, and they had to identify the ideal artist to pull it off.

Enter Peter Max.

Norwegian knew that Max was one of the important and influential artists represented by Park West Gallery on their fleet of ships. Thanks to his trademark bold imagery and uplifting designs, Max was perfectly suited for the new *Breakaway's* exuberant design aesthetic.

If that wasn't enough, Max had some relevant work experience too—back in 1999, he had painted the fuselage of a 157-ton Boeing 777, so he was used to working "big."

While Norwegian had featured art on the sides of select ships since 2002—created by their own design teams—Andy Stuart, president and chief executive officer of Norwegian Cruise Line, noted that, "In 2012, we took it to next level when we worked with our partners at Park West Gallery to commission renowned New York artist, Peter Max, to paint the hull of Norwegian *Breakaway*."

It was the first time a cruise company had ever asked an internationally famous artist to wrap a ship in his or her signature style.

According to Max, when Park West and Norwegian approached him with the *Breakaway* project, he "really got inspired painting this amazing ship when I heard about its size. It's one of the biggest ships ever to be parked in New York City. I couldn't believe it."

Almost two years later, on April 25, 2013, renowned German shipbuilder Meyer Werft delivered *Breakaway* to Norwegian, with Max's unforgettable artwork adorning the hull. A crew of talented artisans, under Max's direction, had spent months bringing his colorful designs to life along the ship's exterior.

The brand-new *Breakaway* sailed from Rotterdam to Southampton, until it was ready for its first transatlantic voyage to its eventual home in New York. Years later, *Breakaway* is still considered one of the most distinctive and recognizable cruise ships in the world.

It also started a tradition that continues today. Since the debut of *Breakaway*, three other artists have painted the hulls of Norwegian ships—David "Lebo" Le Batard on Norwegian *Getaway*, Guy Harvey on Norwegian *Escape*, and Wyland on Norwegian *Bliss*.

All of these artists are represented by Park West. Albert fondly states, "I never even imagined that four different artists I represent could create such large-scale paintings that would be constantly exhibited in different places all over the world."

That alone speaks volumes to how much Park West Gallery has grown.

Take one look at *Breakaway* and the ships that have followed, and it's undeniable that Park West and its artists have helped create the visual aesthetic of an entire industry.

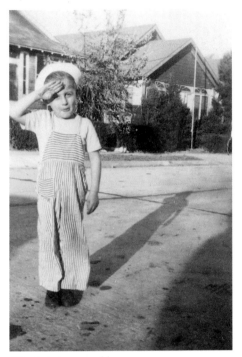

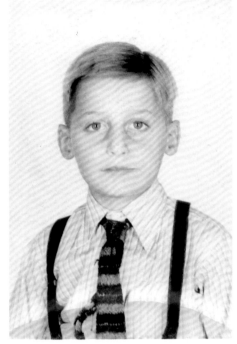

Albert at six years old

Albert at eight years old

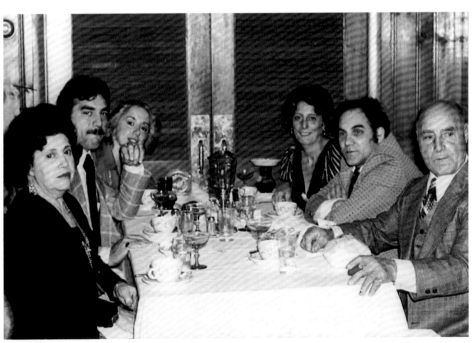

From left: Albert's mother Agnes, brother-in-law Dennis Pandolfi, sister Diane Pandolfi, sister Marie Buglione, brother-in-law John Buglione, and father Joseph Scaglione

Albert and Mitsie Scaglione, Plantation, Florida, April 29, 2019

Mitsie and Albert, Philadelphia, Pennsylvania, July 3, 2017

Mitsie and Albert, Mackinac Island, Michigan, July 6, 2019

Albert at the New Jersey Institute of Technology's University Awards Ceremony, October 9, 2002

Mitsie and Albert with the Albaretto family in their home.

The painting that Albert purchased for his parents when he was sixteen years old.

Albert with his siblings: Joe, Marie, and Diane, Mackinac Island, Michigan, July 6, 2019

Albert with his granddaughter Maria and daughter Lisa

Albert's granddaughter Annabelle, son Marc, grandson Augustus, and daughter-in-law Ann Marie, December, 2019

Albert's son-in-law and artist Tim Yanke and step-daughter Nicky, Chicago, Illinois, January 25, 2020

Albert's grandsons Angelo and Roman Yanke, Philadelphia, Pennsylvania, July 3, 2017

Albert's grandson Michael Karay, Mackinac Island, Michigan, July 4, 2019

Albert's grandson Matthew Karay, Philadelphia, Pennsylvania, July 3, 2017

Albert's daughter-in-law Ann and step-son John Karay, Hendersonville, Tennessee, December 6, 2018

Albert at Park West Gallery, 1980

Park West Gallery at its current location before renovations, 1980

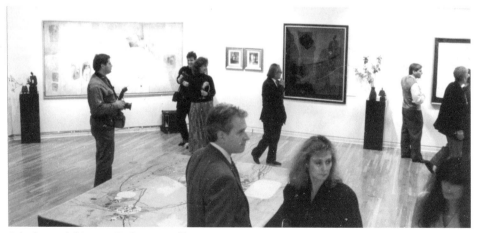

Lebadang exhibition at Park West Gallery

178

An example of a 1972 catalog from a Park West auction in at the Holiday Inn in Southfield, Michigan.

Modern Art Auction

Sunday, May 28, 1972

2:00 P;M.

at

The Holiday Inn

26555 Telegraph Rd.

Southfield, Michigan

Exhibit at Park West Galleries

Saturday, May 27, 10:00 - 8:00

Terms: Cash
 Check
 Master Charge
 Bankamericard
 American Express

Sunday, May 28, 1:00 - 2:00

at Holiday Inn

1. Virgo - Dali - Original lithograph, 10/250, pencil signed.

2. In A Circle - Hwang - Original etching, 209/250, pencil signed.

3. Images - Pelayo - Original lithograph, 159/275, pencil signed.

4. La Luna - Deberdt - Original etching, 40/120, pencil signed.

5. Le Oiseau de L'ete - Guiramond - Original lithograph, 52/120, pencil signe

6. The Tree - Wakata - Original serigraph, 79/90, pencil signed.

7. Face - Appel - Original lithograph, 29/50, stone signed.

8. Carrita con Girasales - M. Silva - Original etching, A/43, pencil signed.

9. Dove - Alvar - Original lithograph, 159/250, pencil signed.

10. Paysage Isbus - Chagall - Original lithograph, stone signed.

11. Divine Comedy - Dali - Original wood engraving, signed in the block.

12. El Toro - Deberdt - Original etching, 69/120, pencil signed.

13. Fleches - Calder - Original lithograph, stone signed.

14. Le Figure - Miro - Original lithograph.

15. Harbor - Daumier - Original oil on canvas, signed.

16. Dove - Braque - Original lithograph, stone signed.

17. Ruins - Tsurutani - Original serigraph, 47/50, pencil signed.

18. Marcel en el Jordan - Galetor - Original etching, 66/110, pencil signed.

Catalog listing for a May 28, 1972 Park West auction in Southfield, Michigan, including signed works by artists like Salvador Dalí, Karel Appel, Joan Miró, Pablo Picasso, and others.

180

19. Nina Y Zandia - Manuell - Original etching, Artist's Proof, pencil signed

20. Roman Lady - Capazzoli - Original etching, 38/80, pencil signed.

21. Summer Day - Montrec - Original oil on canvas, signed.

22. Color Sounds - Alt - Original serigraph.

23. Jordan Public - Chabrier - Original lithograph, 34/120, pencil signed.

24. Bullfight - Jansem - Original etching, Artist's Proof, pencil signed.

25. Floral-Fischler - Original water color on rice paper, signed.

26. Green Face - Appel - Original lithograph, 25/100, pencil signed.

27. Vega - Vasarely - Original serigraph, 155/267, pencil signed.

28. An Inward Eye - Anuskiewicz - Original serigraph, 77/100, pencil signed

29. C. A. #8 - Cruz-Diez - Original serigraph, 139/200, pencil signed.

30. Couple Under the Tree - Chagall - Original lithograph, 35/40, pencil signed.

31. Couple Avec Fleur - Alvar - Original lithograph, 55/140, pencil signed.

32. Children With Balloons - Scott - Original oil on canvas, signed.

33. No. 18 - Kawashima - Original serigraph, 43/95, pencil signed.

34. Dancing Krishna - Bose - Original etching, 89/90, pencil signed.

35. Profil - Scellier - Original lithograph, 122/130, pencil signed.

36. Interlude - Wolins - Original lithograph, 6/250, pencil signed.

37. The Family - Burman - Original water color, signed.

38. Bouquet - Menguy - Original lithograph, 149/200, pencil signed.

39. Nude - Amen - Original etching, 103/200, pencil signed.

40. Mother and Child - Lander - Original etching, Artist's Proof, pencil signed.

41. Kunisada - Shinohara - Original serigraph, 6/100, pencil signed.

42. Februar - Indiana - Original serigraph.

43. Artigas - Miro - Original lithograph, stone signed.

44. Apparation At The Circus - Chagall - Original lithograph.

45. Femme - Giacometti - Original lithograph.

46. Trois Noirs - Calder - Original lithograph, 18/150, pencil signed.

47. Acquarium - Tarrago - Original etching, 46/50, pencil signed.

48. Georgiques - Maillol - Original wood cut, monogrammed.

49. Woman - Maillol - Original drawing, monogr:

50. La Luna - G. Silva - Original etching, A/3!

51. Surrealistic Memory - Dali - Original lithograph, stone signed.

52. Images - Lebadang - Original lithograph, 54/150, pencil signed.

53. Hit - Lindner - Original lithograph.

54. Skowhegan School - Lindner - Original serigraph, Artist's Proof, pencil signed.

55. Paysage - Brilliant - Original etching, 88/120, pencil signed.

56. Abstract - Meyers - Original oil on canvas, signed.

57. Mouse - Appel - Original lithograph, 75/300, pencil signed.

58. La Chat - Guiramond - Original lithograph, 20/120, pencil signed.

59. Still Life - Genis - Original lithograph, 49/140, pencil signed.

60. Woman In The Park - Daskaloff - Original lithograph, 15/20, pencil signe

61. Femme - Daskaloff - Original china ink drawing, signed.

62. Koeb IV - Vasarely - Original serigraph, 212/225, pencil signed.

63. Artist and The Couple - Chagall - Original lithograph, 15/50, pencil signed.

64. Acrobat - Chagall - Original lithograph.

65. Vibrations - Soto - Original serigraph, 68/200, pencil signed.

66. Clown - Valdy - Original oil on canvas, signed.

67. Pindare for VIII Pythique - Picasso - Original celluloid engraving, 1960, 2/10, pencil signed.

68. The Star of Kings - Rembrandt - Original etching. G.112, M.293 (1652) H. 254 (1652) Mz. 278 (1654)

69. Great Ocean Yacht Race - Dali - Original lithograph with collage, 28/50 pencil signed.

70. Lion - Cyrk - Original serigraph.

71. Yellow Square - Albers - Original lithograph.

72. Flutist - Alvar - Original lithograph, 138/250, pencil signed.

73. September - Dietz - Original serigraph.

74. The Bible Series - Chagall - Original lithograph.

75. Clown - Buffet - Original lithograph, stone signed.

76. Kite - Motoi Oi - Original etching, 23/100, pencil signed.

77. Musical - Miro - Original lithograph.

78. L'Art Vivant - Vasarely - Original lithograph.

79. Oiseau - Galetor - Original etching, 36/140, pencil signed.

80. Concert - Farhi - Original farigraph, 111/150, pencil signed.

81. Dove - Braque - Original lithograph, stone signed.

82. Scene de Cirque - Guiramond - Original lithograph, 119/230, pencil signed.
83. Geometrics - Vasarely - Original lithograph.
84. Floral - Danty - Original lithograph, 9/100, pencil signed.
85. Profil Bleu - Alvar - Original etching, 37/140, pencil signed.
86. Before The Castle - Amen - Original etching, 52/90, pencil signed.
87. Village - Cander - Original lithograph, 95/275, pencil signed.
88. Maeght - Chagall - Original lithograph, stone sigend.
89. Lisboa - G. Silva - Original etching, A/15, pencil signed.
90. Scene - Tarlier - Original oil on canvas, signed.
91. L'edete - Brilliant - Original etching, 20/120, pencil signed.
92. Olympische Munchen - Huntervasser - Original serigraph, signed in the silk.
93. Solfege #5 - Agam - Original serigraph, 26/200, pencil signed.
94. The Art of Love - Righi - Complete portfolio of 27 original lithographs, from an edition of 125.
95. Child With Kitten - Lopetique - Original oil on canvas, signed.
96. Suite Vollard - Picasso - Original etching, from an edition of 250, pencil signed.
97. Gestalt - Vasarely - Original serigraph, 61/200, pencil signed.
98. Signs of The Zodiac - Dali - Complete portfolio of 12 original lithographs, including frontispiece, from an edition of 50, pencil signed.
99. L'Idole - Daskaloff - Original lithograph, 154/160, pencil signed.
100. Tanto Y Man - Goya - Original etching, L. & H. 186 B.144 V. L. 695 M. II141.
101. Horse and Rider - Marini - Original lithograph, stone signed.
102. Blue Mirage - Lebadang - Original lithograph, 54/150, pencil signed.
103. #69 - Kawashima - Original serigraph, 19/80, pencil signed.
104. Oiseau Bleu - Galetor - Original etching, 77/110, pencil signed.
105. Interlude - Amen - Original etching, 117/200, pencil signed.
106. Metropolis - Farhi - Original farhigraph, 60/100, pencil signed.
107. Chevaux - Lebadang - Original intaglio - 112/150, pencil signed.
108. Still Life - Buffet - Original lithograph.
109. Divine Comedy - Original wood engraving, signed in the block.
110. Nocturne Over Venice - Chagall - Original lithograph.
111. Petite Croix - Calder - Original lithograph.

112. Scene - Neff - Original water color, signed.
113. Umbrella Clown - Motoi Oi - Original etching, 67/250, pencil signed.
114. Sailboats - Montrec - Original oil on canvas, signed.
115. Gossip - Viko - Original lithograph, 192/200, pencil signed.
116. L'Oiseau Solaire - Miro - Original lithograph, stone signed.
117. Prism - Pfeiffer - Original serigraph, 177/250, pencil signed.
118. Image of A woman - Cappsmoli - Original etching, 74/80, pencil signed.
119. Horse - Esteve - Original serigraph, 103/200.
120. Freedom - Wolins - Original lithograph, Artist's Proof, pencil signed.
121. Mirage - Vasarely - Original serigraph.
122. Colombe - Alvar - Original etching, 119/200, pencil signed.
123. Growth II - Daskaloff - Original lithograph, 44/250, pencil signed.
124. Fruits and Flowers - Dali - Original lithograph with collage, 28/50, pencil signed.
125. Noble Cavalier - Calder - Original lithograph, 53/150, pencil signed.
126. Don Quixote - Picasso - Original etching, from an edition of 50, pencil signed.
127. Rectangulaires - Sobrino - Original serigraph, 59/200, pencil signed.
128. Floral - Valdy - Original oil on canvas, signed.
129. Forever There - Max - Original serigraph, 83/100, pencil signed.
130. Bear - Appel - Original serigraph, 225/300, pencil signed.
131. #68 - Kawashima - Original serigraph, 19/90, pencil signed.
132. Telephone - Lindner - Original lithograph.
133. Sounds of Color - Vasarely - Original lithograph.
134. Felix Retorno - G. Silva - Original etching, A/74, pencil signed.
135. Composition - Soulages - Original lithograph, stone signed.
136. Psychodelic - Amen - Original etching, 12/200, pencil signed.
137. Mai - Anuskiewicz - Original serigraph.
138. Dove - Chagall - Original lithograph.
139. The Tree - Wakata - Original serigraph, 73/90, pencil signed.
140. La Luna - Lebadang - Original lithograph, 54/150, pencil signed.
141. Centre of The City - Hwang - Original etching, 44/250, pencil signed.
142. Bouquet et Melon - Genis - Original lithograph, 42/120, pencil signed.
143. Children - Liberman- Original wash drawing, signed.

144. Swing #3 - Oehm - Original serigraph, 40/175, pencil signed.
145. Butterflies - Frunzo - Original oil on canvas, signed.
146. La Tauromaquia - Goya - Original etching, from the 1905 edtion of 100, listed in Harris as "This edition is best after the first".
147. Coco Magnifique - Picasso - Original etching, from an edition of 200, pencil signed.
148. Head of Christ - Roualt - Original etching, from the Miserere, signed in the plate.
149. An Inward Eye - Anuskiewicz - Original serigraph, 77/100, pencil signed.
150. Saint Tropez - Valdy - Original oil on canvas, signed.
151. Afternoon - Clave - Original oil on canvas, signed.
152. #65 - Kawashima - Original serigraph, 42/95, pencil signed.
153. Composition- Vasarely - Original serigraph, signed in the silk.
154. Paysage - Guitet - Original etching, 50/100, pencil signed.
155. Magie Quotidenne - Picasso - Original etching, 3/10, pencil signed.
156. Floral - Bonas - Original oil on paper, signed.
157. Polka Dot - Max - Original serigraph, 16/100, pencil signed.
158. Cartons - Miro - Original lithograph, stone signed.
159. Whirl - Pfeiffer - Original serigraph, 157/200, pencil signed.
160. La Casade de los Pejaros - G. Silva - Original etching, A/72, pencil signed.
161. Gemini - Dali - Original lithograph, 10/250, pencil signed.
162. Don Quixote - Danty - Original lithograph, 250/250, pencil signed.
163. Duet - Wolins - Original lithograph, Artist's Proof, pencil signed.
164. Chevaux - Lebadang - Original etching, 56/125, pencil signed.
165. Scene - Weinberg - Original water color, signed.
166. Mother and Child - Menguy - Original lithograph, 173/200, pencil signed.
167. Bouquet - Praden - Original oil on paper, signed.
168. Don Quixote - Amen - Original etching, 110/200, pencil signed.
169. Man - Giacometti - Original lithograph.
170. Maeght - Calder - Original lithograph, stone signed.
171. Seascape - Colline - Original oil on canvas, signed.
172. Juni - Dosberger - Original serigraph.
173. The Bible Series - Chagall - Original lithograph.
174. Still Life - Buffet - Original lithograph.
175. Dove - Braque - Original lithograph, stone signed.
176. New York - Kawashima - Original serigraph, 49/75, pencil signed.
177. Spirals - Calder - Original lithograph.
178. Dream - Chagall - Original lithograph.
179. Man Seated - Giacometti - Original lithograph.
180. La Rouge - Miro - Original lithograph.

181. Nude - Lopetique - Original oil on canvas, signed.
182. White Vase - Kahiel - Original etching, 13/100, pencil signed.
183. April - Levi - Original serigraph.
184. Divine Comedy - Dali - Original wood engraving, signed in the block.
185. Georgiques - Maillol - Original wood cut, monogrammed.
186. Musicians - Chagall - Original lithograph.
187. Dimensions - Miro - Original lithograph.
188. Demonstration - Motoi Oi - Original etching, 20/50, pencil signed.
189. Five Nudes - Brandstatter - Original etching, 3/120, pencil signed.
190. The Couple - Chagall - Original lithograph.
191. Scene - Forrisor - Original lithograph, 93/120, pencil signed.
192. Composition - DeMarco - Original serigraph, 40/100, pencil signed.
193. Mediteranno Sombrero - Trepadori - Original etching, 36/60, pencil signed.
194. Fusion - Vega - Original etching, 48/90, pencil signed.
195. Vermont - Gomory - Original wood cut, Artist's Proof, pencil signed.
196. Peace - Linica - Original serigraph, signed in the silk.
197. Breathless I - Freed - Original etching, 31/100, pencil signed.
198. Terres de Grand Feu - Miro - Original lithograph, stone signed.
199. The Couple - Chagall - Original lithograph.
200. Toredore - Buffet - Original lithograph, stone signed.

End of Sale

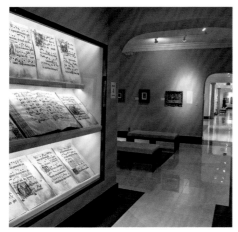

Park West Museum, 13th-16th c. manuscripts

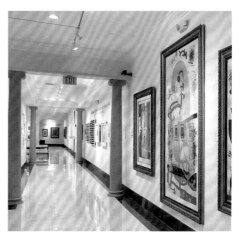

Park West Museum, Salon 7 (Miró)

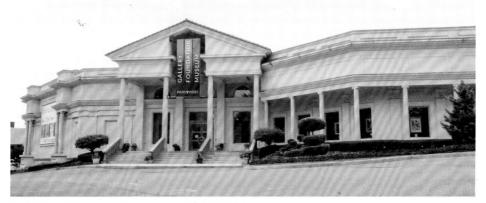

Park West Gallery and Museum, Southfield, Michigan

Park West Museum, Salon 4 (Goya)

Park West Museum, Salon 2 (Picasso)

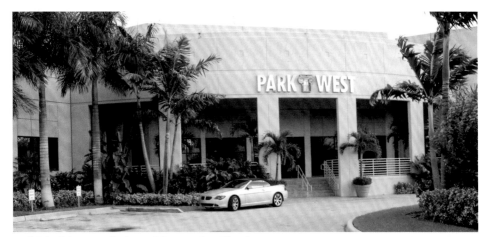

Park West's logistics facility in Miami Lakes, Florida

Park West's 222,000 sq-foot facility in Miami Lakes, the world's largest custom picture framing plant

Auctioneer training at Park West's facility in Miami Lakes, Florida

Morris Shapiro, Peter Max, and Albert, Park West Gallery, March 8, 2006

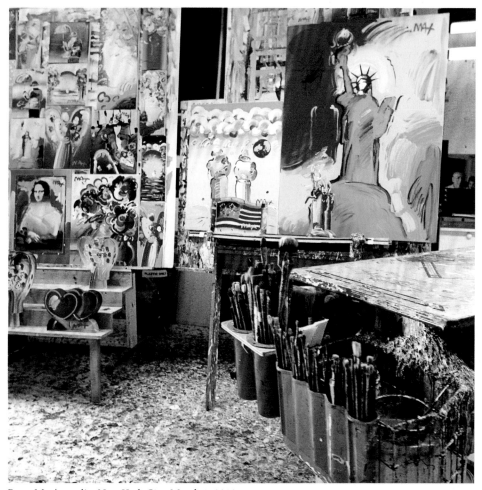

Peter Max's studio, New York City, March 1, 2018

Albert, classical harpist Chantal Thomas d'Hoste, and Yaacov Agam, New York City, July 5, 2017

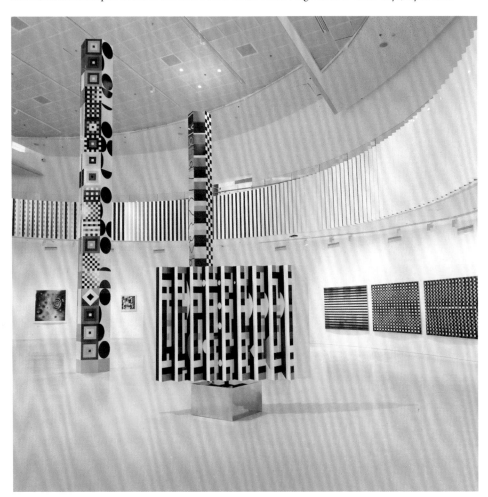

The Yaacov Agam Museum of Art in Rishon LeZion, Israel, October 28, 2016

Albert and Itzchak Tarkay, Park West Gallery, April 16, 2012

Marcel Mouly and Albert, Park West Gallery, September 3, 2004

Albert and Erté in New York City at Erté's 90th birthday party, 1982

Albert and Victor Vasarely, Paris, 1988

Tim Yanke, Albert, and Romero Britto, Mackinac Island, Michigan, July 3, 2019

Tim Yanke in his studio, August 2017

Romero Britto working in his studio, 2018

David Najar and Albert, Miami, Florida, April 16, 2012

Thomas Kinkade and Albert, Park West Gallery, July 16, 2008

Michael Godard and Albert, Mackinac Island, Michigan, July 3, 2019

Allison Lefcort in her studio, June 2013

Guy Harvey on Norwegian *Bliss,* May 9, 2018

Pino at a Park West VIP event, May 24, 2008

Igor Medvedev at a Park West VIP event on Norwegian *Epic*, December 5, 2010

Igor Medvedev, *Shimmering*, Serigraph on wove paper

Emile Bellet, Linda Le Kinff, her husband Jacque, translator Kathryn Stewart-Hoffmann, and Jean-Claude Picot, September 7, 2007

Linda Le Kinff, *Semi Tropical II #2*, painting on wood panel

Albert and Victor Spahn, Paris, August 27, 2013

David Le Batard (Lebo), Miami, March 13, 2019

Wyland on Norwegian *Bliss,* May 9, 2018

Daniel Wall, Albert, and Nano Lopez, Mackinac Island, Michigan, July 3, 2019

Albert and Autumn de Forest, The Butler Institute of American Art, Youngstown, Ohio, April 10, 2016

Duaiv, Mitsie, and Albert, Miami, Florida, April 16, 2012

Albert with Yolanda and Marcus Glenn at the 56th Grammy Awards, Los Angeles, January 26, 2014

Dominic Pangborn and his wife Delia with Mitsie and Albert, Ella Sharp Museum, Jackson, Michigan, July 10, 2014

Csaba Markus and Albert, Park West Gallery, November, 12, 2006

Albert and Mitise with former President George H.W. Bush and Chantal d'Hoste, May 2, 2006

Lithographer Stéphane Guilbaud, Bernard Louedin, Albert, Annie and Marc Scaglione, Côte de Granit Rose, France, April 9, 2013

Scott Jacobs, Mitsie, and Albert, Miami, Florida, April 15, 2012

Albert and Marko Mavrovich, Miami, Florida, April 15, 2012

194

Andrew Bone and Albert, Miami, Florida, April 16, 2012

Michael Cheval, New York, February 3, 2018

Sam Park, California, August 22, 2017

Marc Scaglione, Anatole Krasnyansky, Albert, and Francois "Fanch" Ledan, April 30, 2006

Alexander Chen and Albert, Miami, Florida, April 16, 2012

Wendy Schaefer-Miles, Kevin Miles, Mitsie, and Albert, Miami, Florida, April 15, 2012

Alfred "Alex" Gockel, Mitsie, and Albert, Miami, Florida, April 16, 2012

Peter Nixon and Albert, October 21, 2007

Daniel Wall onboard the *Regal Princess*, August, 6, 2014

James Coleman in his studio, September, 2018

Lebadang and Albert, Paris, April 22, 2011

Anatoly Metlan, March 24, 2015

Maya Green, Israel, October 31, 2016

Michael Milkin, Israel, October 31, 2016

Alexandre Renoir, California, February 3, 2018

Slava Brodinsky, August 16, 2016

Slava Ilyayev, January 3, 2007

Kre8, 2019

Ashton Howard, 2019

Stephen Fishwick, 2019

Matt Beyrer, May 10, 2017

Morris Shapiro, Park West Gallery Director, and Albert, October, 2007

Four Park West artists have painted the hull of a Norwegian cruise ship: Wyland (Norwegian *Bliss*), Guy Harvey (Norwegian *Escape*), David (LEBO) Le Batard (Norwegian *Getaway*), and Peter Max (Norwegian *Breakaway*)

Class of 2017 graduates honored at the Park West Foundation graduation ceremony with Albert and Mitsie, July 20, 2017

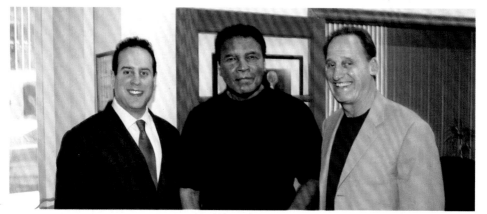

Marc, Muhammad Ali, and Albert first met at a session to sign the contract for their collaboration. At this meeting, Ali created a drawing for Albert, which he cherishes to this day. As part of their agreement, Ali and Albert stipulated that all works signed by Ali would be digitally photographed and placed on the OnlineAuthetics website.

Drawing by Muhammad Ali for Albert.

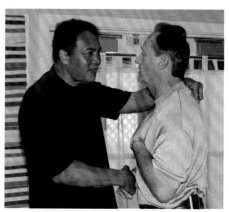

Ali greets Albert for a 2005 signing session

Muhammad Ali with the late Park West Foundation mentor Weusi Olusola (lower left), artist Simon Bull (top left), Park West Foundation youth, and Albert and Mitsie

VIP Auctioneers Rob Ducat and Jordan Sitter in Southfield, Michigan.

VIP Auctioneers John Block and Jason Betteridge in Miami, Florida.

Southfield, Michigan, telecast studio.

Miami, Florida, telecast studio.

Working with Artists

CHAPTER 22

The Essential Qualities
of a Successful Artist

While Park West has undeniably had a global impact on the contemporary art world, whenever the subject is broached, Albert is always quick to turn the conversation back to his favorite subject—artists.

"It all starts with the artist," Albert states emphatically. "Everything we do begins and ends with the artist."

"Someone once called me the 'driving force' of Park West. I'd say I'm the trailing force. The driving force is the artist, always the artist. I stay behind the scenes. Every single artist has a different dynamic that you have to serve. The most important thing for me to bring to the table is integrity. The dynamic of integrity is above all, and that means you really do have to develop a relationship. It has to be real, it has to be close, and it has to be personal."

The word "relationships" comes up frequently when you're talking to Albert. His knack for building meaningful relationships is part of Park West's DNA. It's one of the main reasons why his clients keep coming back again and again. It's also why some of today's most important living artists call Park West their home.

Because Park West has built such a notable reputation for its collection of classical masterworks, many collectors are often surprised to learn that *more than 95 percent* of Park West's art comes directly from living artists or from the estates of artists Park West had represented.

Remember how diligently Albert sought to establish those lines of provenance and ownership back in his early days in Paris, buying his art directly from those who knew the masters?

That whole question of authenticity is a lot simpler when the artists hand you the art themselves.

"I love working with artists, but it has to be a partnership," Albert notes. "It has to be like that because, when you're a partner, you win together, you lose together, you die together. That's how it works."

Park West gives its artists access to unbelievable resources—infrastructure, production facilities, showcase events, exposure, and a global network of loyal clients. "How can I help them reach a wider audience while making the greatest new art of their lives?" Albert asks. "That's my primary concern."

When it comes to the artist's side of the partnership, Albert argues that "their job is to learn, have fun, and invest in themselves."

He notes, "All I can do as their dealer is provide the artist with what they need to do their best work. I can set standards. I can offer them modern tools. I can introduce them to the latest techniques and studio technologies. If they find something useful, great. If they want, I can also give them data about which of their works sell and which ones don't, and they can do with that information as they please.

"It's not my business how an artist wants to express himself. That's why I love hanging out in an artist's studio. Because I don't have to do anything."

"Let me be clear," Albert continues. "We are in the business of art, and this is a business. If I'm going to speculate on an artist's work, it's because I love it, I think they have great talent, *and* I think they can go further, in terms of the art market.

"With our artists, particularly our newer artists, if they're not bringing us something new… if they're not constantly giving us work that makes us feel their power, their energy, their juice… the partnership isn't going to last. We expect the best from them. That doesn't always work for everyone, but some artists skyrocket. The ones that you see appearing over and over at Park West events are my leaders. Behind them, I march."

This begs the question—how does Albert find artists that he thinks will "skyrocket"?

There are hundreds of thousands of visual artists in the world, and Park West represents only a few hundred artists at a time. How does Albert determine whether an artist is a right fit for Park West?

There's a method he sometimes uses, which is similar to his "Four C's," the "Four Pillars of a Successful Career" that he talked about in his CMU commencement speech.

"Of course art will go beyond the boundaries of any attempt to define it, but there are a great number of works which I believe can be broken down into four fundamental components: **Color, Composition, Technique,** and **Creativity.**

"For a work of art to be truly great, all of those qualities should be there. It can be technically great, but that's not everything. It needs to be creatively great, compositionally great, colorfully great, even if it's black and white.

"People have always said that I have a good eye. I've always appreciated beauty and seemed to have an eye for what is new.

I've honed that eye over the years, so when I look at the different perspectives in an Agam work or the figurative beauty of a Thomas Kinkade work, I know instinctively that they will blow everybody else out of the water whoever tried to do what they do.

"The main thing you don't want are imitators. That's where integrity comes in. You don't want an artist who is derivative of somebody else—you want the artist that everyone else is trying to imitate. You might not like all of our artists, and we definitely have our critics, but all of our artists are absolutely unique.

"If someone can bring that truthful perspective… and they're creative, they have the skills, they know composition, and I can tell that people are going to love their work and the artist has the ability to work like a professional… that's when I know they belong with us."

THE BOOK OF ALBERT

CHAPTER 23

Park West's Family of Artists

Since 1969, Park West has represented well over a thousand living artists, in addition to their work with the estates of artists like Picasso, Chagall, and other legends of the past.

However, at any time, the number of active artists on Park West's roster is actually quite a bit smaller. As tastes change and artists evolve, Park West probably works with closer to 120 living artists at a time—usually a mixture of stalwart favorites and new emerging talents.

The names change over the years, as some careers skyrocket and others sunset, but each artist makes up an important piece of Park West's visual mosaic.

Many of those unforgettable names have already been mentioned in these pages…

M.C. Escher, Peter Max, Victor Vasarely, Yaacov Agam…

Pierre-Auguste Renoir, Salvador Dalí, Joan Miró, Marc Chagall…
Itzchak Tarkay, Erté, Marcel Mouly…

If you were assembling an exhaustive list of every artist who has ever worked with Park West, that alone would fill up these pages (and beyond).

With that in mind, in no particular order, here's a look at a selection of artists who haven't been mentioned in detail yet—a brief cross-section of the contemporary talents who've helped define Park West Gallery's identity as the world's leading art dealer.

ROMERO BRITTO

"There was a time when Peter Max was the most licensed artist on the planet," Albert says. "But, today, Britto wears that crown." (A July 2019 CNN profile went even further, calling Britto "the most licensed artist in *history*.")

What does it mean to be history's "most licensed" artist? In the simplest of terms, it means that the public adores your art and they can find it almost everywhere.

Some of the biggest brands in the world—Disney, Coca-Cola, Mattel, Samsung, and more—have all hired Britto to feature his art on everything from automobiles to bananas. The artist also has over sixty public art installations worldwide, he's been the subject of over three hundred global exhibitions, and he's created art for events like the Super Bowl, the Olympics, and the World Cup.

It's all pretty impressive, particularly when you realize that Britto grew up as one of nine children in an impoverished family in Brazil. Britto told CNN, "Since I was a kid, I always liked drawing, but I never knew it would change my life."

He exploded onto the Miami art scene in 1989—thanks to his trademark style that fused together pop art and cubism in new and fascinating ways—and has never looked back.

Britto has been working with Park West since the early 2000s and continues to appear at Park West events all over the world. In a 2007 interview, Britto said, "In my art, I really believe in having things put in place, being organized and systematic. I think a lot of other arts organizations could definitely learn a lot from Park West. They bring art to so many people around the world, so many people who get to bring home a piece of Park West *and* a piece of the artist."

Albert speaks fondly of Britto. "Britto is always experimenting, always innovating. I am always interested in having our artists

explore new media, and after only one (really long) conversation with Romero about sculpture, he ran with it. In a flash, he sent us drawings, he sent us three-dimensional models. A short time later, we produced our first Britto sculptures and they're *phenomenal.* Our collectors love them."

"Art can really be an agent of change," Britto has said. "It can be inspiring and bring people together. I am blessed because I have this gift where I can create art and bring people together."

MICHAEL GODARD

Albert smiles when he talks about Michael Godard. "That guy... he's an emerging superstar."

Godard certainly looks the part. He's a Las Vegas native. On the surface, he more resembles a rock star than an accomplished visual artist, but make no mistake... Michael Godard is the real deal.

He has the soul of an artist and the talent to match, and his unorthodox, irreverent artwork has made him one of the biggest names in contemporary popular art.

Godard spent years perfecting his craft, doing everything from drawing caricatures at theme parks to selling his art up and down the Vegas Strip. But, now, Godard has become an art world celebrity, specializing in bringing to life playful imagery inspired by the pop aesthetic of his hometown.

Often called "the Olive Guy," Godard is best known for the joyful anarchy of his trademark olive paintings in which his animated olives dance, carouse, or lounge around with a martini. (Godard's olives currently appear on more than four thousand products worldwide, ranging from surfboards to vodka.)

In the early days of his career, Godard's art was carried by Princess Fine Arts. After Park West acquired Princess Fine Arts in 2013, Albert was in the process of evaluating which of the Princess Fine

Arts artists Park West should continue to work with. However, before that process even began, Albert knew that Godard was a keeper.

"Michael came to visit us at the main gallery in Detroit years ago," Albert remembers. "He was standing there, overlooking our downstairs gallery space, and I decided to be direct. I asked him, 'What are you looking for, man? What do you want?'

"He replied, 'I want to be number one. I want to be the best of all time.'

"I shot back, 'Are you ready to go? You can paint? You've got your studio? You can produce?'

"'I can produce.'

"'You sure?'

"'Yeah.'

"So, we came up with a deal. And the art he starts sending us… it's delicious. It's better than he's ever painted before. I can tell that he's trying to shock the world. He's like my friend Muhammad Ali. He's that kind. He's like me too. We're super-competitors. There are artists like that, like Agam. Just mega-competitors. They want to be the best.

"Case in point, a few months ago, I texted Godard and told him, 'Start thinking about sculpture.' That was all I said. The very next morning, my in-box was filled with drawings, designs, concepts. He's just driven to create."

It also helps that Godard has a bit of Vegas showman in him.

"Nobody gets a crowd excited like Michael," says Albert. "Nobody. We had an event recently. I went onstage and instantly was like 'Oh, jeez, this is a quiet crowd.' They didn't seem to be responding and I wasn't sure that what I was presenting was reaching them. A few minutes later, Michael came on, he had them swooning, and he sells a painting for $185,000. He gets people *excited*."

THOMAS KINKADE

Known as the "Painter of Light," Thomas Kinkade was one of the world's most collected living artists for *decades*.

Kinkade once said he had something in common with American icons like Walt Disney and Norman Rockwell—he wanted to make people happy. You can definitely feel that in his art. Kinkade's scenes of idyllic, fairytale-like landscapes and cottages exist in a world of beauty, intrigue, and adventure.

Today, his artwork hangs in more than ten million homes and his imagery continues to adorn greeting cards, Christmas ornaments, and millions of other pieces of pop culture memorabilia.

"We began working with Thom in 2002," Albert recalls. "Immediately, we witnessed, firsthand, the extraordinary impact his art had and continues to have on people from all walks of life. Thom, as a person and as an artist, was a 'good channel,' bringing into the world messages of hope, peace, and the joys of family and tradition.

"He was also, through his masterful technique and uplifting messages, a perfect vehicle to bring people into the lifelong pleasure of collecting art."

The appreciation between the two men was mutual. When asked about Park West's legacy, Kinkade said, "Leave it to Albert to be able to bring together a group of artists [with] more positive impact on our culture than probably has ever been gathered... The team here at Park West has been responsible for creating a lot of joy, of inspiration, and a lot of beauty... The art that has been created because of the vision of this company is going to be touching lives, and I just personally want to say thank you to the team at Park West for sharing the light."

Kinkade tragically passed away at the age of fifty-four, but Albert still has very fond memories of working with the popular icon.

"There was one time I was on my boat near Bay Harbor, Michigan. My cell phone rings and it's Thom. We started talking and it was so stimulating. He had so many ideas. He was so creative. He's just got this incredible way of painting, like J.M.W. Turner. Hours went by and I finally had to dock the boat. I said, 'Thom, I'm coming in. I've got to put down the phone. Can I call you back?' He laughed and said, 'No, I'll wait!' And he did. That's just the kind of guy he was. He wanted to continue the conversation."

Park West is still fortunate enough to carry Kinkade art from the artist's own archives and newer works from the artists at Thomas Kinkade Studios. His studio is one of the artist's most enduring contributions to the world of art. Before Kinkade died, like his idol Walt Disney, he had already begun building a studio that would continue his life's work for generations to come.

During his lifetime, Kinkade actively sought out talented artists whom he believed would be able to carry on his vision, training these artists to paint in his hallmark, Kinkadian style. Now, those artists continue to create outstanding works of art, carrying Kinkade's legacy into the future.

One of Albert's favorite memories of Kinkade is when the artist attended Park West's fortieth-anniversary celebration in 2008. Kinkade graciously met his collectors and spent time talking shop with a number of other Park West artists at a gala party at the company's headquarters.

Later in the evening, Kinkade raised a glass to toast Albert.

He said, "The artists in this room have been welcomed in to the homes of real people who may not be the critics of the world, who seek to set themselves up as the experts in art, but they're the people who love art, which is you, the people who care enough about the art that artists in this room create to bring it into your home and make it a part of your family."

CHRIS DERUBEIS

Chris DeRubeis has built an impressive art career doing something few artists can—painting on metal.

A frustrated artist in his youth, DeRubeis discovered something surprising during his day job painting custom motorcycles. While grinding the base paint off a motorcycle's gas tank, he realized that the exposed metal was intricately patterned and reflected light in a distinctive way.

Inspired, DeRubeis began experimenting in his parents' garage with different tools to manipulate the way light reacted with metallic surfaces. This included combining chemicals, pigments, and fire to create exciting, uncommon reactions. After almost destroying the garage and nearly blowing up the house too, he invented his own brand of art—a style that he calls Abstract Sensualism®.

After that, DeRubeis slowly began making a name for himself in the art world, winning a special award at the First Annual Fine Art Awards in Las Vegas. After the normal stint of showing in galleries, in 2013, Park West began selling DeRubeis's work.

At one of their earliest meetings, Albert recalls, "I was sitting with Chris and told him that I always and regularly needed new art, constantly challenging my clients with the creativity and talent of our Park West artists. I asked him, 'Can you do that?'

"Chris, who just seemed to be doodling while I was speaking, throws a napkin across the table and, on it, was 'Opposites Attract' [one of DeRubeis's most popular compositions featuring two ethereal lovers appearing out of the wine in two clinking glasses]. Chris had just sketched it on this little napkin.

"I looked at it and said, 'That's exactly what I'm talking about! That's what I want! Let's get going!' And we did."

SLAVA ILYAYEV

When a collector encounters one of Slava Ilyayev's works for the first time, one of their most common questions is *"How does he do that?"*

There is a level of texture and color in his paintings that has to be seen to be believed. With his trademark palette knife, Ilyayev deftly applies thick swathes of color across his canvases that can sometimes take a full year to dry completely.

The resulting paintings have a striking three-dimensional effect, which makes sense because, according to Ilyayev, "I paint as a sculptor."

Drawing heavily on autumnal colors and changing leaves, Ilyayev often depicts rainbow-colored, tree-lined paths and streets.

Originally from Azerbaijan, Ilyayev later emigrated to Tel Aviv, Israel, where he studied at the renowned Avni Institute of Art and Design. In 2017, Albert visited Ilyayev in his studio in Tel Aviv. A video crew captured Albert watching as the artist applied the base shades to a new canvas and began constructing his images by blurring his colors.

Albert pointed to the canvas. "Look at how he's using the knife. One touch changes the complexion, the color, the mood. He's a master of the palette knife.

"As a dealer, when I first glanced at his work, I was concerned there wasn't enough difference, but then you approach it and there's plenty of difference. There's *so much* difference. He retains his purity through the colors he uses and his knife work. It's fantastic."

DANIEL WALL

When artist Daniel Wall immigrated to the United States from China, he didn't expect his life to change in the way it has.

He had struggled to find work in China as an art teacher and illustrator, but, upon arriving in the United States, Wall pursued his

art career with new vigor. Soon, Wall abandoned a planned career in mathematics and computer science to pursue his art full time. It was a gamble that paid off, and now Wall has collectors around the globe.

Working with a palette knife, Wall paints cityscapes and scenes from nature, but all filtered through his own personal perspective. He was influenced at an early age by the impressionist movement, particularly the work of Claude Monet.

During a recent interview with Park West, Wall noted, "I got a lot of inspiration from Monet. When I was younger, I fell in love with Monet's work, and it made me want to become an artist." Impressionists like Monet were known for their emphasis on accurately depicting light in their paintings. Many painted en plein air—outside amongst nature—so they could bring a more natural quality of illumination to their artwork.

While Wall appreciated the impressionists' devotion to natural light, he also found himself wanting to elevate and enhance the colors and textures in his own paintings.

To accomplish this, Wall adapted the classic Chinese "dry-brush" painting method to work with his own love of impressionism. In his new method, Wall exclusively used a palette knife to create his oil paintings, allowing him to enhance the intensity of his colors and textures. Wall called this new visual approach "Intense Impressionism."

"We love Daniel Wall," Albert says with a smile. "He hits a chord with our clients. It's something really unusual and special. He touches people. His art, his style just has an impact on people. It's an amazing thing to watch."

TIM YANKE

You might remember the name Tim Yanke from earlier.

He was the artist who wowed the young auctioneers at the Park West training program with his sculptographs and augmented-reality art.

He's the artist who inspired Albert to say, "We do the unheard of every day."

Since he joined Park West in 1999, Yanke has been a rising star. When trying to describe his art, the one word that comes up again and again is "spontaneous."

Yanke's own brand of abstract expressionism is bold, energetic, and totally captivating. Whether he's painting one of his trademark neo-West scenes or a new interpretation of an American icon, Yanke always brings a refreshing sense of vitality and motion to his artwork.

Albert says, "Tim cannot produce enough art for us. We are constantly selling out of his work. He's just constantly running hard, constantly painting to keep up."

It was mentioned earlier that Yanke has a familial connection to Albert—he's married to Albert's stepdaughter Nicky—but the two men share another bond as well.

"We almost died together," Albert admits soberly.

In 2016, the *Detroit Free Press* ran the headline "Southfield Art Gallery Owner Survives Tesla Crash."

"Tim and I were in my Tesla on the Pennsylvania Turnpike and the autopilot feature suddenly went off," Albert recalls. According to the police report, the car hit a guardrail "off the right side of the roadway. It then crossed over the eastbound lanes and hit the concrete median."

Albert remembers things a little more vividly. "We hit a wall, hit another wall, *boom, boom,* and did four turnovers before it came to rest. There was a nurse who had been driving behind us for a number of miles and witnessed it. She told us she thought they would be picking up body parts from the crash.

"I practically walked away, but Tim was hospitalized for a couple of weeks. He just had also had both knees replaced. It was rough."

The two men often spend time together in northern Michigan where the family owns some property. "We were up there, not long after the crash, and Tim saw this little house and said, 'It would be great to have a studio up here.' So, we bought the house, tore it down, and built Brave Spirit, a lodge made of logs for Tim's studio with a spectacular view of Torch Lake."

Albert adds, "Tim also just bought a new building in Berkley, Michigan, on the corner of Prairie and 12 Mile Road. Isn't it fitting that a painter from Detroit who paints the American Southwest would have a studio located on the Prairie?"

LEBO

David "Lebo" Le Batard has never shied away from a challenge.

The Miami artist has created everything from paintings to sculptures, from massive murals to eye-popping graphic works. Lebo is also one of only four artists to date to be commissioned to paint the hull of a cruise ship.

(His work adorns the side of Norwegian *Getaway*. The other three artists are Peter Max, Guy Harvey, and Wyland.)

His art is inspired by his own esoteric interests. When visiting Lebo's studio, you'll find the walls covered with sketches and notes alluding to the artist's immersive research into and fascination with cartooning, mythology, alchemy, history, and indigenous art.

Lebo refers to his aesthetic as "Postmodern Cartoon Expressionism"—his own brand of art that combines abstract imagery, drawing, bold hues, and calligraphy together in a way that conveys both story and emotion.

Lebo created the official artwork for the 2003 Latin GRAMMY Awards and was commissioned to paint a mural commemorating

the 2018 FIFA World Cup in Miami's iconic Wynwood Art District. He's also created many private and publicly sponsored mural installations across the United States.

Reflecting on the artist's career so far, Albert says, "Lebo is taking graffiti art and Keith Haring and Miami and Cuba and so many things—so much modern culture—and compressing it and communicating it back at us in his own Lebo-esque style. He's a force to be reckoned with."

WYLAND

"Now, Wyland, he's a smart guy," Albert says with a smile. "A very special guy. He's another member of that small group of artists who have painted their own cruise ship."

The ship, Norwegian *Bliss*, launched in 2018, with Wyland's trademark marine wildlife imagery stretching across its massive hull.

Fortunately, Wyland is used to working on big canvases.

He first rose to fame in the 1980s, painting life-size murals of whales on the sides of buildings all over the world. Known as his "Whaling Walls," the colossal murals reflect the artist's outsized passion for oceanic life and his commitment to raising awareness about environmental conservation.

"As the environmental movement grew in the early '70s, I was an artist who was right there and heard the call for conservation," Wyland says.

In 1981, he painted his first whale mural, "Gray Whale and Calf," in Laguna Beach, California. It inspired Wyland to make a bold declaration—he was going to paint one hundred whale murals in public spaces to help people better appreciate and value the diversity of life in our world's aquatic habitats.

For the next three decades, Wyland painted his murals from Detroit to Beijing. In 2019, he painted his *101st* whale mural on the

side of the Edgewater Hotel in Seattle—the exact same spot where, years earlier, an unsympathetic landlord had painted over one of his earlier "Whaling Walls."

At the mural's dedication ceremony, Wyland told the assembled crowd, "When you do art on a grand scale, it really captures the imagination of people. I think if we plant these seeds of conservation in the hearts and minds of our youth, they'll be world changers. That's why I'm here."

PATRICK GUYTON

Patrick Guyton has combined his passion for ancient art techniques with a tenacious work ethic to create a truly unique body of work.

Guyton takes Japanese leafing from the fourteenth-century Kamakura period and blends it together with Flemish glazing from the seventeenth century to create a completely new, contemporary style he calls "Gilded Modernism."

It's an exacting, volatile, and precarious process. This may sound like an exaggeration, but for Guyton, something as simple as using the wrong paintbrush can potentially ruin an entire work.

What makes Guyton's process so difficult? It comes down to his use of gilding, which Guyton has been experimenting with for over a decade.

Gilding involves the application of unbelievably thin sheets of precious metals onto a surface—like a board or paper—and requires incredible amounts of patience and dexterity. One wrong move and the metal practically disintegrates.

"Anything that happens in the room, or if the edge of your hand or your coat or shirt or if anything rubs against it in that raw sense, it's done," Guyton says.

Guyton's distinctive approach to his art, which blends gilding with traditional painting, took years to perfect. The variables

he had to contend with ranged from experimenting with paints, inks, and thinners to figuring out how to protect the works once they're finished.

Thankfully, his experimentation has paid off.

CSABA MARKUS

With his iconic mustache and top hat, it's hard to miss artist Csaba Markus when he walks into a room. He becomes even more memorable once you see his art.

Evoking the elegance of Renaissance art, Markus's artwork skillfully blends Old World ideals and a contemporary flair. Markus has won wide praise for his "Modern Mona Lisas," in which he paints ethereal portraits of confident, mysterious young women using an exclusive technique inspired by one of his heroes, Leonardo da Vinci.

Markus has mastered a number of different art forms and recently worked with Park West to develop the "caldograph," a new medium that links ancient methods with modern technology. Recognizing that the "Mona Lisa" was painted on a wood panel, Markus sought to pay homage to Da Vinci and his most famous painting.

The caldograph allows Markus to imprint his own "Mona Lisas" onto wooden panels on a molecular level using a method called dye sublimation. The results are artworks that evoke the same tactile feel as Da Vinci's paintings but are embellished and refined using the best in twenty-first-century technology.

In a 2012 promotional film, Albert can be seen standing in front of one of Markus's oversized canvases, explaining the artist's appeal.

"Csaba is from Hungary, he's living in California now," Albert says in the video. "I've had a handful of experiences with artists who began in Hungary and, with those artists, I've found this uniformity of virtuosity, technical skill, pride, energy, good training, and so on. But I have never seen the phenomenon of Csaba Markus.

"He has the powerful presence of a Rembrandt. He's full of energy, expression, explosion… he's a force of nature."

ALEXANDRE RENOIR

"Renoir" is one of the most famous names in art. But there have only been two Renoirs in history who were professional artists—Pierre-Auguste Renoir, one of the founders of Impressionism, and his great-grandson Alexandre Renoir.

Park West not only has an exquisite collection of paintings, rare lithographs, and etchings from Pierre-Auguste, but Alexandre is also represented by Park West Gallery.

"Park West is full of history—an organization that for many years has brought us beauty in art from all over the world," Alexandre says. "It is my absolute pleasure to be a part of it."

Alexandre keeps the traditions of his prominent ancestor alive, yet breaks new ground with his vivid, vibrant paintings. To quote Alexandre, "If your last name is Renoir, you have to try to paint something at least once in your lifetime. For me, it's the only thing I really seem meant to do."

While Alexandre is influenced by impressionism, he innovates and expands upon the movement with his own characteristic style. He paints solely with a palette knife, giving his works a distinct weight and dimension.

His paintings are inspired by nature, and he captures the beauty and life of his subjects with the expert, flowing strokes of his palette knife on canvas.

When asked what he hopes to accomplish with his art, Alexandre states simply, "I want to paint something that will give your soul a little sigh."

MATT BEYRER

Matt Beyrer is one of Park West's up-and-coming new artists. Albert beams, "Beyrer is going to be hot. I can smell it, feel it. He's doing some amazing things."

That's extraordinary when you consider that, just a few years ago, Beyrer was browsing Park West art on a cruise ship like everybody else.

"Early in my career, I spent six months working as a full-time art instructor on a ship," Beyrer remembers. "I remember walking to work every day and passing by the Park West Gallery, just looking and peeking my head in. I thought, 'Man, that would be kind of cool to be a part of one day.'"

And that day is here in a big way. In 2019, Beyrer had more consecutive sold-out shows in a single year than *any* other artist in Park West history.

Collectors around the globe have embraced Beyrer's signature style, in which he paints directly onto wooden planks and cleverly incorporates the wood's natural grain into his compositions.

According to Beyrer, "The biggest challenge is finding the right piece of wood."

He has an uncanny knack for transforming something as simple as wood grain into ripples on a seascape, a hazy sky over a mountain range, or even a stunning figure emerging from the wood.

When asked why people seem to gravitate to his art, Beyrer believes his collectors connect to it on an emotional level.

"I hope it's because they can relate to it in some way, shape, or form," Beyrer says. "I tend to always paint a little journal of my life, and it's nice when it's special enough that collectors are willing to hang it on their wall."

Beyrer will always remember his first show with Park West because of its auspicious date—April 1, a.k.a. April Fool's Day.

"I was so nervous because it was the first time my new art was going to be released to the public," Beyrer recalls. "I'd never done a show like that before, nor had I done any type of event with Park West before. And it was April Fool's Day. It felt like getting thrown into the lions' den.

"But we sold out that first show, so I thought, 'Wow, okay, I guess this is going to work.'"

STEPHEN FISHWICK

Stephen Fishwick doesn't just create art—he "attacks" it.

Known around the world for his "Art Attack" performances—where he creates a work of art, accompanied by music, in front of a live audience—Fishwick has an uncanny knack for infusing his paintings with life, color, and movement. For over two decades, he's painted everything from wildlife scenes to pop culture icons.

"Stephen's a really nice guy," Albert says. "I like him a lot and I like his art. He's very simple and direct, his paintings make clean, clear statements. You really feel his personality through the art, which is a tricky thing to pull off."

Fishwick is one of only a handful of contemporary artists who have won the title of "Disney Fine Artist," which allows him to paint Disney characters and have his artwork featured in Disney parks all over the globe. His art has also been licensed by the estates of cultural legends like Elvis Presley and Bob Marley.

"I am blown away by the many estates I have had the privilege to work with," Fishwick says. "Bands that my brothers and I listened to like Pink Floyd, AC/DC, David Bowie, and KISS are some of the ones I have had the most fun with. But Disney is probably my absolute favorite because I remember doing drawings of Mickey

Mouse ever since I could hold a pencil."

The artist is also a passionate wildlife conservationist and his efforts have raised over one million dollars for different preservation charities. He even has his own "For Life" collection of art where proceeds go to support endangered animals.

When asked about his Park West collectors, Fishwick says, "I want my artwork to move my collectors' souls. I want to connect with people and inspire them to do things they never thought they could do."

JAMES COLEMAN

Even if you're not familiar with the name "James Coleman," you're definitely familiar with his work.

That's because, for over seventeen years, Coleman supervised the creation of the hand-painted backgrounds for some of the most beloved Disney films of all time, including *The Fox and the Hound, The Little Mermaid, Beauty and the Beast,* and many more.

Coleman's artwork is impressionistic and luminous—it's often described as having a "Disney feel." Coleman humbly admits that he's unsure whether he was influenced by his time at Disney or if he was one of the artists who helped create that unique Disney flair. Either way, it's a quality that makes Coleman's art truly stand apart.

From an early age, Coleman longed to become a professional fine artist, but it was only after he completed his work on Disney's *Beauty and the Beast* that he decided to pursue his painting career full-time.

"I felt that it was time to move on," Coleman says. "I'd done everything I thought that I would ever want to do with films and I really had this passion for fine art. I said, 'You know what? I'm going to risk everything in my life.' And I walked away from the studio, and I never even went back to my desk. I couldn't bear to go back and empty my desk out."

It was a monumental decision that paid off. Coleman's art is highly sought after, and he has collectors around the world.

While making an appearance at Park West's fortieth anniversary gala, Coleman told a reporter, "It's so exciting to be a part of Park West and to be able to bring my art to more people. I just feel really blessed in my life to be able to do this, and I'm going to do it until I can't paint anymore."

ASHTON HOWARD

Not many artists understand the ocean better than Ashton Howard.

Raised on Florida's Gulf Coast, Howard was fascinated by the sea from an early age. A self-proclaimed "struggling artist" in his youth, he traveled the world seeking artistic inspiration, eventually settling near California's Laguna Beach, where he supported his art career by teaching surfing and painting surfboards.

While in California, collectors began taking notice of his artwork, which captures the light and movement of water in a brilliant new style Howard calls "Fluid Realism."

His technique utilizes water-based acrylic paints and resins. He brings together his core materials in a unique method that creates a remarkable fluidity of colors across his canvases. He starts by mixing his paints with special acrylic additives. This allows his colors to organically mix and flow together.

He then blends his evolving, amorphous backgrounds with painterly, realist landscapes that he incorporates into the foreground. The end result is a fantastic marriage of abstraction and realism.

Howard notes that his art is inspired by "the power and beauty of nature. I have always loved the outdoors with such passion. I can't hold in my emotions when a brilliant sunset stretches across the sky, a raging storm passes over, or the feeling you get while

standing at the basin of a massive mountain range. We live in a beautiful world."

KRE8

Kevin "Kre8" Vigil knows how to make a splash.

His striking paintings—contrasting colorful, abstract splashes against black-and-gray backgrounds—have earned him tens of thousands of social media followers from all over the world.

His paintings are vivid, electric, and brimming with spontaneous energy. He first started showing with Park West at their VIP events where collectors quickly embraced his dynamic way of bringing a canvas to life.

An accomplished tattoo artist and prolific graffiti writer, Kre8's preferred artistic outlet is painting on canvas. His foundational imagery ranges from the mundane to the fantastic, but each work resonates with Kre8's signature explosions of color.

Throughout his career, Kre8 has experimented with many artistic genres, including impressionism, cubism, and surrealism, but he describes his own artistic style as "Kre8izm," which combines aspects of surrealism and abstract art. Kre8 references Salvador Dalí as one of his main artistic influences but also draws inspiration from Andy Warhol, Jean-Michel Basquiat, and Pablo Picasso.

Kre8 admits that "I want my collectors to be able to relate to my work as if the art they fall in love with was painted exactly for them. We all go through difficult times, and I want them to look at my work and see a moment of clarity that gives them peace for at least a few minutes. There aren't too many times when it's OK to get lost—I want you to get lost in my work."

LINDA LE KINFF

Artists often love talking about how they developed their signature technique. French artist Linda Le Kinff, however, isn't just known for a technique—she's known for multiple techniques.

Le Kinff's mastery of an incredibly diverse range of mediums has made her one of the most accomplished artists of the past thirty years. Dynamic and elegant, Le Kinff's art is beautifully influenced by her years of experimentation and study all over the world.

She lived in Italy for over a decade, educating herself in the ancient ways of the Italian masters. By apprenticing with other artists, she immersed herself in engraving, tempera, gold leafing, and various other forms of painting.

But her studies didn't end there. She studied lithography in France, went to Japan to learn sand and Sumi techniques, and taught herself how to create original paintings on varnished woodwork using materials like casein.

As a result, her body of work is diverse, bold, and evocative, which has won her acclaim from critics and the public alike. In 1998, Le Kinff was selected to be the official artist of the FIFA World Cup. For that distinction, the French government minted a commemorative coin featuring one of her paintings, an honor never before offered to a living French artist.

In 2008, Albert was asked to pen the introduction to a comprehensive catalogue raisonné of Le Kinff's graphic works. In his foreword, he recounted his memories of the first time he met Le Kinff. Here's what he wrote:

"I first met Linda Le Kinff in Paris while making my usual rounds there visiting the dealers and artists I worked with at that time. Arriving back at my hotel, I received a call from her. She introduced herself and asked me to view her work. Since I already knew of Linda and was aware that she was a highly respected artist, I agreed. The rest, as they say, is history.

"The following day, I was treated to a collection of paintings resembling nothing I had ever seen before. There were at least thirty pieces in all, each one painted on wood, and of various sizes and subjects. They glowed with a luminescent quality. Linda's

use of line and color was completely unique. They all displayed unusual varnished surfaces and interesting textures incorporating the grain of the wood. Her subjects were delightful as well, revealing a 'retro' quality while being at the same time completely distinctive and contemporary.

"Needless to say, I was very impressed, and I bought them all."

DUAIV

A hugely talented artist and musician, Duaiv has spent the past fifty years developing a reputation as one of the world's leading contemporary impressionists. He's been a successful artist for decades and, in 2009, Park West Gallery was fortunate to begin to exclusively represent Duaiv.

The partnership between Park West and Duaiv has brought the artist to a much broader global audience and, subsequently, the world has embraced his art.

Park West Gallery director Morris Shapiro has called Duaiv "one of the few true descendants of the School of Paris. He carries forward the mantle passed on to him by artists such as Gauguin, Bonnard, Chagall, Matisse, Dufy, and so many other great masters. However, Duaiv has forged his own unique stamp on that grand tradition, much to the delight of literally thousands of collectors all over the world."

Duaiv is inspired by impressionist artists like Claude Monet, Paul Cézanne, and Vincent van Gogh. He also draws inspiration from Dutch artists Johannes Vermeer and Frans Hals. Duaiv employs Van Gogh's dynamic brushstrokes, Vermeer's soft texture, and Monet's subtle palette of color to create a beautiful contemporary approach that is entirely his own.

Not long after Duaiv signed with Park West in 2009, Albert flew down to Miami to introduce the artist to a training class of young auctioneers. With Duaiv by his side, Albert told the group the story of their first meeting.

"I've known about his work for years," Albert said. "A few months ago, a meeting was arranged between the two of us. I went into his studio and he had about fifty paintings out. I rarely get that turned on by somebody that I haven't worked with before. I was… how do I put this… *fulfilled*.

"The best thing I can say is fulfilled because I saw this extraordinary range, this incredibly high level of skill and craft. I saw this fearlessness that I needed to see in an artist.

"I don't think he had anything left much on the wall when I left. I could have bought them all."

NANO LOPEZ

The majority of Park West artists work in two-dimensional art, but Colombian sculptor Nano Lopez brings something extraordinary (and extradimensional) to the Park West family.

Lopez once said that, "Everything is a miracle, everything is amazing. The richness of the world is my inspiration."

You can see that boundless optimism and imagination at work in every one of his sculptures. Lopez is world-famous for his iconic "Nanimals," his series of ingenious bronze works that bring to life a menagerie of playful animal characters.

Lopez carefully crafts his "Nanimals," imbuing them all with an astounding level of detail and personality. He creates a backstory for every animal, which develops and expands as he works on each one.

"Sometimes the piece might have the basic story from the beginning, but sometimes the story develops," Lopez says. "I always say I have communication with the piece."

To create his "Nanimals," he utilizes what's known as the "lost wax" process, an intricate procedure that sculptors have been using for thousands of years.

Lopez begins with early sketches and then sculpts with clay to bring his artistic vision to life. Next, he casts a silicone mold from his original clay sculpture and then pours wax into this mold to create a wax copy of the sculpture. It is then coated in multiple layers of liquid ceramic and placed in a kiln. The name "lost wax" is derived from how the wax melts out of the ceramic mold.

From there, Lopez forms a bronze version of his design by pouring molten bronze into the ceramic shell. Once cooled, this final sculpture is cleaned, polished, painted, and finished with a protective clear coating. Each sculpture takes several months to complete.

His fanciful bronze works invite his viewers to experience a range of emotions—from a joyful sense of wonder to deeply felt emotions relating to the human struggle.

After a special exhibition of his works at Park West's headquarters in 2015, Lopez remarked that displaying at Park West Gallery "is a pretty cool experience. I always say it completes the cycle of the artist doing the work in the studio. The personal interaction makes it, I think, very satisfying for both the artist and the collector."

MICHAEL CHEVAL

Looking at a Michael Cheval painting can be a mind-bending experience.

Once you stop admiring the Russian-born artist's technical skill, you find yourself drawn into the surreal landscapes and absurd narratives that have become his calling card. He's a master of the fantastical, and Park West collectors will often spend hours exploring and debating the symbolism in his works.

"I turn everything upside down and let people see common things in a new light from a different angle," Cheval says.

Inspired by the surrealist movement and the literary works of Lewis Carroll, Cheval turns reality and logic on its head in his

232

art. His realistic details, imaginative imagery, and enigmatic titles encourage viewers to imagine the stories behind his artwork and become "co-authors" of his paintings.

Cheval has said, "I want a dialogue to take place—the dialogue between the artist and the viewer and the dialogue between the viewer and a painting. Most importantly, the result of this dialogue should be that the viewer creates his own presentation, his own concept, based on the idea of my painting."

While working with Park West, Cheval has welcomed the use of new mediums, especially when it comes to capturing his imagery onto aluminum. He's said, "Since I work in the traditional technique of oil painting, creating three-dimensional space on the canvas, I was always interested in how my paintings look in different mediums.

"In the twenty-first century, it is very difficult to surprise someone. Technologies are developing so fast, people are always waiting for something new. I think these new materials from Park West allow me to increase the depth and appeal of my works."

DOMINIC PANGBORN

"Born in Korea, refined in America." That's how Dominic Pangborn describes his early path to becoming an artist.

Originally born in Korea, Pangborn was adopted by an American family in Michigan when he was ten years old. His passion for art helped him overcome language barriers in his new home, and his early artistic talent was undeniable.

Pangborn's artwork is often noted for its "evolutionary" tendencies because the artist firmly rejects adhering to just one static artistic format. In Pangborn's words, "I like to create things, invent things, and make things, so I can never be pigeonholed into just doing a painting."

After studying graphic design at the Chicago Academy for the Arts, Pangborn apprenticed with the Ed Jaster Studio before eventually moving to Detroit to open his own design firm—Pangborn Design.

Corporate clients adored his innovative, eye-catching designs, and Pangborn soon began marketing his own fashion accessories featuring his artwork.

As he opened new Pangborn Design branches in Chicago, New York, and Tokyo, Pangborn found himself interested in returning to his earlier passion for creating fine art.

"Fine art has always been a pleasure for me," Pangborn has said. "What was so beautiful in my situation was that, unlike many other artists, financially, I was very successful. So I didn't have to paint for the sake of making money. So I got to be creative. Create things the way I want to create. I didn't have to be at the mercy of an art gallery telling me what to paint.

"I think that the major difference between Park West and any other art gallery is that Park West doesn't ever tell their artists, 'Well, you're known for poppies so I don't want to see anything but poppies.'

"Park West brings art to the people, rather than just having a building and waiting for people to come by. They're really opening the minds of people who have never had art before."

PINO

Giuseppe Dangelico, better known as Pino, was one of the most celebrated figurative artists of the twentieth century. He's also one of those artists you would instantly recognize even if you didn't know his name.

That's because, over the course of his career, Pino hand-painted more than three thousand book covers, movie posters, and magazine illustrations, making him one of the highest-paid illustrators of his time.

His wraparound book cover paintings for best-selling authors like Danielle Steel revolutionized the publishing industry and put romance novels on the map during the 1980s and 1990s.

But Pino was so much more than an acclaimed illustrator-for-hire. From his humble beginnings in Italy to his inevitable international fame, Pino built an artistic career defined by his unforgettable depictions of love, family, and romance.

Pino's style, known as "Contemporary Realism," is characterized by its softly lit subjects, warm colors, and loose, flowing strokes. The expressions of his mysterious subjects—often women nurturing children or reclining older men—suggest they are in the midst of contemplating life's great mysteries.

Sadly, the artist passed away in 2010 at the age of seventy.

"I only got to meet Pino a few times," Albert recalls. "He was a wonderfully devoted man to his family. He knew he was dying for years, so he worked and worked and worked—just building up this legacy of art for the benefit of his family. His estate is managed by his son, Max Dangelico, who knows what he's doing. He does a really good job.

"Pino is one of those rare artists who just touches the public because they can recognize the quality of his paintings. The romance, the emotions. He knows how to paint, how to draw. He's a classic.

"Because we have such a great relationship with his estate, every Pino work we sell through Park West is an exclusive. That's how we operate. Every work is an exclusive, wonderful, signed Pino that's coming straight from his family."

ANATOLE KRASNYANSKY

The name "Anatole Krasnyansky" has come up before. He's the artist-architect who designed the facade of Park West's headquarters in Michigan.

There aren't many artists still working at his age—he was born in 1930—but Krasnyansky has never been a traditional artist.

From his earliest days as a youth in Kiev, Krasnyansky distinguished himself with his hard work and artistic excellence. His art centers on dualities: old and new, history and imagination, structure and surrealism.

Trained as an architect, Krasnyansky's art is fueled by the cultural dichotomy between his early life in the former Soviet Union and his later life in the United States.

Krasnyansky has two distinct styles. One is inspired by his work as an architect, which shows off the naturalistic beauty of Russian buildings. The other is more surreal and expressive, featuring masked figures that embody the artist's philosophy that "life is a masquerade." But, regardless of his subjects or aesthetic, Krasnyansky's artwork has always been marked by the artist's own profound humanity.

In his words, "My art is not about politics—it's about the human soul."

Remarkably, even at his advanced age, Krasnyansky is still experimenting and innovating with his art. While talking about Krasnyansky's legacy, Albert mentions that, "Anatole frequently worked in the same studio that Tarkay and Agam worked at in Israel. Recently, as though his age didn't even count, he's been talking about going back and utilizing his studio in Israel to try new things. I think he's going to find it's the most important thing he ever did in his life. It's what will keep him alive and young."

DAVID NAJAR

The sublime landscapes David Najar creates could be plucked straight from a fairy tale. It's fitting, then, that there is a moral to his serene images.

"Nature is you, it's me, it's us," Najar asserts. "My paintings are an invitation to sit down and breathe."

Najar is one of the top artists in the "Contemporary Expressionism" movement, emerging alongside other renowned artists in his native country of Israel. However, he doesn't paint scenes directly from nature.

Instead, Najar captures the essence of nature in his idyllic paintings by evoking the same wonder he experiences when viewing a sunset, watching a field of flowers, or listening to the waves against the shore. It's through these timeless scenes that Najar shares his message of tranquility.

Najar's instinctual style was enhanced by years of study and mentorship with prominent Israeli artists like Itzchak Tarkay. As previously mentioned, Najar was at Tarkay's bedside when the famed artist passed away in 2012 while visiting Park West.

Tarkay and Najar originally met in 2003, and a year later, Tarkay invited Najar to move his studio next to his own. "It was a very powerful and strong part of my life," Najar says of his time with Tarkay.

Najar also learned from Moshe Rosenthalis, a Lithuanian artist who was a soldier and illustrator during World War II before immigrating to Israel. Najar says Tarkay sent him to learn from Rosenthalis, telling him "go to the best teacher, I want his opinion about you."

Following his study with Rosenthalis—where Najar wholeheartedly received his teacher's approval—Najar has built an exciting career in the art world, inspiring numerous international exhibitions devoted to his work.

"I thank God that I do things that I love," he says. "I don't take it for granted."

SCOTT JACOBS

When introducing Scott Jacobs to an auctioneer class in 2007, Albert smiled, telling the crowd, "Scott is a seasoned artist. I mean, this guy can *paint*."

It's easy to see why Albert holds him in such high regard. Jacobs has become an international art superstar thanks to his sensational photorealistic artwork.

However, "photorealistic" might not be a superlative enough term to describe Jacobs's art. Park West's Morris Shapiro once commented that Jacobs's paintings are "so shockingly realistic that many viewers refuse to believe they're not photographs."

Working in art since he was nineteen years old, Jacobs became so popular for his precise photorealism that the Harley-Davidson Motor Company selected Jacobs as its first-ever officially licensed artist.

Soon after, Jacobs became a hugely recognizable figure in American fine art. He continues to provide art for Harley-Davidson, as well as a number of other global brands such as Ford, Chevrolet, Mattel, and the estates of both Marilyn Monroe and Elvis Presley.

Jacobs's artwork can be seen in galleries and museums across the United States—including his own gallery in Deadwood, South Dakota—and his imagery has appeared on merchandise, apparel, and a massive variety of products worldwide.

In 2011, *Art World News* profiled Jacobs and his relationship with Park West. In the article, Jacobs told the magazine that working with Park West has been "one of the best experiences… I can take [an artwork] and offer it to my clients and I may sell two, but Park West can sell eighteen because their clients are educated and they know how it was made. The education they give is *huge*."

IGOR MEDVEDEV

Igor Medvedev was born in the Soviet Union during the years leading up to World War II. With that in mind, perhaps it's not surprising that his artwork is so singularly focused on his quest for tranquility and peace.

He worked across many different mediums throughout his lifetime—painting, watercolor, sculpture, printmaking—but his masterful command of light and shadow was apparent in every single work he created.

Medvedev passed away in 2015, and Albert remembers him fondly. "Igor was an amazing painter and a great friend," Albert says. "His wife, Marina, was an extremely important element in his painting. She was a fantastic art dealer with a strong eye.

"When you look at a Medvedev painting, there are elements of surrealism, there are senses of color and shadow. I guess the best way to describe a Medvedev painting is carefully structured, carefully orchestrated visual poetry. It's poetry created by a consummate master who was concerned with each and every stroke of the brush."

Medvedev and Marina traveled extensively throughout the Mediterranean, searching for inspiration, but it was Greece in particular that spoke to the artist. He was fascinated by Cycladic architecture—its vaults and domes—intrigued by both its functionality and its aesthetic appeal. The architecture was favored in Greece for its ability to withstand earthquakes, but the round shapes also reminded Medvedev of the human form.

In his architectural works, Medvedev was typically drawn to the villages of Greece and Turkey, finding himself moved to capture their beauty as they deteriorated due to development and tourism. "Medvedev was on a mission," Albert states. "And his mission was to capture, spiritually and artistically, as much as he can of those ancient cities before they were destroyed.

"Medvedev was a complete person. What I mean by that is… his artwork *adds* to life, it fulfills, it tries to offer something a little different than anybody else. That's what all the great artists try to do. He was a very special man."

GUY HARVEY

People everywhere know the name "Guy Harvey."

While he first became famous for his paintings of ocean life and game fish, Harvey has since transformed his art into a hugely popular international brand, now encompassing clothing, merchandise, magazines, resorts, and even cruise ships. (His artwork proudly adorns the side of Norwegian *Escape*.)

However, what people might not know about Guy Harvey is how tirelessly he works to protect marine wildlife and advocate for ocean conservation causes. In 1999, he founded the Guy Harvey Research Institute to better "understand, conserve, and effectively manage the world's marine fishes and their ecosystem."

In 2008, he established the Guy Harvey Ocean Foundation to fund scientific research and host educational programs aimed at conserving the marine environment. Both of these organizations have had an enormously positive impact on the world's oceans and the astounding animal life Harvey so beautifully captures in his paintings.

Harvey signed on as a Park West artist in 2015, saying at the time, "this relationship will broaden the reach of my art for patrons and at the same time help spread the message for ocean conservation."

"Guy Harvey is a very neat guy," says Albert. "He got his Ph.D. and then realized he needed to be not *around* the oceans, but *in* the oceans. He's a diver, he's a marine biologist, he's a conservationist. And he's a superb artist."

At the end of a 2019 interview with Morris Shapiro, Harvey was quick to praise Park West, pointing out that "Park West has the

largest collection of my original artwork that I've ever put together, which is really great because you guys do an amazing job.

"You reach all the corners of the earth that we could never reach. Even with social media, it's quite different for people to go and look at art and touch it and feel it, feel the vibrancy and the quality... So I think your real strength is that you get it in front of so many eyeballs all around the world with such professionalism."

Harvey laughs. "I'm talking about Albert, of course. What a human being. I love him."

AUTUMN DE FOREST

Autumn de Forest has come a long way since selling her first painting at the age of six.

That's right—*the age of six.*

The term "art prodigy" gets thrown around a lot when discussing Autumn, and it's an apt phrase. Her art career has soared since her debut. Despite barely being old enough to enter elementary school, Autumn explored a diverse range of media and themes in her early art, sometimes using canvases larger than herself. When she was eight years old, she sold more than $100,000 in paintings at an auction in just sixteen minutes.

Shortly after that auction, Autumn was dubbed an "artistic genius" by the Discovery Channel and an "advanced child prodigy" by Dr. Joanne Ruthsatz, an authority on clinical studies of prodigies.

Now a teenager, Autumn already has a track record, having sold-out gallery shows, holding museum exhibitions at the Butler Institute of American Art and New York's LeRoy Neiman Art Center, and being named one of *Teen Vogue*'s "21 Under 21." She has even presented one of her paintings to Pope Francis after receiving the International Giuseppe Sciacca Award.

Park West first recognized her astonishing talent in 2013, when Autumn was only twelve years old.

Albert remembers Gene Luntz—long-time art manager for Peter Max, Bob Dylan, and John Cougar Mellencamp—calling him numerous times about Autumn and sending him images of her work. When Albert finally saw her work in person at an exhibition in Florida, he recalls feeling "overwhelmed. The works looked like those of a seasoned serious and incredibly talented painter. I phoned Gene and asked him if he could get together everything that hadn't been sold and get them to our facility in Florida."

From that group of paintings, Albert curated an exhibition of her work, framing them like he was preparing a major museum show. Then Autumn, along with her father, Doug, was invited to visit Park West in Michigan to see the work hung in the gallery. Albert says, "When they arrived, we were all overwhelmed. We started working exclusively and never looked back."

Here's what Albert wrote about her first visit to Park West:

"Autumn's work is her—fun, yet deep and serious, thoughtful, spirited, and intense. She's inspired by what she sees as much as she is by the methods and materials of painting. She has that seemingly endless energy that would be nice to bottle and sell alongside her work.

"Autumn's a great conversationalist and exceptionally intelligent. But once you see her work and talk to her about her art, it only takes a split-second to realize that her extraordinary gifts set her apart from all children her age—and the label 'prodigy' suits her very well.

"She is—quite remarkably at this age—extremely accomplished and deeply thoughtful. I'm looking forward to what's next for this talented young artist."

ALEXANDER CHEN

If you've ever seen a painting by Chinese artist Alexander Chen, you can understand why he describes his art as "hyper-realism."

Chen isn't just a realist painter. He specializes in bringing a level of staggering detail to every work of art he creates.

The artist immigrated to the United States in the 1980s and now he is widely known for his intricate depictions of the world's most celebrated cities. Each Chen cityscape is exquisitely detailed. For example, in his portraits of New York City, it's not uncommon for Chen to depict every building he captures with the exact number of windows it has in real life.

Chen only paints places he's visited personally, taking thousands of reference photos and meticulously planning his compositions.

Chen once said, "I want my paintings to become a dictionary of history," recording the world's iconic landmarks before they change over time.

"There are not a whole lot of people on the planet who can paint like Alexander Chen," Albert says.

"Here's a quick Alexander story that I love. I cruise from time to time, but I don't usually tell people I'm going to show up. I just show up. So, I go to Alaska and Alexander is on the cruise. But I hadn't let anyone know I was there yet.

"It's a really chilly day, so I'm wearing this big coat with a hood… I'm in very Alaskan garb. It's a misty day and I'm standing there, looking out at the water. Suddenly, I get this sense that's something's going on behind me. I hear *click, click, click.* And I turn around and there's Alexander with his camera.

"He's surprised and says, '*Oh!* I thought you were a Native Alaskan! I thought I had the real thing! But it's just *you!*' It was the most incredible thing. Everyone was off somewhere else, but he was still out there with his camera, looking to capture a perfect moment in time."

ANATOLY METLAN

There are few artists who can capture drama, tension, and passion on their canvases like Anatoly Metlan. This Israeli artist, born in Ukraine, has taken the world by storm with his romantic landscapes and dynamic portraits of dancers in motion.

Metlan's global travels serve as his inspiration, whether it's the beauty of Mediterranean landscapes or talented dancers from Spain. From a young age, Metlan was influenced by the Impressionists, often traveling to southern France to draw the same inspiration as artists like Gustav Klimt and Toulouse-Lautrec.

During a visit to Metlan's studio in Tel Aviv, Israel, Albert admired the painter's work, commenting that, "Metlan has two distinct styles, and the one that our clients have been really, really taken with are his portraits of women. They've been doing just sensationally. Whenever we get one of those paintings from Metlan, it sells rather quickly."

Metlan's striking portraits of women in the arts—both dancers and musicians—have become hugely popular with collectors. His dancers are never at rest, captured in brushstrokes that convey their fluid motions. Metlan first became interested in painting dancers after witnessing flamenco performances in Spain.

"I was captivated by the dramatic suspended tension and the emotional expressiveness of their dance moves," he told Albert.

Alternatively, Metlan prefers to show his female musicians in moments of repose. The women are delicately posed with their instruments as if they've just finished a performance or are just about to step onstage.

"Celebrating female beauty, both physical and spiritual, is an aim of any creative person," Metlan says. "It's not an easy task."

MARCUS GLENN

Detroit artist Marcus Glenn has been part of the Park West family of artists for over twenty years, a fact that speaks both to the quality of his art and to his long-lasting popularity in the contemporary art world.

Collectors love how Glenn draws from various artistic traditions—everything from cubism to illustration—and reinterprets them like a jazz ensemble, creating his own idiosyncratic visual lens. In 2005, his work was featured in his first museum exhibition held at the Charles H. Wright Museum of African American History in Detroit. The museum now hosts one of his paintings in their permanent collection.

Glenn fondly remembers how he and Albert first met. "I first got introduced to him at his Southfield gallery," Glenn recalls. "I used to visit the gallery often and one of his employees recommended me to him.

"Eventually, Albert asked me to show some of my work at a local event he was doing. He asked, 'Do you have ten to fifteen pieces ready to go?' And, of course, I said, 'Yes,' even though I didn't. I was working at Chrysler at the time, so I'd come home and just paint and paint and paint.

"After the event, Albert calls me and says, 'Do you want the good news or the bad news?' I said, 'Good news.' He tells me, 'The good news is that people liked your work and we can definitely sell it. The bad news is we don't have any left, we sold all ten of your paintings, and we need a lot more... *quick.*'"

Glenn laughs, "We could all use bad news like that."

Since that first event, Glenn's career as a professional artist has continued to grow at an astonishing speed. One particular highlight was when Glenn was selected as the official artist for the 56th Annual GRAMMY Awards in 2014.

Glenn was accompanied to the awards ceremony by two important guests—his lovely wife Yolanda and Albert.

SAM PARK

Korean artist Sam Park wants his artwork to inspire an emotional response. Specifically, he has one response in mind.

"When people look at my art, I want them to be happy," Park says.

Park is the innovator of "New Impressionism," his own brand of art influenced by French impressionism and neo-impressionism.

Park applies vibrant paint to his canvases using a palette knife. The artist's mastery of the palette knife allows him the freedom to add texture as well as fine details. Coupled with his infusion of emotion and atmosphere, Park's art transports its viewers to globetrotting locales without the need for travel.

Discussing how he originally started his relationship with Park West, Park says, "Albert and Marc came to my studio and they liked my work. Even if they didn't like it, what could I do? *(laughs)* But they liked it, so now we're working together.

"Park West collectors are so nice, so kind to me. They have a very good education in the arts. I'm not always good at speaking English, but they try to understand me and they make me feel so easy and comfortable. I really appreciate them."

BERNARD LOUEDIN

To Bernard Louedin—the renowned French painter, sculptor, and illustrator—imagination isn't just something to be valued in children. He's built a career around exploring the most fantastical depths of his imagination in his art.

Louedin's surreal imagery draws from influences as diverse as classical Greco-Roman art to twentieth-century artists like Yves Tanguy, Joseph Cornell, and Giorgio Morandi. His paintings

immediately pull the viewer in with their dreamlike color, delicate intricacy, and copious wonder.

In 2013, Albert and his son Marc visited Louedin's home and studio in the northwestern town of Trébeurden, along France's Pink Granite Coast. The artist's home was once the abode of a French naval officer who sailed around Cape Horn more than a dozen times. The property was not far from the coast, and even the smell of the fresh north Atlantic air is different. Located on a beautiful property are a number of charming outbuildings that function as studios and galleries. In short, the place is spectacular.

Louedin paints in a second-floor space with soft natural light and views of the grounds. The room under his studio is a lighted gallery in which he displays his paintings and sculptures.

Louedin's wife, Dominique de Serres, is also a renowned fiber artist, who interprets his works and the imagery of other artists into highly sought after limited-edition tapestries.

At the conclusion of their visit, Albert and Marc joined the artist on a trip to a local retrospective of Louedin's work titled "Art & Rencontre."

While touring the exhibition, Albert told a camera crew that was filming for local television, "This is a great way to look at Louedin's work because you can see his ever-improving mastery. You can see his later works developing even more in color and sensitivity. It's outstanding."

EMILE BELLET

Another French artist with a long history with Park West is Emile Bellet. Bellet is a self-taught artist who has aligned himself with the discipline of twentieth-century Fauves like Henri Matisse, Paul Cézanne, Raoul Dufy, and Maurice de Vlaminck, who painted in vivid nonauthentic colors. Bellet has mastered this discipline himself with an impasto knife, using his own brand of highly saturated colors to paint his elongated mannerist forms.

Bellet's paintings often center on a mysterious figure, representing a timeless and ageless femininity.

The whimsical movement derived from Bellet's impasto knife lends a sense of vision to his work. His settings are ethereal and transient, creating an atmosphere of intrigue.

In 2016, Bellet told Park West, "In my studio, in my artist studio, I work every day. It's every day because it's more than just painting, it's my passion. It's my second breath. There's physical breathing… and then there's painting."

A few years earlier, Bellet was interviewed by a translator about his working relationship with Park West. According to the translator, "Emile says he enjoys working with Park West Gallery because they have an approach… that's kind of unique in the way they interact with their artists. They brought him to meet with his collectors, and he really enjoyed that part. He's very happy with their relationship."

MARKO MAVROVICH

Marko Mavrovich, a California-born painter of Croatian descent, makes no apologies for the state of his studio. To him, the cluttered piles of paintbrushes, wood, and canvases are perfection.

"It's just one of those messy things where I know where everything is," Mavrovich says with a laugh.

When he was young, Mavrovich's family returned to their homeland of Croatia. It was here where the young artist fell in love with the sea.

Mavrovich learned to paint from his father, a master watercolorist. At the age of twenty-five, Mavrovich moved back to California to seek a maritime career but, ten years later, turned his artistic hobby into a career.

The artist quickly found success with his lush, colorful landscapes.

As he developed his skills further, Mavrovich aspired to create larger works but found his father's preferred medium couldn't accommodate his new direction. So, he switched to painting on canvas and soon discovered the advantages of acrylic paints.

His approach to art is singular but methodical. Mavrovich generally paints seascapes and boats using colors he believes are most representative of his beloved home state of California—shades of red and gold. His warm colors evoke an atmosphere of serenity, optimism, and peace.

However, Mavrovich continues to explore different imagery and inspirations in his art—an evolving process largely made possible by his work with Park West.

In a 2014 interview with Albert, Mavrovich said, "I've moved on with subject matters since being with Park West. We were taking a cruise to Bermuda, which started in New York City. I walked around Times Square at night. I loved it. I really discovered New York that time… I fell in love with the city, even though I'm not a city boy.

"I started painting images of the city, then moved onto painting on different surfaces—like metals—that came from what inspires me about the city. And I'm happy that Park West allows me to go off in that direction, which is unusual for a gallery. Most galleries say, 'Paint what you came in with.' Not Park West, which as an artist has been very important for me."

ANDREW BONE

Andrew Bone takes a simple yet profound approach to his painting in Africa: "Don't paint it unless you've studied it, been chased by it, or done something to save it."

Born in Zimbabwe, Bone grew up fascinated by Africa's diverse animal life. While working as a guide in the Zambezi Valley, he began photographing and sketching the flora and fauna around him. People quickly took notice of his incredibly realistic depictions

THE BOOK OF ALBERT

of African wildlife and, within a few short years, Bone was an internationally renowned artist and conservationist.

His exacting process begins with his camera. Bone packs his Land Rover for the day, goes into the wild, and photographs everything. He claims that he's as excited to study a dung beetle as he is a charging herd of elephants.

Once Bone is back in his studio, he analyzes his copious photographs but finds his true inspiration on the easel. Although he does not attempt to copy his photos precisely, he still strives to maintain the acute anatomy of each species, allowing him to paint each animal exactly as it appears in the wild.

"I see myself as a recorder of nature," Bone says. "What sets me apart from other artists that paint African wildlife is the fact that I've witnessed it myself."

Bone regularly appears at Park West events all over the globe. In 2012, while visiting Park West's headquarters, he sat down with a film crew to discuss his time with Park West.

Bone said, "I'd been doing the marketing stuff myself for many years in the States and it's really hard work doing all the bookings, the framing, the shipping, the crating, and I didn't think that there was any other way of doing it. I went through a number of agents, a number of galleries, and eventually, Park West got in touch with me and said, 'You are a terrific wildlife artist and we would really like to work with you.'

"That was years ago and it just took all the pressure off my work, took the pressure off my family, and I think, since then, my art has grown. And, through my association with Park West, my art is better represented. My clientele list has just grown astronomically and we've recently had a show here, where I just couldn't believe that I saw so many familiar faces from other shows, people who are following my art and have been invited by Park West. We sold a lot of paintings to a lot of really satisfied customers.

"That's the history of Park West. It's the enthusiasm and the integrity that they have behind their huge organization, which doesn't have to penny-pinch. I'm always amazed at the lengths and the costs that Park West goes into selling art to their clients. It's of the highest standard. If someone wants to start collecting from Park West, they're treated like royalty and I'm always amazed by that because you don't get that anywhere else. I've found that the clientele is loyal, the artists are loyal, the people who work for Park West are totally loyal. It's like a huge family that relies on each other and actually they roll with the punches together as well, which I think is great."

FANCH LEDAN

Albert describes French artist Francois "Fanch" Ledan as "a very strong painter and a very strong personality. He's got lots of energy."

Ledan has been working with Park West since the early 1980s. Having left behind a potential career in business to pursue his passion for painting, Ledan quickly gained the attention of galleries in the United States and France.

He just as quickly learned that his detail-oriented approach to painting wasn't going to keep up with the demand for his art. "I'm not a prolific artist," Fanch says with a laugh.

How did this self-taught artist go from creating a few paintings at local exhibitions to having his art internationally collected? Like many great artists before him, he discovered something that would allow him to create multiple, high-quality works: printmaking.

He began experimenting with lithography and serigraphy, quickly becoming a master of both mediums.

Ledan's passion for printmaking also fueled his love of travel, leading the artist to hold exhibitions and create new editions in different countries, including France, Japan, Australia, and the United States. Based on his travels, he began painting what he called

"Interiorscapes" in 1984 and, only a year later, started creating graphic editions of them. They were an instant hit with collectors, who loved Ledan's idyllic depictions of well-known locales.

"Fanch evolved from a naive style," Albert says. "He eventually began to be inspired by a sense of fantasy and fancy from the different places he'd been, and he's a very charming man. He's really into life, he's into living, he's into enjoying himself. He loves people.

"His Interiorscapes… they're not realism, they're Fanch interpretations. They're contemporary chic with a sense of humor and a great deal of creativity and imagination."

KEVIN MILES AND WENDY SCHAEFER-MILES

They say opposites attract, but occasionally shared interests can create a relationship unlike any other. That's the case with Kevin Miles and Wendy Schaefer-Miles, a couple that's been creating beautiful artwork together for decades.

In 1987, Wendy and Kevin were married, and they soon began painting together. While having two artists simultaneously working on a single painting may seem problematic, it was a natural fit for this artistic pair.

"We each get to do the part we like in painting," says Wendy. "The way we would naturally paint and be creative—what fills our soul up—is what comes out on the canvas. I like starting paintings and Kevin likes finishing them."

Kevin compares their special method of painting together to other arts like dance or music.

"Those kinds of art forms are generally done by more than one person," Kevin says. "It's odd to me that people hold visual artists to be this singular thing."

Despite coming from different backgrounds, the artists have very similar tastes. They're both influenced by the French impressionists

and the Dutch baroque age, and they're both inspired by positivity and serenity, rather than personal hardships or isolation. In a world of stress and anxiety, Schaefer-Miles paintings revolve around the more tranquil aspects of life.

The couple's neo-impressionistic oil paintings—featuring their colorful and serene depictions of American landscapes—have garnered worldwide recognition and acclaim.

Kevin and Wendy began working with Park West in 1999. In a 2016 video, Kevin praised Park West for having "a way of introducing the artist to the public and making it entertaining, exciting, and accessible. Also, the camaraderie between the artists that you get really inspires you."

ALFRED GOCKEL

Alfred "Alex" Gockel has one of the best rags-to-riches stories in the art world.

He went from working in Germany's coal mines in his youth to becoming one of the most prolific distributors of modern art lithographs and serigraphs in the world.

Since 1983, more than one hundred million examples of his imagery have been sold internationally, including serigraphs and other limited-edition graphic works.

There is an enormous body of Gockel collectors all over the world—even sports superstar Michael Jordan has his own Gockel collection.

In a 2019 interview with Morris Shapiro, Gockel told the story of how he first came to work with Park West. The year was 1993 and Gockel had purchased a booth to showcase his work at Artexpo in New York, which was the biggest international trade show for the art industry at the time. However, because of the truck bombing at New York's World Trade Center earlier that year, Artexpo's attendance was less than spectacular.

As Gockel sat at his empty booth, he said to himself, "'Okay. Here's the thing… nobody is showing up and I'm losing $60,000. So, this is the first day of the rest of my life. I have to do something.'

"I got a cab and drove to Michaels, and bought an easel, a canvas, brushes, and paint. I took everything back to my booth and just started to paint live because that's my job. That's what I do every day. The guy at the booth next to me bought some champagne and cookies and we had a party. Because of that, almost everyone in the hall passed through my booth over the next three days.

"A representative from Park West was there and said, 'You're a cool guy. In your left hand, you have a glass of champagne, and in your right hand, you have a brush, and you're painting live in front of people.' She asked if I could paint in front of more people…

"A few months later, I got a contract with Park West. I flew down to Miami to take part in one of their auctioneer conferences and they asked me, 'Tomorrow, we're hosting a cruise line party at the American Airlines Arena, would you paint at it?'

"I didn't have any clue what the arena was. The next day, I'm standing behind a black curtain, hearing a lot of noise on the other side. The curtain opens and there are fourteen thousand people sitting there from all the cruise lines. That was the first time I ever had an audience like that. So I turned around and I started to paint. It was wonderful. That's how it all began."

PETER NIXON

Peter Nixon's art is luminous—beautifully blending the contemporary with the classical. His personalized "sketch style" utilizes a series of working alterations left visible in each image, creating a dynamic sense of movement across his compositions.

Nixon is known as a "painter's painter." A student of art history, Nixon spends as much time visiting museums as he does painting. He was inspired to become an artist at the age of nine

after seeing Leonardo da Vinci's masterpieces on display at London's Royal Academy.

Every artwork he creates is a joyous homage to the best of art history. Nixon is strongly influenced by artists ranging from Raphael to Rembrandt, and expertly creates tributes to their masterworks within his art.

In a 2012 video, Nixon talked about his time working with Park West, arguing that the company's "ethos—born of long experience—is, like all brilliant ideas, a simple one. They bring the artist and the collector together over a length of time in order for them to be able to get comfortable with each other and to discuss the artwork together.

"What this means is that the artist is able to give the collector insights into the artwork and enhance the experience of enjoying the painting. The artist benefits from the collectors' enthusiasm, which can fuel future paintings. Only a gallery with experience and a keen organizational ability can make this happen successfully.

"The Park West experience is unique. I've been an artist for a long time, and I've never come across an organization before that has such love and enthusiasm for its subject."

RON AGAM

Ron Agam is an innovator in the world of lenticular art. It may come as a surprise, then, that he never attended art school or had any formal training. Instead, Ron was able to, quite literally, "learn at the feet of the master."

Ron is the son of the world-renowned Yaacov Agam—one of Albert's earliest artists, the unquestioned pioneer of the modern kinetic art movement, and a man Ron calls "the best teacher people could dream of."

Ron didn't originally set out to become a fine artist. Instead, for years, he worked as an internationally acclaimed photographer.

However, as time passed, Ron became increasingly interested in the creative possibilities of kinetic art, particularly its ability to "create imaginary worlds."

This led to the development of his breathtaking new "3-DK" (three-dimensional kinetic) designs—artwork that both embodies the best of his father's legacy and offers an electrifying artistic perspective that's undeniably his own.

According to Albert, "What's interesting about Ron's work is that he presents us with another look at the fifth dimension through the eyes of the son of the great Yaacov Agam. Those are eyes that have studied Agam for more than fifty years, and that study has resulted in some wonderful new creations."

SIMON BULL

Simon Bull has painted everything from delicate floral scenes to portraits of professional boxers. In the art community, he's become particularly known for his profound understanding of color, which he uses to impart his appreciation for life onto every one of his canvases.

Bull often finds inspiration from nature and, earlier in his career, had a more realistic approach that centered around landscapes and flora. Over time, Bull transitioned more to abstraction, focusing on his vibrant colors and gestural brushstrokes.

Bull told the *Oakland Press* in 2016 that, "Like a chef, I felt the need to spice things up—to go brighter and bolder. In the mid-90s, my style changed. I moved from a traditional approach to a more flamboyant one, and have been enjoying my time with color ever since."

While introducing Bull at a Park West event in 2007, Marc Scaglione said, "There is a great range to his work. No matter what the style is that he does, it's always Simon doing Simon's work. He's not doing something that's derivative of something else. It's truly his work. I think that's very important."

Throughout it all, Bull's overall artistic mission has never changed: "If I can touch a life... if through my painting I can show something previously unseen, if I can reveal something old in a new way, if I can enrich a soul on its journey into the eternal, then my painting—my living—has not been in vain."

JIM WARREN

Jim Warren has always been inspired by music. In 2017, he told Park West, "One of the first things I ever wanted to do as an artist was, back in high school, I really wanted to paint album covers because, in the 1960s, album cover art was a big thing. So, some of the best artists or best art I've ever seen came from album covers."

A self-taught artist, Warren first began painting with oil on canvas as a teenager. While he was definitely influenced by his favorite album art, Warren also quickly became enamored with iconic artists like Salvador Dalí and Norman Rockwell.

While developing his own personal artistic spin, Warren felt a strong connection to Dalí's penchant for free expression and Rockwell's unparalleled ability to tell a story through his art. Warren's first paintings had a strong surrealistic feel, capturing fantastic landscapes and imagery, though his artwork continued to evolve in theme and perspective throughout the next two decades.

During the 1970s and '80s, he was commissioned to paint hundreds of magazine illustrations, movie posters, and book covers. Warren also fulfilled his childhood dream by becoming a popular album cover artist for a variety of musicians ranging from Prince to Alice Cooper. Perhaps the pinnacle of his album career, however, happened relatively early on when his original cover art for Bob Seger's "Against the Wind" album won a GRAMMY award in 1981.

Since then, Warren has continued to experiment with realism, abstraction, and other artistic forms. But music still plays a huge role in his artwork.

"Probably the biggest inspiration for my art comes from music," Warren says. "Because, in my youth, I was more into the music of the Beatles, the Beach Boys, anything like that, than art itself. I was inspired by that lifestyle. I just conveyed it with a paintbrush and a canvas."

LEBADANG

In April 2011, Albert traveled to Paris to visit an old friend—the Vietnamese artist Lebadang.

As Albert strolled around Lebadang's studio, a smile never left his face. "What a treasure trove here," Albert said. "I'm in heaven."

Lebadang was born in 1921 in Bich-La-Dong, a village along the Huong River in the Quang-Tri Province of Hue, Vietnam. As an artist, he expressed himself through a variety of media, including painting, watercolor, sculpture, jewelry, and graphic works. He loved merging together various mediums, creating highly textured works of art.

"I don't just use brushes to paint on canvas. Instead, I mix pasteboard, paint, and limestone and spread my works on large pieces of thick burlap," Lebadang once said. "So, my paintings usually look rough and irregular in shape, but I think they are strange in a beautiful way. It is often a marriage between different kinds of art, painting, and sculpture, as well as installation art and architecture."

In 1939, he moved to Paris, where he studied at the École des Beaux-Arts in Toulouse for six years. After his first one-man show in 1950, Lebadang found his first marketable success by painting images of cats on hundreds of ceramic plates, which are still in high demand today.

Following a popular exhibition at the Cincinnati Art Museum in the 1960s, Lebadang's profile in the art world began to rise, though the artist, unfazed by his new popularity, continued to experiment.

He created large-scale abstract oil paintings with vivid blues and glowing puddles of orange and red, which entranced Parisian tourists and collectors alike. He also utilized pure foam board as a medium, using a knife to cut out intricate designs. He placed the finished foam between two pieces of glass, creating a frame that allows light to shine through, producing ornate patterns and effects.

After dozens of high-profile exhibitions, Lebadang began sending money back to Vietnam to rebuild his home village, which was devastated during the Vietnam War. He was eventually honored by the Vietnamese government, who created the Lebadang museum and charitable foundation, which was Vietnam's first arts foundation. Splitting his time between Vietnam and Paris, the artist claimed that one day he would retire.

But, nevertheless, his creativity continued to flourish.

Lebadang and Albert worked together for over thirty years until the artist passed away on March 8, 2015 at the age of ninety-four.

MAYA GREEN

Maya Green believes her artistic talent is a gift, and her mission is to share that gift with as many people as she can.

She finds inspiration in her adopted hometown of Tiberias, Israel. (She was originally raised in Ukraine.)

Albert understands why she finds her surroundings so inspiring. During a visit to her studio, he commented, "The color and the light in Tiberias is absolutely amazing. There's nothing like it anyplace else in the world. Every place is different, of course, but it's a special kind of different in the Holy Land."

Green aptly uses a palette knife to achieve her signature impasto technique. By applying oil paints in bold colors, she transforms her sketches of northern Israel into colorful, textured landscapes. In her paintings, she emphasizes composition and contrast, especially between light and shadow and the subtleties of the four seasons.

Israel's Galilee region is full of blooming flowers in the springtime, which inspires Green to frequently paint radiant flowers and floral bouquets. Through her mastery of composition, Green imbues her painted flowers with the beauty and tranquility of the blossoms surrounding her home.

"I seek to complement the moments I encounter," Green says. "I attempt to break down life to its visual essentials: light, dark, balance, movement, tone. In doing so, perhaps I can reveal a new perspective."

As he toured her studio, Albert told Green, "Your pictures are very joyful. They're colorful, they're bright, they make you feel happy."

MICHAEL MILKIN

Michael Milkin has a similar origin story to Maya Green.

He was also born in Ukraine, where he was a student of architecture at the Kharkiv National University of Architecture and Civil Engineering. After graduating with a Master of Architecture, Milkin worked professionally as an architect but continued to teach, paint, and display his personal art in public art exhibitions.

Like Green, Milkin eventually immigrated to Israel, where he was profoundly moved by the country's lush natural beauty. He met with local artists and began experimenting with new materials to express his singular artistic vision.

Milkin concentrates on still lifes and landscapes, painting with acrylics and oils with thick, dramatic brushwork and brilliant colors.

Milkin has always found inspiration from the artwork of Impressionists like Édouard Manet, Claude Monet, and Paul Cézanne. Milkin particularly enjoys capturing the beauty of birch trees across various seasons and, like the impressionists, places a strong emphasis on light.

While touring Milkin's studio, Albert said, "Our Israeli artists, they are all being well received in the international world. People look at them and the light and the energy of their country comes out magnificently. With Milkin, ten years of university teaching and painting, and then another fifteen years of work have gotten him where he is today."

JEAN-CLAUDE PICOT

A long-time member of the Park West family, artist Jean-Claude Picot was greatly influenced by the works of the Fauvist masters—Vlaminck, Derain, and Matisse—whose exuberant canvases drew great attention for their revolutionary use of color, texture, and abstract form.

These artists inspired Picot for decades, and you can find many similar characteristics in his work.

Picot developed his own singular style that recalled a postimpressionist application of color combined with the expressive qualities of his own distinct form and line. His compositions were often calming, possessing his personal joie de vivre. His landscapes and cityscapes possess a sense of animation, romance, and vitality that is instantly identifiable.

"Jean-Claude's studio was an enclosed terraced room at the back of his home," Albert recalls. "Three walls were glass, and the translucent ceiling let in a soft light. The landscape was green with some pops of color. It was such a quiet and peaceful environment.

"When we talk about our artists becoming family, it's not just a marketing catchphrase. For many, their studios are in or connected to their homes. We're invited into their lives—their dwelling places—where they live and create. That is an honor and a privilege that we don't take for granted. Yes, we do business together, but we also build relationships that we personally cherish." A kind and talented friend to Park West, Picot passed away in August 2020.

VICTOR SPAHN

Often referred to as the "Painter of Movement," Victor is inspired by sports, dancers, and other energetic activities. He paints championship sailboat races, rugby matches, prima ballerinas, and tennis stars—each with the same individual grace and emphasis on motion.

Albert notes that "Victor has the same exuberance as his art—he's full of energy, motion, and color. Victor's work has often been featured on posters, books, and program covers for important events in France.

"Victor is an ambassador for Lexus and has provided the automaker with numerous original pieces of art. The French government honored Victor recently with a building bearing his name in a housing community named for artists. The Victor Spahn building sits alongside the Claude Monet building.

"Victor is a joy-filled, upbeat person and is easy to be around. That joy is visually reflected in his work."

SLAVA BRODINSKY

"Brodinsky... he's just fantastic with landscapes," says Albert. When collectors encounter a Slava Brodinsky painting, they find it hard to disagree with Albert's assessment.

Brodinsky was born in the former Soviet Union and, following his military service, he studied art at the fine art academy in his home country of Birobidzhan. He became a well-known artist in the U.S.S.R, but, in 1991, he moved his family to Israel.

The perspective in many of Brodinsky's paintings comes from a high point of reference, giving an expansive view of rolling fields sprawling before the viewer. He uses sweeping brushstrokes in crisscrossing patterns, defining areas of color with thick black outlines.

Initially inspired by his travels through the Galilee region of northern Israel, Brodinsky continued his travels to Europe

capturing the rolling hills of Tuscany, Umbria, and the South of France. During this time he developed a unique technique, which involves brushing a mixture of sand, paint, and plaster onto his canvases adding a new element of texture and depth to his work.

These changes of scenery inspired an artistic awakening in Brodinsky. Now, enriched by the amazing changes of landscape in Israel, he is overwhelmed by the sunshine and color of Israel's countryside everyday as he paints. His style has evolved and matured in a positive and powerful sense. No matter what tones he uses, his paintings have an extraordinary sense of light and shadow. He has become a modern master of the landscape.

FEW ARTISTS AMONG MANY

If that seems like a long list of artists, keep in mind that these are only select highlights from Park West's history. They make up a representative sample, for sure, but are certainly not even close to being every Park West artist. Every name that is listed here (and below) is someone that Albert and Park West have personally worked with, and they have the utmost respect and love for all of them. All of them are deserving of their own book. Albert appreciatively says, "We thank them all for being part of the Park West family."

In addition to the artists mentioned in the previous chapters, there are also names like New York's Robert Kipniss, with his numerous museum shows... or France's François Boucheix, who has his own art museum in France... or certainly Alexandra Nechita, an early child prodigy who earned the nickname the "Petite Picasso" for her wonderful cubist paintings.

There are the deceased art world legends like LeRoy Neiman, who Albert would visit in his New York studio... Charles Bragg, who would have dinner with Marc in his home... or Harold Altman, who would host Albert in Paris at his studio (that formerly belonged to Alexander Calder), which was only a five-minute walk from Agam's studio (which used to belong to Paul Gauguin).

There is the deceased French impressionist master Claude Cambour, who lived in Claude Monet's former home in Giverney, where Albert would visit him regularly.

The list of artists goes on and on. There are memorable artists like Craig Tracy, Yuval Wolfson, Leslie Lew, Fabian Perez, Gregory Arth, Pat McManus, Orlando Quevedo, Alexander Grinshpun, Eric Dowdle, Viktor Shvaiko, and Charles Fazzino.

There is Alex Pauker, Donna Sharam, Hua Chen, Graeme Stevenson, Shan-Merry, Steve Bloom, Bill Mack, Holland Berkley, Daniele Cambier, Pierre Eugene Cambier, David Schluss, Felix Mas, Alex Perez, Rachael Robb, Robert Pope, Andre Bardet, Frank Gallo, Gradiega Kieff, Heddy Kun, Roy Fairchild, Lucelle Raad, Littorio Del Signore, and Sonia Del Signore.

And there are the emerging figures—the next generation of artists, like Allison Lefcort, Michael Romero, Clare Sykes, and so many more.

Albert is quick to point out, "as you can appreciate, over our fifty years, it would become impossible to mention every artist we've ever represented and sold and, for those artists we didn't list, we send our fond regards to both the artist and their collectors."

As Albert said at the beginning of this section: *"Everything we do begins and ends with the artist."*

Artists are the lifeblood of Park West. As Park West moves into its next half century, its family of artists will continue to grow and evolve, just like the company.

That family will continue to be made up of old favorites and new talents, undisputed masters and unexpected surprises. This is because Albert works tirelessly every day to bring his clients the best of the best.

THE EVOLVING ROSTER OF PARK WEST ARTISTS

Albert loves talking about the artists—you can see the palpable excitement on his face when the topic is raised—but his mood gets more contemplative when asked about the artists who are no longer with Park West.

"That's such a challenge to talk about," Albert says. "The reasons why we feature some artists over others. Our company has a life cycle and sometimes we lose certain artists during that cycle. And it can happen for a variety of reasons."

Remember Lazlo Dus, the artist featured at the inaugural opening of Park West's new headquarters? "He just stopped working," Albert shrugs. "He didn't have the desire to create at that level anymore."

But it's not always the artist's choice to leave and, in fact, it's not always Albert's personal choice either.

"I do this for the love of doing it. I'd love to represent every artist whose art speaks to me. But, if I want to keep the business thriving, that won't work. We're in the business of selling art. We can't pretend we're not a business."

He mentions the names of a few former artists who worked with Park West for years—Charles and Jana Lee, Mark Kanovich, Jay Lefkowitz, Tomasz Rut, Zamy Steynovitz—and speaks about them with almost fatherly affection.

"All of them worked incredibly hard. They put so much love and effort into their work. And the fact that we exhibited and sold their work is a testament to their talent.

"So, if you've been one of our artists, in any capacity, that's an enormous validation. We don't sell art that we don't believe in. We only carry incredible art and we only carry incredible artists.

"Sometimes, I think of our gallery like a big movie theater. You have limited space, limited screens. If a movie is popular enough, it can keep running on one of your screens for a long time. But most theaters change their movies—based on demand, based on public taste, based on the desire to show something new—and they have to find a way to do that with their finite number of screens. You wouldn't expect a cineplex to keep showing the same movie for fifty years. We're like that too."

"Fortunately, Park West has a fantastic archiving program, so, if you have a favorite artist whom we're no longer featuring, we often still have collections of their works available.

"But, at the end of the day, we're putting on a show for our collectors and there's only so much space in the show. More than anything, our primary goal is making sure that we're bringing the world the most exciting art possible."

CHAPTER 24

Animation Art—
Park West's Animation Collection

One of Albert's points of pride is the sheer variety of art that Park West makes available to its clients—paintings of all kinds, graphic works, sculpture, ceramics, Japanese woodcuts, and countless other mediums.

Park West also has an incredible collection of perhaps one of the most popular (and frequently overlooked) art forms in modern history… animation art.

Animated films and TV shows are *hugely* popular worldwide. Yet, even though those movies and cartoons hold a special place in the heart of the public, critics often overlook the sheer artistry and technical skill that goes into creating them.

Those animated classics aren't just artistic masterpieces when they're viewed as a whole. Each animated film is made up of thousands of individual masterpieces, flicking by at twenty-four frames a second.

Animation is a particular passion for Park West President Marc Scaglione, who has led Park West's efforts to develop a one-of-a-kind animation collection.

Initially, Park West offered unique production cels from Warner Brothers, Disney, and Hanna-Barbera. The company later expanded its offerings to include art from most major animation studios and original works by renowned animation artists. These works can take a variety of forms, including production cels, sericels, and hand-painted limited-edition cels.

"In terms of our own inventory, it's staggering," says Marc. "I don't know of another entity that exists, gallery or otherwise, that has the animation collection that we have, not only in the number of works, but in the quantity of imagery and the breadth of our collection."

Along with jazz and the Broadway musical, animation is one of the few *uniquely* American art forms. Animation is also a truly artist-driven medium. Some of the greatest artists of the past century have either worked in animation or been inspired by animation art.

Here's one example…

WHEN SALVADOR DALÍ MET WALT DISNEY

Salvador Dalí is best remembered as one of the innovators of surrealism, but, when he first came to the United States, he found a kindred spirit in one of the founding fathers of animation.

In 1937, in a letter to André Breton, author of the surrealist manifesto, Dalí wrote, "I have come to Hollywood and am in contact with three great American Surrealists—the Marx Brothers, Cecil B. DeMille, and Walt Disney."

If anyone doubts the validity of animation as an art form, keep in mind that Dalí—one of the most famous fine artists of the twentieth century—considered Disney's animation to be on par with his own artistic endeavors.

Disney admired Dalí's work too and, after meeting at a Hollywood party in 1944, they decided to collaborate on a project. Their partnership resulted in the short animated film "Destino."

Dalí, along with noted animator John Hench, created twenty-two paintings and over 135 storyboards, drawings, and sketches for the project, calling it "a magical exposition on the problem of life in the labyrinth of time."

The project was unfortunately halted before production was finished and languished in the Disney vaults for decades until Roy E. Disney, Walt's nephew, finally resumed production in 1999. "Destino" was officially released in 2003, garnering numerous awards and an Academy Award nomination.

The art Dalí created for "Destino" is breathtaking. When the original art from the project is not on display at galleries or museums, it's returned to Walt Disney Studio's Animation Research Library (ARL), the largest repository of artwork currently in existence, comprised of over sixty-five million original works.

To date, Park West is one of the few art dealers on Earth authorized to sell etchings, lithographs, and serigraphs from Dalí's original art for "Destino"—both his preproduction art and artwork capturing quintessential moments from the film.

"Destino" is just one of Park West's many animation collections, but it stands as an outstanding example of the importance and vitality of animation in the world of art.

In the words of Marc Scaglione, "Animation is a critical component of entertainment, culture, and even commerce. There really is nothing else like it on Earth. The characters, films, and art will live forever."

CHAPTER 25

A Different Kind of Artist— Muhammad Ali

Albert loves sports. On any given Sunday in the fall or winter, it's not unusual to find Albert sitting in front of the massive screens in Park West's merchandising department—where he usually analyzes inventories and spreadsheets—cheering on his favorite football teams.

In addition to football, boxing was also a big presence in Albert's childhood. His father and uncles were huge fight fans and, to this day, Albert and Mitsie still enjoy watching "the noble art" together.

Much like in art, the sports world is dominated by personalities. There are individuals who become so iconic that they help define their sport for generations to come.

One of those rare individuals was the late great Muhammad Ali. The outspoken boxer from Louisville captured the world's attention and its heart. He is probably the most-loved athlete of the twentieth century and one of the most iconic people of any profession.

Ali was massive, bigger than life. He embodied his most famous quote: "Float like a butterfly, sting like a bee." Back when Albert watched Ali take the ring for his career-defining fights in the 1960s and '70s, the young art dealer would have been delighted to know that, one day, he and Ali would become friends.

When Park West started to work with Ali in 2004, the company had only dealt in a very limited amount of sports memorabilia in the past—mostly signed photos and objects from athletes like Pete Rose or Joe Namath—but working with a legend like Ali was an opportunity that Albert couldn't pass up.

"Muhammad elevated boxing into something totally else, something transcendent," Albert says. "Art was this guy's life. He really lived an *artistic* life."

The initial collaboration between Park West and Ali was fostered by Harlan Warner, Ali's longtime friend and associate. Albert's plans were ambitious. He wanted to build a new Park West collection based on art, photography, and memorabilia that could tell a visual story of Ali's amazing life. As an added bonus, all of those artifacts would be signed by Ali's own hand.

The most important part was that Albert—with his engineering background—had been experimenting with the effect of optics on the amazing hand-signed photos of Ali. After experimenting for more than three years, Park West trademarked the Optigraph™, where each of these photos is preserved forever and given a three-dimensional quality unlike any seen before.

The photographs are beautiful and moving. There are over a hundred and fifty of them and they catch all the facets of Ali's adult life: the man, the star, the legend, the hero, the underdog, the pretty boy.

Despite his diagnosis with Parkinson's syndrome in 1984, Ali was still fiercely intelligent and independent when he and Albert began working together in 2004. While his health would take a turn for the worse in the years preceding his death in 2016, Ali kicked off his Park West partnership with his trademark gusto.

In fact, when Ali signed on with Park West, they commemorated the new contract with a photo session of Albert and Ali sparring together. "I got to box with Muhammad Ali," Albert recalls warmly. "That's something I'll never forget."

Between 2004 and 2009, Ali worked with Albert to build Park West's collection and schedule signing sessions. At each event, Ali's mischievous spirit was always on display.

"One time, Muhammad was doing a signing in Disney World and I snuck up on him," Albert remembers. "He jumped up and said, 'You're crazy!' I said, 'I'm crazy?' He shot back, 'No, I'm crazy!' We went back and forth. Finally, Muhammad let me own it. He said, 'That's right, you're crazier than me.'"

John Karay, Park West's executive vice president of operations, has similar memories. "I took my son Michael to meet Muhammad at one of the signing sessions," says Karay. "Ali's manager asked the Champ to stand for a photo, which made me cringe because Muhammad was clearly tired. We didn't want to bother him." But when Karay saw the final photo, a big smile crept across his face. There was the famous Muhammad Ali standing behind his son… and playfully holding up two fingers to give Michael bunny ears in the picture.

The Park West Ali collection includes not only signed photographs but also an impressive assemblage of signed memorabilia as well—including boxing gloves, trunks, robes, magazines, tickets, envelopes, three original torches from the 1996 Olympics, and even two sets of boxing gloves used by actor Will Smith while filming the movie Ali.

Looking to expand the collection further, Park West and Ali decided to commission original artwork based on a series of thirty iconic photographs from Ali's career. Ali would personally select two artists for the project and he would sign the final art alongside the artists.

Ali ended up choosing Peter Max and Simon Bull.

Bull says that being selected to work with Ali was the "thrill of a lifetime."

According to Bull, "Not many people are aware that Ali was also an artist. As part of his therapy, he would sit in his recliner and do intricate designs with colored markers all day long. We sat together

sketching once when I was at his home in Scottsdale. He with his markers and me with my pencil, working on his portrait. It was an intimate moment—the world's greatest sporting figure sitting quietly in his favorite chair while I carefully observed and sketched."

These paintings—along with other items from the Park West collection—have been featured on display at the Muhammad Ali Center in Louisville, Kentucky. First opened in 2005, the center has a mission to "preserve and share the legacy and ideals of Muhammad Ali, to promote respect, hope, and understanding, and to inspire adults and children everywhere to be as great as they can be."

In August 2008, the first works from Park West's collection were installed at the Ali Center. To commemorate the event, Albert and Mitsie brought a group of young adults supported by their charitable Park West Foundation to visit the Ali Center and meet Muhammad and his wife Lonnie.

Over the years, friendship and respect had developed between Lonnie and Muhammad and Mitsie and Albert. The two couples quickly discovered a shared passion—helping young people to make their way in the world. Lonnie and Muhammad had been tireless advocates for human rights—particularly, children's rights, and Mitsie and Albert, through their Park West Foundation, had been assisting young men and women aging out of the foster care system in Michigan.

The meeting in Louisville was a once-in-a-lifetime experience for the Foundation youth. They spent time with Ali, touring the Ali Center and learning firsthand the importance of Ali's six core principles for a fulfilling life—respect, confidence, conviction, dedication, giving, and spirituality.

While there, the young visitors—along with their mentors, Saba Gebrai, director of the Park West Foundation, and Weusi Olusola, founder of Pioneers for Peace in Detroit—presented Ali with an award expressing their gratitude and admiration for his

accomplishments, his strength of character, and his commitment to his enduring beliefs.

Despite the effects of his Parkinson's syndrome, Ali still greeted the Foundation guests warmly, even taking a baby from one of the women and cradling the child on his lap.

During the event, Albert spoke warmly about the boxing legend to the assembled visitors. "As human beings, we all have an obligation—to each other and to ourselves—to love our fellow man," Albert told the crowd. "Muhammad Ali is a perfect representative of that."

"There is probably not a public figure on planet Earth who is more loved than Muhammad Ali. Who has had more courage to go up against adversity than Muhammad Ali? Who invented and created his own name because he was not satisfied with the name that had been put upon him? He is an inspiration to the world, and our young friends will be returning home with stories and motivation that will last a lifetime."

Everyone at Park West was devastated when Ali passed away in 2016, but Albert still finds inspiration and optimism from the man's legacy. For over a decade now, he has been working on a book highlighting Park West's Ali collection. "I really want it to be perfect," Albert says. "I want people to feel like they've had the opportunity to tour the Ali Center every time they open it."

Ali has also found a way to become a part of Albert's daily life.

Visitors to Albert and Mitsie's home in Michigan will notice a small framed drawing on one wall, a sketch deceptively simple in its form and design.

It was a drawing that Ali created for Albert the first time they met. Evidently, the idea of an athlete creating a work of art for an art dealer appealed to Ali's playful nature.

In a home filled with works by master artists, this drawing stands apart as one of Albert's most treasured possessions—perhaps one of the few artworks that Albert would never consider parting with.

Remembering his friend, Albert says, "Muhammad was a gentle man, a kind man, a funny man, a direct man. He was a giant."

Park West Gives Back

The Creation of the Park West Museum

By the beginning of the twenty-first century—three decades after its founding—Park West Gallery was well on its way to becoming the largest art dealer in the world. It was now holding hundreds of auctions at exotic locations around the globe every year, its cruise ship galleries were flourishing, and its footprint was growing at its brick-and-mortar locations in Michigan and Florida.

The business was thriving, but Albert continued to look for new ways to give back to the art-loving public that had embraced the gallery over the years.

"Being a part of a community is very important to me," Albert says. "From the start, we've stressed the importance of education and bringing art to the people where they live. I want to make it easy for people to experience art in their everyday lives."

In the early days of Park West, that outreach took the form of the company donating art to various charities or loaning certain works to international museums. As Park West expanded globally, the company began offering free works of art to people who attended their events, making it possible for almost anyone to begin their own art collection.

However, Albert came up with an idea to take his art outreach to the next level—he was going to start his own museum.

It would be a museum dedicated to sharing art from past and present masters. A museum inspired by Albert's lifetime of collecting art. A museum that would be open seven days a week and always be free to the public.

That museum is known today as the Park West Museum.

It is hard to determine what one might call the official opening date of the museum. Albert had always displayed masterworks from his personal collection alongside the works for sale in his early gallery spaces. And, by Albert's own design, the galleries themselves always shared aesthetic similarities to visiting a museum.

In those early interviews with Paul W. Smith, Albert proudly commented, "We believe that we've developed an art of collecting. It begins the moment you enter the gallery with your pleasant surprise at finding yourself in a place that's kind of like a museum."

As time went on and Albert began expanding Park West's headquarters to take over all sixty-three thousand square feet of their campus in Southfield, more and more space became devoted to Park West's "museum collection."

The devoted museum space soon became a sought-after travel destination for many Park West clients and a popular location for Detroit-area locals to spend an enjoyable afternoon browsing art.

When one visits the Park West Museum in Michigan, the entire upper level is devoted to the museum's salons. There are administrative offices near the back of the complex, though Albert is increasingly moving Park West staff to a nearby office building— with new custom-designed workspaces—in order to make more room for the museum.

On the lower level of the museum, you will find art for sale in the galleries. Albert playfully refers to this as "the world's most expensive museum gift shop." It is not unusual in any given day to have some amazing works priced at over $100,000 sold in this "gift shop."

Many of the works featured at Park West Museum come from Albert's personal collection or the company's archives. Other works are multiples or duplicates of other masterworks that Park West has acquired over the years. Often, when Albert is working with his merchandising team to obtain significant new art collections, he

puts certain works aside for the museum. These works will never be sold and will instead join the permanent museum collection.

"I am very fortunate that I started out just trying to have a really nice art gallery and one day it became a museum," Albert says humbly.

TOURING THE MUSEUM

Today, Park West Museum welcomes patrons seven days a week at its location in Southfield, Michigan.

It attracts a diverse range of visitors—ranging from longtime Park West collectors to field trips from local elementary schools. Recently, as a handful of art lovers strolled around during their lunch hour, the children from Maybury Elementary in Detroit followed one of Park West's museum docents on a guided tour.

Upon entering the museum, guests are greeted by one of Park West's digital art walls, a bank of linked smart computer screens that allows them to interact with Park West's catalog of art or watch videos of its artists in action. The technical marvel can actually track people walking by, turning their movement into swirls of virtual art. (This feature is particularly popular with the visiting schoolchildren.)

The first gallery is devoted to original paintings by Peter Max. The collection is the same one that appeared in Max's "50 Years of Cosmic Dreaming" exhibition at the Tampa Museum of Art in 2016—an exhibition that was organized by Albert and Park West. Many of the Park West Museum collections come from major exhibitions that have been featured in museums around the world.

After spending some time with many of Max's most iconic characters—like his "Umbrella Man" or "Statue of Liberty"—guests encounter a multiroom gallery devoted to Pablo Picasso.

These rooms collect an impressive selection of original linocuts, etchings, and lithographs from different eras of Picasso's career.

Remember Picasso's Vollard Suite and how Albert pursued it so diligently in Paris with Henri Petiet? You can see select etchings from Albert's complete set of the Vollard Suite at Park West Museum.

There are other works from Picasso in the museum collection—including original lithographs from the artist's early Barcelona Suite—but the real attraction is the ceramics.

PICASSO CERAMICS

Over the past fifty years, Albert has assembled the largest collection of Picasso's ceramic works that are currently on display anywhere on the planet. The museum's Picasso ceramics collection is constantly changing because the entire collection—comprised of more than one thousand works representing over two hundred different images—is too large to properly display. But, at any given time, a collection of over one hundred different ceramics is on display at the museum.

While Picasso is known for many different achievements, perhaps his greatest contribution to modern culture was his unwavering eagerness to experiment.

But how did such a revered painter first become interested in ceramics, a medium so very different than the one for which he was most famous?

In July 1946, Picasso visited Vallauris, France, for the first time in the company of Françoise Gilot, the painter, art critic, and bestselling author who was Picasso's lover at the time. The small coastal town was known for its pottery, and Picasso quickly became enamored with the ceramics being produced by the Atelier Madoura, owned by Suzanne and Georges Ramié.

Picasso had experimented with pottery in the past—firing a few vases with sculptors like Paco Durrio and Jean van Dongen—but witnessing the work at Madoura lit a fire in the artist. He partnered

with the Ramiés to begin producing his own ceramics, ushering in one of the most prolific periods of his career

There were several reasons for Picasso's fascination with ceramics. He was intrigued at how quickly and inexpensively he could create these new ceramic works. In an era when only the wealthy could afford his paintings and sculptures, Picasso welcomed the notion that his pottery and ceramics could potentially be owned by everyday people in the postwar world.

It's incredibly similar to Albert's own philosophy about art, perhaps explaining why he might find himself so drawn to these works.

Picasso also loved the idea of his ceramic works being both aesthetically pleasing and functional—he frequently gifted his pots, plates, pitchers, and bowls to friends and family members. More than anything, however, Picasso was eager to test the creative potential of this new medium.

"My father never considered himself a potter," said the artist's son, Claude Picasso. "But he approached the medium of clay as he would any other in order to find out what the materials and techniques of the potter's studio could offer him and what he could discover by probing their inherent qualities or possibilities."

According to Claude, his father's involvement with his ceramics was "so profound and personal… that, until recently, it went unrecognized as a significant part of his oeuvre."

In recent years, art lovers have truly begun to appreciate the significance of this phase of Picasso's career. The ceramics he produced while working at Madoura have been acquired by some of the most notable collectors of modern art, and now appear in museums around the globe. And you can see the largest collection of them in the world—for free—every day at Park West Museum.

CONTINUING THE TOUR

After leaving the Picasso galleries, visitors to the museum find themselves transitioned away from the twentieth century and experiencing classical works from some of Europe's greatest masters. The museum's Albrecht Dürer collection, for example, showcases the legendary printmaker's virtuosity and creative range with woodcuts and engravings created during the sixteenth century. His mastery in printmaking remains unrivaled over five hundred years later.

In the Rembrandt gallery, a selection of etchings from the seventeenth-century Dutch master feature some of his best-known subjects, including religious scenes, landscapes, and even self-portraits.

Visitors to the Park West Museum will be pleasantly surprised by the substantial collection of medieval illuminated manuscripts on display, some of which can be traced back to ownership by Catherine de Medici, a descendant of the Medici family, eventual Queen of France, and patron of the arts.

Moving forward in history, patrons can next appreciate the museum's constantly evolving Pierre-Auguste Renoir collection, which includes original oil paintings, drawings, and rare graphic works by the impressionist master. One highlight is a rare landscape painted in 1917, just two years before Renoir's passing.

In the same gallery, guests will encounter the stirring etchings of Spain's Francisco Goya. The museum currently features selections from three of Goya's most noteworthy etching series—"Los Disparates," "Los Caprichos," and "The Disasters of War." Goya's acclaimed fantasy-filled compositions inspired the likes of Salvador Dalí over a century later.

Nearby, one can browse through original pencil sketches taken from the personal sketchbooks of the notorious French master Toulouse-Lautrec. These early illustrations shed light on the career

of the noted postimpressionist who later transformed the medium of lithography and inspired generations of artists to come.

As one moves deeper into the museum at this point, one begins encountering collections from some of the master artists that Albert collected in Europe during his first years as a dealer.

There's a gallery devoted to Marc Chagall, focusing on his brilliant crucifixion paintings and his captivating lithographs for the ancient myth of "Daphnis and Chloe." (Many consider these works to be Chagall's printmaking masterpiece.)

The next salon is all about Joan Miró. The Spanish surrealist is fantastically represented at Park West Museum—some of the graphic works on display are over six feet tall.

Many of the museum's Miró works come from what's known as "The Broder Collection." Louis Broder was a French publisher who helped bring to life many incredibly important graphic works of the twentieth century. He collaborated with artists such as Picasso, Georges Braque, and André Masson, among others, to create striking visual interpretations of literature, poetry, and music.

In 1956, Broder began a partnership with Joan Miró and Atelier Mourlot, a world-famous French lithographic studio. Much of Miró's Broder Collection emulates the whimsical, dreamlike images associated with surrealist artwork, while also juxtaposing concise, recognizable shapes with abstract figures. The results are inviting, colorful scenes of organized chaos that allow the viewer to freely interpret Miró's intention with each shape and line.

This emphasis on color carries through to the next gallery—one of the museum's largest—which presents the work of Albert's old friend, Yaacov Agam.

The museum's Agam collection ranges from 1953 to current, literally encompassing Agam's entire career as a professional artist.

Patrons can experience Agam's preliminary studies for some of his monumental sculptural installations, works from the artist's retrospective at the Guggenheim, original paintings, monotypes, and even early examples of his trademark "Agamographs." These are all anchored by a grand-scale kinetic sculpture in the center of the gallery.

The final gallery is inspired by another major museum exhibition— "Salvador Dalí's Stairway to Heaven."

"Stairway to Heaven" was conceived by Albert and noted curator David S. Rubin. It collects complete portfolios of Dalí's illustrations for two of his most ambitious publishing projects—his artwork for unforgettable editions of Dante's "The Divine Comedy" and Comte de Lautréamont's "Les Chants de Maldoror."

Each project comes from a different era in Dalí's life. He completed his 43 illustrations for "Les Chants de Maldoror" in the 1930s when Dalí was proudly identifying himself as a surrealist. At the time, the subject matter was ideal for Dalí. The poetic, nonlinear novel was all about a man who had denounced God, humanity, and conventional morality.

When Dalí illustrated Dante Alighieri's "The Divine Comedy" two decades later, he was a much different man. By the 1950s, he had renounced surrealism and embraced Catholicism. Thus, Dante's famous story of a man traversing the levels of Christianity's Hell, Purgatory, and Paradise held special meaning for Dalí.

Dalí's attention to detail was meticulous in his "Divine Comedy" suite—he created over one hundred watercolor studies, worked tirelessly with the publisher, and even personally approved more than three thousand woodblocks used for the engravings. The final result was a series of one hundred breathtaking engravings bringing the classic poem to life.

The "Stairway to Heaven" exhibition began a tour of the United States in 2018 at Louisiana's Hilliard University Art Museum where it broke attendance records. It will complete its multicity tour in 2021.

Park West Museum currently features a complete set of Dalí's "Divine Comedy" engravings. It's a memorable way to end a tour of the museum—experiencing in vivid, vibrant detail how one of the most famous artists of all time imagined Heaven, Hell, and everywhere in-between.

While walking around the museum with Albert, it's apparent that he's justifiably proud of his collections… and that he's not fully satisfied yet. He still has grand plans for the facility's evolution. He wants to expand, add more galleries, and enlarge the artist offerings. He wants to encourage more community involvement. He wants the museum to continue growing as a free resource for local schools and students.

He's even kickstarted a new program to create satellite locations of the museum aboard cruise ships. At the moment, there are five Museum@Sea installations on major ships—museum-quality collections by artists like Picasso, Dalí, Max, and Agam that are available for passengers to browse twenty-four hours a day.

Albert frequently tells his staff that his mission is to "reach people with pictures," noting that "society can't live without pictures." The ever-growing scope of Park West Museum is just another way that he's bringing that mission to life.

During one visit to the museum, Albert admits, "I don't know where I'm going with this, but I like it. I like not knowing where I'm going. It makes it more exciting."

CHAPTER 27

Building New Futures with the Park West Foundation

Throughout this book, there have been mentions of the Park West Foundation. It's often described as Park West's "charitable arm," an admittedly apt description that somehow doesn't really tell the full story.

Many corporations make donations to various causes, but charity has been a Park West priority since its beginnings in 1969.

It started with Albert running auctions for charitable causes, donating his time and artwork to help worthwhile organizations raise funds. As Park West grew, so did their philanthropic efforts.

It's just part of the company's culture now. Throughout a normal business year, Park West donates hundreds of artworks to charity drives and fund-raisers, supports youth sports, funds events, and offers financial support to a vast array of causes.

Those efforts can range from the Park West Miami staff holding a donation drive to assist victims of Hurricane Dorian to Albert donating $50,000 to the Guy Harvey Ocean Foundation.

Albert believes in giving back to the global community and, through leading by example, has set the tone for how Park West as a company embraces those who need help.

However, something happened in 2005 that completely changed how Albert approached charity.

That year, Albert and his wife Mitsie hosted a benefit for the Lutheran Child and Family Services of Michigan at Park West's headquarters.

After the event, a young girl in Michigan's foster care system—who had been assisted by Lutheran Family Services—drew a picture for Albert and Mitsie to thank them for organizing the fund-raiser.

The Scagliones were profoundly touched by the gesture, and it inspired them to learn more about the state's foster care system. What they discovered shocked them. The system was struggling to provide even the most basic support to Michigan's poor, disadvantaged children, and the couple decided right there and then that they had to help find a solution.

"The Lord really opened our eyes to a problem," Albert says. "What was the problem? Kids who were aging out of the foster care system. They're mostly women, they're mostly from minority populations they're mostly between fourteen and twenty-one years old. For various reasons, they either are too old for the system or they get booted out of it. Maybe they can't get along with the foster parents or they're trying to make a life for themselves when the system won't support them anymore. They often don't even have a roof over their heads. Those kids weren't being helped, so we set out to help them."

Albert knew that just a few financial donations wouldn't make the kind of difference he wanted to make. So, in 2006, he and Mitsie created the Park West Foundation, a nonprofit organization focused on providing a range of services for Michigan children and families in foster care, especially those aging out of the system.

Their goal is to empower "aged-out" young adults by building a sustainable and supportive community that can exist for them as a resource for the rest of their lives.

"We're there to help these kids ease the difficult transition from state-sponsored care to a fulfilling life," Albert says.

Their aid can take many different forms. The Park West Foundation provides advocacy and legal assistance, access to health care, crisis intervention, vocational training, and a whole lot more.

"Often these kids are already on a good path," Albert notes. "They have a good trajectory, a good head on their shoulders. There are just obstacles in front of them. We help these kids finish high school or get into college. We teach them how they can get grants or government support. We teach them how to get a job. We teach them how to navigate the various social systems in front of them. We teach them a lot.

"How do we do that? The most important method is mentoring. We act as mentors and we help them build bonds and cement the relationships with the positive, encouraging people in their lives."

The first year the Foundation was established, they provided personal assistance to six foster care kids. Over a decade later, that number has grown to over one thousand.

The support the Foundation provides ranges from the personal to the universal. They've done everything from helping a young woman get an outfit for her first job interview to sponsoring a statewide "Jump Shot Your Future" college fair that helps kids from the foster care system get into college. (Stressing the importance of this work, Albert points to a study from the National Foster Youth Institute that says kids who have aged out of foster care have a less than 3 percent chance of earning a college degree.)

Every year, the Foundation holds a special graduation ceremony for all of their kids who have graduated from high school that year. Mitsie affectionately calls the students their "Blue Babies."

In 2019, the ceremony took place at Detroit's Charles H. Wright Museum of African American History. The thirteen graduating students spent months writing and rehearsing their own "Come Up Graduation Production," in which they dramatized their own struggles with surviving in the foster care system. Following their performance, there wasn't a dry eye in the house.

At the graduation ceremony, Albert told a reporter, "If a young person has the determination and the desire and the drive to get help, they get involved with the Park West Foundation and they will get that help. Whether it's medical help, whether it's economic help, help about learning, help about relationship building. We provide the help they need."

It was a proud night for everyone involved, as anyone could see from the smile on Albert's face every time he handed a student their diploma.

PARK WEST FOUNDATION GOES GLOBAL

With the tangible success of their early charitable efforts fresh in their minds, Albert and Mitsie began seeking out other ways to expand the scope of the Park West Foundation.

The perfect opportunity presented itself in 2015 when the United Kingdom's Prince Charles formed Prince's Trust International, a global organization aimed at addressing youth unemployment throughout the world.

Prince's Trust International is an extension of the Prince's Trust organization. Since its founding in 1976, the Prince's Trust has given more than a million young people in the United Kingdom practical and financial support to lead stable lives while developing self-esteem and work skills.

Early on, Prince Charles asked Park West artist (and noted philanthropist) Romero Britto to sit on the Prince's Trust International's board of directors.

When Britto learned that the Prince's Trust was seeking out founding patrons for its initial launch, he knew just who to call.

"Knowing how caring and supportive Albert is of charities, and the fact of his global business, I thought it was a perfect match between Park West and the Prince's Trust International," Britto said.

Albert agreed with Britto's assessment and quickly pledged his support to the organization.

As a result, the Park West Foundation pledged one million pounds to the Prince's Trust International, becoming the trust's sixth founding patron and its only patron from the United States.

When the donation was announced, Albert told the press, "We are extremely proud to expand the work of the Park West Foundation as the first founding sponsor from the United States. It is gratifying to join Prince Charles as he brings forty years of his acclaimed work from the

United Kingdom to the international stage in support of helping disadvantaged youth around the world improve their lives."

One benefit of the new partnership was that Albert and Mitsie were invited to meet Prince Charles at Buckingham Palace for the fortieth anniversary of the founding of the Prince's Trust. "That was a special afternoon," Albert remembers. "Prince Charles was very interested in the work we were doing with disadvantaged youths in Detroit. He was engaged and a good listener as well."

Since then, Jonathan Townsend, the CEO of Prince's Trust, has twice visited the Park West Foundation and Museum in Southfield.

MAKING A DIFFERENCE IN THE FACE OF TRAGEDY

A more recent effort by the Park West Foundation was inspired by something a little more personal (and more painful) for Albert and the Park West family.

In 2019, Mary Max, the wife of Peter Max, tragically took her own life at the age of fifty-two. Immediately, Albert knew he had to do something.

He worked with the Foundation to create the Park West/Peter Max Charity Fund, which donated $250,000 to the American Foundation for Suicide Prevention.

"Peter and I have been friends for over forty-five years," Albert says. "I was there when Mary and Peter got married. Her death was just heartbreaking for our entire community."

Representatives from Park West Gallery and the Park West Foundation present their donation check to Robert Gebbia, CEO of the American Foundation for Suicide Prevention. (Pictured left to right: Michael Karay, Park West's Associate Vice President of Merchandising; Albert Scaglione, Park West's Founder and CEO; Mitsie Scaglione, Park West's Corporate Secretary; Diane Pandolfi, Director of the Park West Foundation; Marc Scaglione, President of Park West Gallery; and Robert Gebbia.)

Park West raised the first $150,000 of the $250,000 donation by contributing 20 percent of the proceeds from every sale of an original Peter Max serigraph titled "Angel with Heart" to the charity fund.

The remaining $100,000 came from a matching contribution by the Park West Foundation.

"This tragedy has opened my eyes to the insidious impact of suicide in our culture," Albert admits soberly. "After research of all of the organizations in America that we could find, we settled on the

American Foundation for Suicide Prevention as the organization to receive our $250,000 gift."

The American Foundation for Suicide Prevention is a nonprofit organization that raises awareness, funds scientific research, and provides resources and aid to those affected by suicide.

"They are making a difference and hopefully this gift will help them to make even more of a difference."

Albert has plans to continue the work of the Park West/Peter Max Charity Fund. Next year, Park West will be contributing 20 percent of the sale proceeds from another Max serigraph—titled "Two Sages Looking at Sunrise"—to suicide prevention causes. The serigraph is a fitting way to represent the close friendship between two art icons, which has spanned over five decades.

"If you know Peter, you know that Mary was the inspiration for many of his paintings," Albert says. "I hope that, through this fund and through our charity efforts, Mary can continue to act as an inspiration to those who need help around the globe."

PROVIDING ACCESS TO ART

While the Foundation is primarily concerned with helping disadvantaged children around the globe, as the organization expanded, Albert began noticing other causes that could use some assistance.

One that immediately rose to the top was something near and dear to Albert's heart—arts education.

"You might be able to tell that I'm a big believer in museums," Albert beams. "But museums and art institutions are suffering right now. There is a lot less public money available for the arts these days. That's a shame because the public *needs* access to the arts. Now more than ever. So, we decided to step up."

That's why, in 2016, the Park West Foundation started its "Museum Spotlight" program, an endeavor that funds and supports museums in bringing world-class art exhibitions to their patrons.

Albert had helped organize museum exhibitions for decades—ranging from Peter Max at the Hermitage to Yaacov Agam at the Guggenheim—but the "Museum Spotlight" initiative would now be able to operate on a much larger scale.

With the past in mind, perhaps it's appropriate that the Foundation's first exhibition was "The Magic of Yaacov Agam" at the Museum of Geometric & MADI Art, in Dallas, Texas.

Since 2015, the organization of these museum exhibitions fell under the direction of Diane Pandolfi, Director of the Park West Foundation. Through her tireless efforts and with the help of Carole Sorell, truly, one of the world's experts at organizing museum exhibitions, many different kinds of exhibitions have followed over the years.

Autumn de Forest at the Butler Institute of American Art... Peter Max at the Tampa Museum of Art... Anatole Krasnyansky at Los Angeles's Museum of Tolerance... Lebo at the Bradbury Art Museum... the aforementioned "Salvador Dalí's Stairway to Heaven"...

The Foundation quickly found a fantastic partner with the prestigious Monthaven Arts & Cultural Center in Nashville, where they have been able to sponsor free-to-the-public exhibitions from artists like Autumn de Forest, Alexandre Renoir, Tim Yanke, Picasso, Marcel Mouly, and Michael Godard.

In 2017, the Park West Foundation provided funding for one of their most ambitious projects to date—"Monet: Framing Life"—a special exhibition at the world-renowned Detroit Institute of Arts.

It was the first-ever exhibition by famed impressionist Claude Monet in the DIA's history. "Framing Life" presented a fascinating look at Monet's early impressionist works all centered around one pivotal painting, "Rounded Flower Bed (Corbeille de fleurs)."

At the time, Albert told ABC News, "Claude Monet's impact on the art world cannot be overstated, and 'Rounded Flower Bed' is one of the jewels of the DIA's collection. 'Framing Life' beautifully illustrates how such a painting could help give birth to the impressionists and influence generations of artists to come."

It's telling that, in 2016, when *Forbes Magazine* did a feature on "corporate philanthropy," they chose to highlight Albert.

In a section titled "Get Out in the Community," the article shined a spotlight on how the Park West Foundation is "entirely based on the idea of interacting with people."

The piece captures Albert's enthusiasm and dedication. "The idea that I could have this life where I still have the opportunity to work with the artists, educate, bring art to the public. I'm thrilled about that."

The reporter follows Albert's quote by saying, "While [Albert's] motives are certainly in the right place, it is also clear that the success of his foundation is partly due to the personal commitment he makes to the community."

That personal commitment to giving back—on a micro and macro level—has been at the core of Park West from the very beginning.

CHAPTER 28

Entering the Next Fifty Years

2019 was a year of celebration for Albert—a year that commemorated the fiftieth anniversary of Park West Gallery.

With his first half-century of art dealing behind him, Albert was focused on kicking off another fifty years of growth and innovation in 2020.

It's one of his defining characteristics. Albert is a man who is extremely knowledgeable of the past, but the thing that excites him the most is the potential of what comes *next*.

Whenever anyone asks him about the future of Park West, he has an endless supply of things he wants to talk about.

He will tell you about new office spaces and the full-scale gym he's built for his employees in Michigan—"I want them to be excited about coming to work"—or his ambitious plans for upcoming museum exhibitions.

Albert will tell you about a resort he's constructing in Puerto Vallarta called "Marcela," which is Spanish for "The Silver River." (From the look of the photos, it's gorgeous.) Albert will tell you about the new collections, new technology, and new infrastructure he's building to make Park West the most technologically advanced art dealer in the world.

Albert will tell you all about his plans for adding new artists to the Park West family. At the moment, Albert is energized by the potential of a burgeoning partnership with artist Mark Kostabi— one of the charismatic stars of New York's East Village art scene in the 1980s and a contemporary of giants like Andy Warhol and Jean-Michel Basquiat.

Albert has followed Kostabi's enigmatic, surrealistic art for decades, but only recently, the two men were brought together by Gene Luntz, Albert's old friend. Luntz, you may remember, is the famed art manager who has represented everyone from Peter Max to Bob Dylan.

"I've always been a Kostabi fan. And when the opportunity presented itself for us to meet, we hit it off," Albert says. "Kostabi really took Warhol's Factory model and ran with it. He's a fantastic studio artist and he only works with the best.

"Here's a story I love about Kostabi. During the '80s, Kostabi got the bright idea that Russia needed his art. But he sees his art as this intellectual concept and he works with other artists to bring it to life. So he sought out artists to work with inside Russia and he would only work with an artist if they could flawlessly paint a Caravaggio. He somehow put together a team of those artists, he intellectually engaged them, he worked with them via fax, and he collaborated with them to create his paintings behind the Iron Curtain.

"And, because all the art was created inside Russia, he got a show at the Hermitage, which completely sold out. He was the only contemporary Western artist ever to have a modern art show in Russia before the fall of the Soviet Union."

To celebrate that achievement—and their new partnership—Albert is in the early stages of organizing an exhibition at Russia's State Museum in St. Petersburg, which he calls "From the Masters to Kostabi."

"We'll have Kostabi surrounded by paintings, drawings, and even large handmade posters by Renoir, Lautrec, Chagall, Picasso, and Mouly. I suspect, following that exhibition, Kostabi will be back at the Hermitage not long after that," Albert adds.

New artists, new countries, new museums… all challenges that others would find daunting, but, for Albert, they represent just another day in the office.

However, as Park West began its fifty-first year, the one thing that Albert could not anticipate was how dramatically the world would change in 2020.

He would be confronted with an existential threat to his entire business—a global threat that would force him to not only reconsider how Park West sold art but also what lengths he would go to maintain his hard-won relationships with his collectors.

CHAPTER 29

Re-inventing Park West
for a New World

If 2019 was a year of celebration for Albert, 2020 would be a year of testing his mettle.

The year started like any other, opening with the Park West Foundation sponsoring a fantastic museum exhibition by Michael Godard at Tennessee's Monthaven Arts Center. The company's domestic and international sales were already trending above 2019's targets. In January, it looked just like another strong year for Park West.

That was, of course, before the coronavirus.

In late 2019, there was growing international concern about a new coronavirus that had been identified in Wuhan, China. The disease caused by the virus, termed COVID-19, was similar to pneumonia or SARS in its symptoms, primarily attacking the respiratory system.

In January 2020, the World Health Organization (WHO) was reporting growing outbreaks of COVID-19 across Asia, and there was evidence that the virus was beginning to spread internationally. Yet, by January 28, the WHO still not consider COVID-19 a "Public Health Emergency of International Concern."

That all changed after a month. By the first week of March, COVID-19 could be found on every continent except Antarctica, and tens of thousands of people had already died from the disease.

Governments were closing their borders, Italy declared a countrywide lockdown, and, by March 11, the WHO had begun calling COVID-19 a "global pandemic."

Yet even before COVID-19 received its pandemic label, even as the world was growing more and more concerned about the spreading disease, Park West was still thriving.

"Our clients were concerned and so were we," Albert remembers, "But, in those first ten weeks of 2020, even though people were becoming apprehensive about travel, we were continuing to do amazing business. In February, cruise ships were running at fifty to seventy percent capacity and yet Park West was performing at 89, 92, and 115% of our budget targets for the year! We were practically doubling our revenue per passenger from the previous year.

"Our clients were really upbeat and supportive during those last weeks before the virus went global. Both our cruise and land events were doing incredibly well. We did our final land event in February in Atlanta. Tim Yanke gets up in front of the crowd and his first three works bring in $100,000. We sold seven figures in art that weekend, even with everyone's anxieties about traveling. That's such a testament to how passionately our clients feel about our art."

Albert had initially planned to weather out the storm, encouraged by the sales numbers at Park West's land and sea events, even with their diminished capacities. But, unfortunately, March 2020 had a few more challenges in store for Park West.

Things got serious on Wednesday, March 11, when, while Albert was dealing with the impact of COVID-19, something entirely unexpected happened.

Park West was attacked.

"I got a call at 11:30 pm that Wednesday night," Albert says. "They tell me that cyber-terrorists, sponsored by the North Korean government, had attacked our network systems. They call it a 'ransomware' attack. They hack in, cripple your systems, encrypt files, and then attempt to charge you an *enormous* ransom to unlock your data. I can tell you they asked us for a huge *number*!"

Albert is still working with the authorities to determine the exact origins of the attack, but, at the time, he had to act fast.

Albert says with a smile, "What the terrorists didn't know was that our encryption was so good, they couldn't access anything important. They locked up some of our systems, which slowed things down, but there was an impenetrable wall around all of our client data and all of our other important financial information too. They couldn't get into *any* of that. They hit us Wednesday night and, by Friday afternoon, our customer service was back up and running."

However, Albert was faced with a decision—would he attempt to deal with the hackers to restore Park West's systems sooner than later or would he reject them completely and potentially face dealing with crippled systems for weeks or possibly months ahead?

"For our customers' benefit, we had to get this thing over with rapidly," Albert admits solemnly. So, he made a few calls and, with the help of a U.S. expert and a Russian intermediary, he was able to negotiate an end to the state-sponsored hacking, paying the North Koreans only a small fraction of what they had asked for in ransom.

"That was Wednesday," Albert recalls. "Two days later, on the very appropriate date of Friday the thirteenth, the other shoe drops."

On Friday, March 13, Norwegian Cruise Line announced that it was ceasing operations for 30 days to help combat the spread of COVID-19. Next came similar announcements from Royal Caribbean, Celebrity, Carnival, and all of Park West's other cruise ship partners.

Cruising was being placed on indefinite hold and, soon after, thanks to new travel restrictions hoping to lessen the impact of the pandemic, hotels around the world began temporarily closing as well. (Those ceased operation dates were later moved back even further, stretching out well past Spring 2020.)

Park West had spent fifty years building an identity as the art dealer that took its art off the gallery walls and brought it to collectors all over the globe. But now global travel had been brought to a halt. How could Park West survive?

"I was never worried about the future of our business," Albert says. "We've always been a smart company, we're family-owned, we carry no debt. Nothing has happened to our inventory. We still have the largest and most impressive collection of art in the world, and we still have partnerships with some of the greatest living artists and estates. We know we have a client base that wants to collect out art. Our business model works. We bring the best art, the best selection, the best pricing, and the best collecting opportunities to the best art lovers on the planet.

"Plus I truly believed that we would be back on cruises and in our hotels once we are able to manage the virus." Albert points to an April 9 article in the *Los Angeles Times,* which noted that, even during the height of the coronavirus crisis in March 2020, there was still a 40% increase in cruise bookings for 2021.

"People want to get back out there. No one is going to stop travel," Albert argues. "But, in March, our challenge was essentially building a new business in the meantime—a new aspect of our business, that is—which would allow us to still connect people with our art, even if we couldn't interact with them in person at the moment."

His solution was a mixture of the old and the new.

Albert knew his model of selling worked. He wanted to spend time with his collectors, educate them, entertain them, and make sure they were making the most informed purchase possible.

That was never going to change. That would always be a part of the Park West experience. But now Albert wanted to bring that experience directly into their homes.

GOING VIRTUAL: PARK WEST STARTS ONLINE AUCTIONS

When someone mentions the idea of an "online auction," their mind can immediately turn to a website like eBay, a comparison that Albert is quick to dismiss.

"I never wanted it to be like eBay where you're just pushing a button," he admits. "I have always believed it's the connection between the client and the dealer that sells art. So we needed to find a way to mix our personal touch with an online experience."

Albert's concept was to essentially recreate the experience of attending one of Park West's VIP auctions in a way that collectors could enjoy from home.

In the initial model, like the VIP land events, it would all revolve around a weekend. Through streaming video, a select group of Park West clients could join their auctioneers for a preview on Thursday night. The auctioneers would give them a look at the art available over the next few days and also videochat with artists around the world, giving the collectors a glimpse into their private lives. Imagine sitting at home and having Romero Britto give you a personal tour of his Miami studio or Michael Godard walking you around his palatial Las Vegas mansion.

On both Friday and Saturday, there would be an auction in the early afternoon and a live preview broadcast in the evening, both streamed right into the collectors' homes.

The auctions would look just like a regular auction—with the same fast-paced and fun atmosphere—and there would be a variety of ways for people to bid. If the collector wanted to bid themselves, there would be a robust series of bidding tools on screen that they could use to win a work of art.

But, if they were a little nervous about technology or if they craved more of a personal touch, Albert arranged for every guest to have their own private art consultant who would stay on the phone with them during the auctions to offer advice or place bids for them.

"I insisted on that," Albert says. "This is a new world for everyone and we're asking our best clients to try something new. We needed to offer them white-glove service. That human connection is a very, very important part of what makes Park West unique."

The other aspect of the personalized associates that really appealed to Albert was that it let him utilize many of his employees in new and exciting roles, both the front line art dealers and auctioneers *and* the support people who provide the infrastructure that makes it all work. "We have a fantastic team," Albert says proudly. "I love that this lets us connect our best associates with our best clients in a way that benefits everyone."

The collecting weekend would conclude on Sunday with two live auctions. The evening auction would be known as the "Collectors' Only" auction where the clients would have the opportunity to take advantage of the amazing premiums Albert was offering for the online experience. ("We have never, ever offered deals like this before," Albert states plainly. "I wanted to give both our new collectors and our long-time collectors a fantastic collecting opportunity.")

If there was one word that best describes Albert's initial plans for his online auctions, it would be "ambitious."

In the very first meetings about the video broadcasts, Albert had one credo—"Make it better than Netflix." Quickly, the company decided to set up a recording studio in the lower level of the Park West Museum in Michigan. An Emmy-winning film crew was soon hired and hundreds of artworks were shipped to the museum to be featured on camera.

Albert personally chose the first two "hosts" for the inaugural online auctions—two of the most successful auctioneers in Park West's VIP program, John Block and Jason Betteridge.

Rehearsals began and web developers began methodically and rapidly building a website to accommodate the scope of what Albert wanted. On Thursday March 19, at a meeting with his team, Albert threw down another challenge: he wanted their first-ever online auctions to debut on the first weekend of April 2020... less than two weeks after the project began.

Teams of Park West staff were assembled and the problem solving was going a mile a minute. Albert always nearby, eagerly looking forward to each new problem that had to be solved. For him, it was like being back at university, trying to get a man on Mars. It's safe to say there was great personal satisfaction for Albert when the first Park West preferred client online auction went live on April 3, 2020.

ENTERING THE NEW ERA OF ONLINE AUCTIONS

Less than three weeks.

That's how long Albert's team took to build a whole new way for his collectors to buy art.

It's a testament to his leadership skills that his team at Park West never questioned the decision. If Albert said it could be done, it could be done. But that didn't mean it was easy.

The auctions had to be streamed live online. Non-existent custom software had to be built that could easily and rapidly access Park West's multimillion-dollar inventory. Camera crews that Park West had never worked with before had to turn Albert's museum into a live TV studio. John Block and Jason Betteridge had to leave their families and move to Michigan for over a month. Web requirements had to be created and tested at a moment's notice. Associates had to be trained to work with clients over the phone, and they had to choose the perfect selection of VIP clients to invite to that first weekend.

And, remember, this was all happening during a worldwide pandemic. So, not only did things have to be done quickly, but they also had to be done *safely*.

"That was not something I was willing to compromise on," Albert declares. "I'm not going to put anyone in danger. Our challenge was to keep people working and keep them excited, but only if they were as safe as they possibly could be."

As the preparations continued, the vast majority of Park West's employees worked remotely while the limited on-site staff adhered to rigid safety protocols put in place by Albert himself.

Protective masks and gloves were provided. Ample stores of hand sanitizer were placed around the studio. Social distancing was rigorously enforced. Albert would personally walk the halls chiding anyone who was standing less than six feet apart. (He was even a stickler for keeping John Block and Jason Betteridge at least six feet away from each other while they were on camera.)

Albert's commitment to safety was absolute, even if it did further complicate an already ambitious schedule.

Soon enough, the weekend of April 3 arrived, and the first auction weekend of this new online era began.

Albert was cautiously optimistic. He knew that his way of selling art worked and he knew that his clients were enthusiastic about getting back to collecting, but he didn't know if this new online model would engage them in the same way.

As the weekend commenced, it's safe to say that not everything went smoothly.

Perhaps it should have been expected.

When Disneyland first opened its doors in 1955, Walt Disney found himself facing broken rides, food shortages, counterfeit

tickets, unbearably hot weather, and even a plumbers' strike. If something as iconic and successful as "The Happiest Place on Earth" had to deal with opening day growing pains, it makes sense that Park West might encounter something similar on the opening weekend of their brand-new online platform.

There were a variety of hiccups throughout that first weekend—production problems, behind-the-scenes scrambling, and, at one point, the server company mistakenly locked down Park West's server during a live auction making it impossible for them to use their online bid system.

Fortunately, an early decision by Albert almost completely mitigated that problem. Because Albert had insisted on "white-glove service," even when the website was having issues, his clients could still keep bidding over the phone via their personal art consultants.

As long as the clients could see their auctioneers on-screen—the video never ceased, thankfully—the auctions could go on with a team of assistants working a phone bank and yelling out bids live to the auction hosts.

Even with all of those technical challenges, by the end of the weekend, something was very apparent.

The online auctions were a hit. A *huge* hit.

"I had certain numbers in my head before the weekend started," Albert admits. "'If we make *this* much, it's a failure. If we make *this* much, it's a success.' We totally surpassed the numbers I would've considered a success. What's even more important is that our customers *loved* it. They loved it. People were sharing photos on social media of them holding a glass of wine and watching our auctions on their big-screen TVs at home. That's exactly what I wanted."

As April continued, Albert's team swiftly solved any technical complications, and, by the second weekend, things kept getting smoother and the customer experience kept getting better. On Easter Sunday, Albert even dropped by the studio and led everyone watching at home in prayer.

Albert is confident that, when the cruises start back up again, Park West "is still going to be doing these online auctions because our clients are telling us—with their words and with their actions—that it's filling a need for them and they love the experience."

"That experience is *everything*," says Albert, smiling broadly. "And I have to admit—I'm finding that this new online experience is, bar none, the best possible way for us to offer art.

"How can that be? Remember that my primary concern is educating and entertaining our clients. I want to slow things down, spend time with them, make sure they have the most information available. Informed buyers are always the best buyers.

"With our online auctions, we can just provide *more*. Our streaming live visits to the artists' studios have been spectacular— it's something we should have done a long time ago. As a collector myself, it gives me the opportunity to become much more deeply involved with the artist and their work.

"I'm working with Lauren Mesaros and our Merchandising Team every week to add more and more art to every weekend's catalog. We're pulling works from our archives that we haven't featured at an auction in years. We're getting more input from our clients on what art they want to see every week. We have the ability to hugely increase our offerings because we're not constrained by the space limitations that our travel teams have to contend with.

"Thanks to those catalogs, our clients are getting a lot of information. They can see the image, read the description, know what the sizing is, so they can figure out how it would fit on their walls. If they want to know more, we can get our principal

auctioneers, our gallery directors, or our associates on the phone with them.

"I maintain our people are the best in the world. These aren't brand-new hires. We have ten-year, fifteen-year, twenty-year veterans with the company. They can tell a client anything they want to know. In fact, every week, our curators and associates have been creating short, personal videos for our clients, letting them get an up-close look at any particular paintings they might be interested in from our catalog. It's a level of client-specific service we've never been about to offer before.

"The schedule and atmosphere is very similar to our land and sea events—we just get to offer *more*. I really think this is the future of our industry. We'll always be on ships and in our hotels, but we're in a different place now. The world has changed.

"The good news is we're still going to be selling art all over the world, but we now also have the ability to come right into your home and give you exactly what you want. We put the pedal to the metal to get this up and running, and it's been an overwhelming success so far."

That success can be measured by the impressive amount of art that's been sold through the live streaming auctions and the staggering number of e-mails that Park West has received from clients telling Albert how much they love the new online experience.

"We have never received anywhere near the number of positive reviews as we have for these online auctions," Albert proudly admits.

Here is a powerful sampling of them:

"The program was very informative. I learned a great deal from the presentations, especially increasing my understanding of limited and unique offerings from the different artists. The 'live' aspect of

the auction was also fun. Having a real auctioneer talk through the artwork and explain the history or design philosophy was great. As close to your shipboard auctions as you could realistically get."

J.S., Texas - 4.13.20

"It was an awesome experience and I hope you keep doing them moving forward! I enjoyed seeing the diversity in artwork and prices."

M.K., Michigan - 4.13.20

"The auctioneers were great. It's very hard to act in a vacuum. Your auctioneers adapted to being on screen very well. The imperfections made it seem more real and live, and I was engaged the whole time."

L.M., Florida - 4.17.20

"Seeing the artists live from their studio was wonderful. Really made you feel like an 'insider' to know that they were taking the time to appear live just for us and Park West."

S.R., California - 4.20.20

"Many talk about 'location, location, location.' Well, with the online auctions, it's about 'selection, selection, selection.' The catalog was plentiful, and the speed of the auction made you feel as if you were right there. Having your own concierge one-on-one with you helped get those desired additions to your collections. The prices were some of the best I have ever seen."

T.R., Minnesota - 4.21.20

"We just wanted to send a message to let you know how much fun we had this past weekend with our first online auction. Our entire family got engaged. We learned so much and enjoyed every minute Your staff was remarkable—and that includes those we didn't interact with… like the back-of-house technology personnel who created a very friendly platform (not easy to pull off). You broke new ground and paved the way for a new culture of access to art and art appreciation."

<div align="right">J.B., Colorado - 5.11.20</div>

"We recently participated in your online art auction and, throughout the time leading up to and during the weekend auction, we were made to feel so special. Our associate went over and above…. to try and answer questions, interact immediately with a 'well done!' when we won an auction, etc. … the feeling of having a personal concierge was deeply appreciated by my wife and I. We love being members of the Park West family and appreciate the opportunities to interact with both the art as well as the artists at your events."

<div align="right">J.H., New York - 5.11.20</div>

"We greatly enjoyed the art auction telecast and the opportunity to get to go into the studios and get to know the artists a little better. While we are definitely looking forward to the day when we can get back on cruise ships and into hotels and being able to attend auctions in person, the online version provided a much-needed distraction from the day-to-day and was literally 'appointment viewing' in our house all weekend."

<div align="right">D.W., Pennsylvania - 5.13.20</div>

"We would like to thank the awesome PWG team for the absolutely wonderful VIP auction over the past four days. …the art presentations, the artist studio visits, and the auctions themselves were amazing. The results are a tribute to the team on the event's success."

<div align="right">S.J., Minnesota - 5.17.20</div>

"Our associate made us feel as important as those who could afford much more that we could. He did a fantastic job not only addressing the many questions we had, but also attending to a few requests we had relative to framing. He was very personable and professional at all times so we felt in good hands. Thanks so much for everything. You're the best!"

M.B., Ohio - 5.17.20

"I have to say—you all pulled off the impossible in my book. You got me to spend my weekend in my office watching and bidding on the online auction. I work from home so try not to sit at my desk on a weekend, but it was worth it! It was a great experience and so well organized. The hosts did a great job, but it was the team on the phones, behind the scenes, that made it so much fun. The shouts when a phone bid came in always made me laugh and smile. Thank you for a wonderful weekend. I walked away with some fantastic works of art but more than that—I had a wonderful, wonderful time!"

C.W., Texas - 5.17.20

"This weekend was a blast! I loved the artist interactions and the incredible new works. The prices were amazing. I know it must have been a massive amount of work, but from where I was sitting, it was seamless."

K.E., California - 5.17.20

"Watched the first auction today and had to thank you for the fun afternoon. This auction and every one that we've been to is thoroughly enjoyable and made me forget everything else. We didn't think we'd do an auction with everything going on and the financial state everyone is living with but we couldn't resist. Looking forward to cruising with you again. The gallery is always the first place we go when getting onboard."

M.L., Georgia - 5.22.20

316

"I'd say the online premiere was a success. Visiting with artists in their own environment—wow, what a phenomenal opportunity to see their studios and works in progress! Thanks for a great format and incentives. Thank you for another GREAT day! Thank you too for acknowledging us... we truly love our Park West family dearly and want you to know how much we both enjoy and appreciate all you do! Looking forward to tonight and tomorrow. Will hate to see it end!"

D.K., North Carolina - 5.23.20

"I wanted to take this opportunity to let you know how much my husband, son, and I enjoyed your new online VIP auction format. The videos, visits to the artists' studios, and the incredible art presented made our weekend one we will not soon forget. I need to pay special tribute to John and Jason. They are the epitome of what Park West represents. They were knowledgeable, helpful, and so much fun and truly made the experience for us one we will long remember. We were truly made to feel that we were Park West 'family' and what an honor that is. You have made it possible for us to collect art we never thought we could have, and we are encouraging our son and others to follow in our footsteps."

E.S., Florida - 5.24.20

"It was important for me to let you know that the people representing your company are the absolute BEST in every way possible. We look forward to working with Park West for years to come."

S.M., Georgia - 5.24.20

"I just wanted to take a couple of minutes to let you know how much my wife and I enjoyed the telecast auctions and the artist presentations this weekend. I think I watched all but about five minutes of the entire broadcasts. You both keep it so interesting and informative that it was near impossible for me to walk away."

D.W., Virginia - 5.25.20

"I wanted to thank the Park West team for orchestrating an amazing event this weekend. It was an incredibly welcome (and socially responsible) gathering for a few fun-filled days. The interviews were great and what a treat to get a peek into their real live studios—truly heartfelt and inspiring. I would also like to take a moment and give HUGE kudos to my liaison throughout the event. He is incredibly knowledgeable, the consummate professional, and an overall joy with whom to partner. His ongoing check-ins, follow-ups, and prompt replies were greatly appreciated. In summary... he ROCKS!"

T.M., Florida - 5.25.20

"Thanks for the videos! I used my HDMI cable to broadcast the preview last night on my big-screen television and remarked to my wife that they must be doing some strong production because of the off- site cut-ins and the lighting. Definitely giving us the high-end feel."

J.R., Alabama - 5.29.20

"Great job to the whole team! I know it's not easy to put these together."

J.K., Texas - 5.30.20

"Thank you for everything so far this weekend! The auctions are always our favorite part of the cruise! It's been great to be able to buy on land! We have really enjoyed learning so much about artists that are new to us and continuing to learn about ones we aspire to be able to collect in the future! You've all done a wonderful job! Thank you for letting us be a part of it!"

K.J., Georgia - 5.30.20

"A very special thank you to you for making my first art auction such a fun experience! I should have been in CA this weekend celebrating my 40th birthday with my family. Instead, I'm still in lockdown here in Singapore and not allowed to travel anywhere. You really made my weekend. Thank you. I look forward to the day I can drink champagne with Park West on a cruise in Asia. In the meantime, I decided to roll my credits, so I'll see you again soon at another virtual auction."

H.H., Singapore - 5.31.20

"You guys did a great job. I know you've had to adjust quite a bit in this virtual arena. A lot of people who are great in person are pretty horrible on camera, but you guys nailed it. You were great at managing the tech glitches, killing time 'off the cuff,' and being so natural on camera. As someone who makes my money from speaking, I had to admire you from a professional perspective as well. Well done. I truly enjoyed welcoming you into my home!"

H.M., California - 5.31.20

"I will admit that I wasn't sure how engaging a virtual art auction would be but I will tell you that my heart is racing, my fingers are flying as I text my 'art guy' about pricing. Great job and I'm totally IN for this weekend... I can't wait! GREAT JOB, CONGRATS TO YOUR TEAM!!!"

R.A., Washington - 6.4.20

"Awesome job tonight! I truly dream of visiting the Park West Museum one day."

S.B., Alabama - 6.4.20

"I'm watching this morning's auction and I just wanted to say thank you to the whole Park West family for making this possible and such a fun experience! My senior art consultant is spectacular and has been such a big help."

C.B., Michigan - 6.7.20

"I bought some beautiful pieces that really speak to me and I'm grateful to Park West for having something for everybody! I am so excited and thrilled for the Collector's auction that will be happening tonight. The relationship you all have together really made these auctions and interviews so worth watching! You're all so funny and it made my day sitting alone in my apartment cracking up at all the jokes and love you all have for each other. Again, thank you for this opportunity and just wanted to praise you all for everything."

K.W., Montana - 6.7.20

"I attended the online auction this weekend and enjoyed it immensely. I would love to attend more events like this as my wish list is growing!"

T.S., Georgia - 6.7.20

"Great job! We really enjoyed the broadcast and all the hard work that went into making it successful."

D.W., Washington - 6.8.20

"We wanted to take a minute this morning to thank you for last weekend's auction. We tuned into every session beginning Friday and thoroughly enjoyed every session. We have been on cruises with Park West and those auctions were equally as entertaining and

informative. We appreciate your knowledge of art and art history and your humor during the auctions. Thank you again to all the crew who made the telecast successful!"

<div align="right">T.W., Oregon - 6.10.20</div>

"When I was first contacted about the online VIP event, I wasn't exactly sure what to expect. I had only previously attended one VIP event in a hotel in Seattle and I had a great time. With this event last weekend, boy, was I in for a treat! Start to finish, it was an amazing experience!

"I thought the live Skype interviews with the artists were really fun, interesting, and gave a unique insight into their lives. It was great to meet their families and see what they've been working on. It was a welcomed departure from the regular professional videos you create for the interviews. This was so much more interactive—you forget when you're flipping through a catalog or walking through a gallery. These artists have such large personalities!"

<div align="right">P.N., Washington - 6.11.20</div>

"I thought the hosts were amazing. I thought the artists corner was a fantastic idea—I really liked the in-house artist creating art while we watched the auction. It was also great to see and hear Albert Scaglione, who I've never had to opportunity to meet or listen to in person. So it was interesting to hear his input on the art market and Park West. The energy was amazing! I can only imagine what it must've been like in person."

<div align="right">W.K., Texas - 6.11.20</div>

"I really enjoyed the variety of items that were offered. The AR stuff from Tim Yanke was really cool—I've not heard of that and that really seems like how we might interact with art in the future. I also

<div align="center">321</div>

appreciated the fact you realized some of your viewers might not know what an app is on a phone, let alone how to use one, so it was cool you offered assistance. I think this is a great solution for the current times. This event you put together was a total blast and the chemistry works really well with your team."

T.R., Michigan - 6.11.20

"Great Auction! We really enjoyed the experience and the artwork is simply fantastic. Couldn't be happier! Our associate went above and beyond to get us beautiful pieces for our collection."

J.M., Texas - 6.12.20

"Thanks for all of your hard work. I really enjoyed this event start to finish. It was awesome. Thank you for filling my home with warmth, fun, love, and allowing me the chance to display great works for art. The world needs warmth, fun, love—we need ART! I look forward to seeing you guys at the next auction!"

N.P., Ohio - 6.12.20

"I am over-the-top stoked! I got not 1, not 2, but 3 Godard sculptures! What a deal! And another awesome deal—'Scent of a Woman' by Mark Kostabi! Very, very excited about this as well. Your great auctioneer got me bidding. I'm so excited to see what tomorrow brings. Park West—your team is my gift from god. From bottom of my heart, thank you!

"This was a very emotional weekend for me. Again, I want to thank Park West... what perfect timing to feel joy! I saw my first Nano Lopez at a land event and fell in love. My patience paid off and I now own 4... how lucky am I? My secret crush is Michael Godard. I went to Nashville this year to one of his exhibitions. I

now own 3 of his sculptures and 2 paintings and got to see him live! I took the time to count my art last night... I started in 1989 on my first cruise... now I have 48 pieces of framed art... not counting this weekend. Amazing—my home looks fabulous. A year ago yesterday, I lost my brother to cancer. He fought hard and I was lucky enough to take care of him. But grief did not take over because of Park West! PARK WEST, YOU ROCK! THANK YOU VERY, VERY MUCH!"

<div align="right">C.J., Illinois - 6.12.20</div>

"I just wanted to say that my husband and I have been thoroughly enjoying ourselves during this weekend's events. Your whole team has been a joy to watch and have brought lots of much-needed happiness to our time here at home during these trying times."

<div align="right">E.M., Washington - 6.13.20</div>

"We look forward to tonight's studio visits and the continued auctions tomorrow. There is nothing quite like a Park West auction to brighten the day through beautiful art and lots of laughs."

<div align="right">F.G., Ohio - 6.14.20</div>

"We want to express our gratitude for the auction and making us feel so welcome—it was as if we were at the auction in person. We love Chris DeRubeis' artwork and are slowly collecting a lot. The pieces we bought today now equal 11 pieces we have acquired. Thank you again for an amazing auction and time, we cannot thank you enough!"

<div align="right">J.F., Pennsylvania - 6.14.20</div>

"I am writing to inform you that I thoroughly enjoyed this new style of auction, it's a brilliant idea. I hope you will do it often and keep me on the list to participate. I also want to mention that my associate was very helpful, cordial, and friendly. Always returning my texts in a timely manner. She deserves a pat on the back."

E.S., Ohio - 6.22.20

"When my husband and I participated in our first web-based auction, it was fun, but this one is such a big improvement—night and day! Kudos to all involved!

"The audio and video have been wonderful. The bidding process has been smooth, not only with actual bidding but keeping track of the others in the process. Another fabulous thing we have enjoyed with the new online system—the ability to click on and see how the piece will look framed. That is awesome! I would never attempt to pick mattes and framing—I rely on the expertise of the Park West staff. Seeing some of these pieces framed not only makes them 'pop' but can also give a better sense of its ultimate size."

D.H., Ohio - 8.8.20

"I appreciate the helpfulness and friendliness of all of the Park West staff. My husband and I are not amongst your really big spenders, our budget is more modest, but we have acquired a dozen or so pieces over the past few years. I appreciate that we are always treated with courtesy and friendliness and never feel as if our more modest purchase is unimportant. Been watching and buying from the start! Just love your enthusiasm! You are the highlight of my weekends!"

D.L., New York - 8.9.20

"We've just completed another successful auction, and I'd like to let you know how exceptional my art concierge, Jade, has been to me as I build my collection. I've attended five online auctions so far. Jade was my concierge on my third, and he excels in a number of ways. First, he reaches out early to introduce himself, provide contact information, and distribute the catalog. Even though he's half a world away, he always replies promptly, as if he's right next door. Second, Jade nudges me out of my comfort level by recommending artwork I might surely have overlooked. For example, he suggested an original Krasnyansky painting, unique Kostabi drawings that recently became available, and a once-in-a-lifetime commissioned work from Lebo, all of which I bought. He always points out the value in his recommendations—not just identifying the most expensive pieces. The items that he suggested are works that I can display proudly and enjoy for decades. I want to be clear on how well he—and Park West in general—have treated me and that I plan to continue my art collecting."

<div style="text-align: right;">Y.S., Tennessee, 8.9.20</div>

"Re-inventing yourself can be a healthy thing," Albert says. "We took something that we knew already worked and we just refined it to fit a changing world. I'm glad that people are responding to it so positively."

When asked why he thinks Park West was able to thrive when so many other organizations were closing during the pandemic, Albert thinks for a moment and then replies, "As a business, when you focus on staying customer-oriented, solution-oriented, and eliminate a lot of the distractions, you can get something special done. That's what we've always done as a company."

Closing Thoughts

CHAPTER 30

CODA

"Art goes beyond intrinsic value." Albert is quick to point this out. "It's a chance to invest in yourself. Art is a piece of life that's very tangible—our clients are bonding with someone when they take home art from an artist they met."

That basic formula has worked exceedingly well for Park West, even when it has to slightly re-invent that formula for changing times.

Ever energized by the future's endless possibilities, Albert is eager to "catch up with my art load and give lots of people work. You don't find many like us. You come in for a four-day world of fantasy, of fun, of knowledge, learning, collecting, making friends, and bonding with artists. It's a pretty life-changing experience. Art is filling a need for a changing world."

Albert is helping fill that need.

With billions in sales behind him, this dynamo continues with no signs of slowing down.

It's a joy to listen to him go. His sentences pop like corn. Looking forward, he fires off an improvisational poetic mantra.

"Every day's a new challenge.

Every day's a new dynamic.

Every day's a new idiom.

Every day's a new mile.

Every day's a new method.

Every day's a new methodology.

Every day's a new metric.

Every day's a new matrix."

Leaning back in his chair, Albert draws a distinction between Park West and other art dealers.

"Sotheby's and Christie's are superb art sellers, but they don't concern themselves with the creative process. They have almost no interaction whatsoever with the artist. I live my life with our artists, getting my gratification from seeing them scale new heights, overcome obstacles, and push the envelope redefining and re-imagining the boundaries of art."

The concept of brand is central to a business, and Albert is extremely keen about the Park West brand. It's easy to see why. With more than three million clients and a fifty-year history, Park West has not only established itself as the premium art brand in the world but also, like Amazon, it has no true competitors.

Albert is proud of what the brand embodies.

The Park West brand is known for providing an honest and fresh experience that culminates in making it easy for people to acquire art, often art that most people normally wouldn't be able to access. The company excels at commissioning art, presenting art, packaging art, and delivering art. Summing up what the brand means, Albert says, "We have a great selection. More than anybody. We have a reputation for the best framing. We're educational and we're fun to deal with too."

Complacency is not a word in Albert's vocabulary. He's all in or all out.

"My spirit. All of this is spirit. It's a connected life. What you sow now—you will reap."

Looking at his life, Albert knows what time it is now. It's time to give back.

"I have a spirit that wants to be approaching God. If I'm not thinking in an existential way, a surreal way, then how do you think in a God-like way?"

A great collector follows through with a concept. A really great collector finds a way to share his or her unique treasures. Albert would love to keep a lot of the works he's acquired for public display. "It's an idea. It's a thought—to show *everything*."

Albert's success is giving him a chance to share his good fortune. So far, he's pleased with the results.

In a moment of reflection, Albert sums up what makes him tick. "I'm about God, country, family, friends, clients, everyone. I so love this country and what I've been able to do in this country. I so love what my grandparents were able to do when they came to America… get an education, build a business. It's the blessings of America.

"What do we consist of? Our soul, our spirit, our body. One thing's for sure—the soul and the spirit are eternal. We are eternal. I know when I pass, I won't die; it's a passing. My spirit goes on. My soul goes on. I want to keep on charging like I am now. What could be more rewarding than solving problems? You look forward to the surprise, the mystery. And then you did it! You're done!"

He whoops with brio, having clearly done it and done it up right.

For Albert, the God-like way has been one of deep faith and remarkable toil. He's worked (and prayed) like the dickens. His God-like way has been to engender the creation of art and its dissemination to the public. He wants to continue to acquire and distribute art because he is so good at it and it provides such a service. He's not quitting any time soon.

"You get to the position where the reason you're doing it is that you still can and you still want to. You want to because of the collectors, artists, and people you've woven into your life—they're part of your fabric. It would be a sin to pull out. Whatever skills and talents you've been able to acquire, it would be mandatory to continue using them."

For Albert, his happiness and his accomplishments are grounded in belief. He works actively on his connection to the divine and has the confidence to be himself and share his wisdom.

"Mammon used for the purpose of helping people, of making society better—that's what God wants. Look at Bill and Melinda Gates. As Melinda said to Bill, 'Would you rather be the richest or the kindest?' No contest.

"You get to a place in life where the point is giving back."

Albert's gratitude and graciousness create a kind of synergy with his clients and artists.

"I want them to see me in themselves so we can get together."

Albert is a Renaissance man in the sense that he is remarkably gifted in several areas. What he has accomplished reflects genius. He's like a diamond in his multifaceted achievements. From running a business to being a NASA engineer to being a loving husband and family man.

At heart, Albert's not unlike a shaman in his conjurings. Convivial, urgent, loquacious—he's someone who grabs your attention, offering a gift of rapture, charm, and intellect to those who fall into his orbit. He is a combination of so many talents and successes that he is sui generis. He's an innovator and inventor.

Albert has brought his engineering skills, work ethic, faith, family, passion, and humor into creating Park West.

For over fifty years, he's brought one-hundred percent of himself into the game. His eye for art and his mind for utility are married in this vast enterprise. He's done for art what Henry Ford did for automobiles. He's made it available to the middle classes as well, not just the elite. He's created a buying experience like no other, where people can be entertained *and* educated. This magic mix of the practical and the imaginary is the key component in Albert's unique success.

As he puts it, "The combo of right brain and left brain is what gets me going."

Reaching people in a meaningful way and elevating them is the driving force behind Albert's vision. He's built an institution that exposes a massive audience to art. Through various paths in life, Albert has gained a unique set of skills and united them. By harnessing his unique array of seemingly boundless talent and energy, he has brought invaluable experiences to people around the globe.

Reflecting on what he does for the participants at Park West events, he touts the impact he's had on collectors.

"On very memorable occasions, people will be able to bring home something that makes them feel good." And, as that energy spreads to others, "It makes the world a little happier."

Albert regularly refers to outsized characters like Elon Musk or Jeff Bezos as "monsters." However, he's using the term as a compliment, recognizing their impact. He's talking about someone who has vision.

"A monster is someone who sees what others can't."

Of course, Albert is a "monster" himself, a major player, a Daniel Boone in the art wilderness or a Clint Eastwood fighting for individual expression. He's the Larry Gagosian of the heartland. He's a Medici in his commissions, his court, and his commerce.

His legacy forms a rich tableau—of people reached and people helped, of artists, friendships, entrepreneurship, and technical breakthroughs. He is helping shape the artistic development of civilization and has already enriched the lives of millions. And, in so doing, he has found a powerful platform that fulfills a desire in the public—to have a personal experience with art.

Park West is a great constellation with Albert Scaglione at the center, holding it all together like a distinguished ringmaster of the stars.

Jason Betteridge, one of the VIP auctioneers at Park West's first online auction, has said what many feel: "Albert's the most amazing person I have ever met."

At this point, Albert's a legend, the real deal—a Napoleon of the art world, devising new campaigns. He's a larger-than-life figure who is truly gifted in multiple areas and is eager to bring his light to others.

"Our teaching has been the backbone, bread, and blood of our business. Our clients will tell you that over and over. Again, that's a beautiful part of what we do. I'm really very pleased with the mission I'm on."

At the heart of it all has been knowledge. "There were so many things I had to learn," Albert says looking back on all he's accomplished. With a smile, he adds, "It's fun."

Soon after, Albert begins a riff on all the ways a person will feel after attending a Park West event—whether it's in person or over the internet. He comes up with a spontaneous consummation… a conflagration of words.

"You'll laugh so much, your belly will hurt. You'll learn so much, your brain will hurt. You'll see so much, your eyes will hurt."

Funny, aspirational, visionary. It's a fitting encomium, an apt testimonial to Park West's approach to art.

Albert finds value in the things he puts faith in—spirituality and imagination.

It is said that from those who are given much, much is asked. Albert Scaglione has risen to that call.

May we all be so measured by our devotion.

Dedicated to Giving Back

The Park West Foundation is devoted to making the world a better place. It actively works to provide support and safe environments for vulnerable youth in our global community and passionately strives to provide easy access to art for the general public.

To learn more,
visit parkwestfoundation.org

Since Park West Gallery was started over fifty years ago, Albert and Mitsie Scaglione—together with the Park West Foundation—have provided financial and material support to a wide range of charitable causes. On the following pages, you will find some of the worthwhile causes and organizations that Albert and Mitsie and the Park West Foundation have supported over the years.

On behalf of Albert and Mitsie,
and the entire Park West family,
we invite you to help us help others.

4Kids of South Florida, Inc.
www.4kids.us

Abbott Middle School
www.wbsd.org/abbott-middle-school

The Algemeiner
www.algemeiner.com

Alternatives for Girls
www.alternativesforgirls.org

The Amelia Island Jazz Festival
www.ameliaislandjazzfestival.com

American Cancer Center Relay
www.cancer.org/content/cancer/en/involved/fundraise/relay-for-life.html

American Cancer Society
www.cancer.org

The American Foundation for Suicide Prevention
www.afsp.org/

Archangel Gabriel Greek Orthodox Church, Traverse City, MI
www.tcorthodoxchurch.com

Armed Forces Service Center
www.mnafsc.org

Armed Services YMCA
www.asymca.org

Berea Family Tabernacle of Faith
www.experienceberea.org

Best Buddies International
www.bestbuddies.org

Bible Study Fellowship
www.bsfinternational.org

Black United Fund of Michigan
www.bufmi.org

Blessed Sacrament Monastery
www.opnuns-fh.org

Bowen Center for the Arts
www.bowenarts.org

Boys & Girls Club
www.bgca.org

Bravo Programs of America
www.bravoprograms.org

The Brooksie Way
www.thebrooksieway.com

Calvary Chapel, Fort Lauderdale, Florida
www.calvaryftl.org

The Cameron Fitzwater Memorial Scholarship
www.cameronfitzwatermemorialscholarship.org

Camillus House
www.camillus.org

The Charles H. Wright Museum of African American History
www.thewright.org

The Children's Foundation
www.yourchildrensfoundation.org

Children's Leukemia Fund
www.leukemiamichigan.org

Child's Hope
www.childs-hope.org

Clinics Can Help
www.clinicscanhelp.org

Closing the Gap Detroit
www.ctgdetroit.org

College for Creative Studies
www.collegeforcreativestudies.edu

Comfort Cases
www.comfortcases.org

Community Home Health & Hospice
www.ecommunity.com

Congressional Coalition on Adoption Institute
www.ccainstitute.org

Covenant Baptist Church
www.covenantbaptistchurch.org

Cranbrook Boys Hockey Fund
www.schools.cranbrook.edu/camps--cranbrook/sports-camps/ice-hockey

Cypress Lake Middle School
www.cym.leeschools.net

Deering Estate Foundation
www.deeringestate.org/foundation

Deliver the Dream
www.deliverthedream.org

Dell's Children's Hospital
www.dellchildrens.net

The Detroit Center for Family Advocacy
www.detroit.umich.edu/news-stories/the-detroit-center-for-family-advocacy

The Detroit Institute of Arts
www.dia.org

Detroit PAL
www.detroitpal.org

Detroit Phoenix Center
www.detroitphoenixcenter.org

Detroit Rescue Mission
www.drmm.org

Diamond Blackfan Anemia Foundation, Inc.
www.dbafoundation.org

Disabled American Veterans
www.dav.org

Coro d'Italia Programs, New Jersey
www.ditaliaprograms.org/programs.htm

Dominican Literacy Center
www.dlcliteracy.org

Dream Corps
www.thedreamcorps.org

Drug Enforcement Agency: Survivors Benefit Fund
www.survivorsbenefitfund.org

Dystonia Medical Research Foundation
www.dystonia-foundation.org

Ella Sharp Museum
www.ellasharpmuseum.org

The Environmental Council of the States
www.ecos.org

Equality Michigan
www.equalitymi.org

Farmington Hills Police Benevolent Association
www.fhpba.org

Farmington Musicale
www.farmingtonmusicale.org

Fidelity Charitable
www.fidelitycharitable.org

The Florida-Caribbean Cruise Association
www.f-cca.com

Focus: HOPE
www.focushope.edu

For The Seventh Generation
www.fortheseventhgeneration.org

Ford Piquette Avenue Plant
www.fordpiquetteplant.org

The Forever Wild Foundation
www.foreverwildfoundation.com

Foster Youth Internship Program
www.ccainstitute.org/programs/view/foster-youth-internship-about

Fostering Futures Scholarship
www.ffkids.org

Freedom House Detroit
www.freedomhousedetroit.org

Girl Scouts of Greater Los Angeles
www.girlscoutsla.org

Gleaners Community Food Bank
www.gcfb.org

Good Shepherd Clinic
www.goodshepherdmbc.org

Guy Harvey Ocean Foundation
www.guyharvey.com/ocean-foundation

Hartford Memorial Baptist Church
www.hmbcdetroit.org

Haven
www.haven-oakland.org

Hellenic Museum of Michigan
www.hellenicmi.org

Holy Cross Greek Orthodox Church
www.holycrossgo.org

Hope Water International
www.hopewaterinternational.org

The House of Providence
www.thehofp.org

Huntington Woods Women's League
www.hwwl.org

Jamaica Charity Gala
www.theafj.org/all-event-list/2019-jamaicacharitygala

Jennifer Adams Breast Cancer Medical Expense Fund
www.gofundme.com/f/jennifer-adams-breast-cancer-medical-expense-fund

Jewish Adoption and Family Care Options
www.jafco.org

The Kappa Foundation
www.aayikf.org

Lakes of Taylor Golf
www.lakesoftaylorgolf.com/343/Lakes-of-Taylor

The Life Project
www.thelifeproject.com

The Lingap Children's Foundation
www.lingapcenter.org

Living Arts
www.livingartsdetroit.org

The Lori Haber Buckfire Foundation
www.planetlori.com

Lower Columbia College
www.lowercolumbia.edu

Make-A-Wish America
www.wish.org

Menorah in the D
www.menorahinthed.com

Michigan Armed Forces Hospitality Center
www.mifreedomcenter.org

Michigan Animal Rescue League
www.marleague.org

Michigan Freedom Center
www.mifreedomcenter.org

Michigan Humane Society
www.michiganhumane.org

Michigan State University
www.msu.edu

Michigan Urban Farming Initiative
www.miufi.org

Michigan Youth Appreciation Foundation
www.metrodetroityouthday.org

Millennial Trains Project
www.millennialtrain.co

Mission 1:17
www.themission117.org

Monastery of the Blessed Sacrament
www.opnuns-fh.org

Monthaven Arts & Cultural Center
www.monthavenartsandculturalcenter.com

National Congress of Parents and Teachers
www.pta.org

National Council of Jewish Women
www.ncjwmi.org

National PTA: National Parent Teacher Association
www.pta.org

National Pediatric Cancer Foundation
www.nationalpcf.org

National Youngstars Foundation
www.youngstarsfoundation.org

New World Symphony
www.nws.edu/support-nws/ways-to-give

NJIT Athletics
www.njit.edu/athletics

Orchards Children's Services
www.orchards.org

Orthodox Christian Mission Center
www.ocmc.org

The Orthopedic Kneed Foundation
www.kneedfoundation.org

Paralyzed Veterans of America
www.pva.org

Paul W. Smith Golf Classic
www.paulwsmithgolf.com

Penrickton Center for Blind Children
www.penrickton.com

Pontiac High School
www.pontiac.k12.mi.us/Domain/13

Prince of Wales Island International School
www.powiis.edu.my

The Prince's Trust
www.princes-trust.org.uk

Project Upward Bound
www.oakland.edu/upwardbound

Pros for Africa
www.prosforafrica.com

Pushcart Players
www.pushcartplayers.org

Putnam Chorale Ltd
www.putnamchorale.org

Ravenswood Australian Women's Art Prize
www.ravenswoodartprize.com.au/artprize/home

The Savannah College of Art and Design
www.scad.edu

Scleroderma Foundation
www.scleroderma.org

The Shul
www.theshul.net

Sigma Xi Fund
www.sigmaxi.org/about/donate/the-sigma-xi-fund

Southfield Area Chamber of Commerce
www.southfieldchamber.com

Special Operations Warrior Foundation
www.specialops.org

St. Demetrios Greek Orthodox Church
www.stdemetrios.mi.goarch.org

St. John's University
www.stjohns.edu

St. Joseph's Indian School
www.stjo.org

Stanton Heights Neighborhood Association
www.stantonheights.org

Surviving the Social Jungle
www.survivingthesocialjungle.com

Tamarack Camps
www.tamarackcamps.com

TeamConnor Childhood Cancer Foundation
www.teamconnor.org

THAW: The Heat and Warmth Fund
www.thawfund.org

Torch Lake Protection Alliance
www.torchlakeprotectionalliance.com

Tri-Community Coalition
www.tricommunitycoalition.org

Troops Need Love Too
www.troopsneedlovetoo.com

United Way of Broward County
www.unitedwaybroward.org

United Way Charity Golf Tournament
www.unitedway.org

University High School Academy
www.southfieldk12.org/schools/hs/university-high-school-academy

University of Michigan
www.umich.edu

University of Mississippi Foundation
www.umfoundation.com/main/

United States Veterans Association
www.usva.org

Variety, the Children's Charity
www.variety-detroit.com

Voices for Children
www.voicesforcac.org

Williamson County Children's Advocacy Center
www.wilcocac.org

Index

Main discussions in **bold**. Photographs in *italics*.

Medvedev, Igor, 97, 130, *190*, **239-240**
 Shimmering, *190*
Medvedev, Marina, 239
Mehta, Zubin, 93
Mellencamp, John "Cougar," 130, 242
Merchant of Vino, 107
Mesaros, Lauren, 312
Les Métamorphoses (Picasso), 85
Metlan, Anatoly, 98, *198*, 244
Metropolitan Museum of Art (New York), 84
Miami
 Miami Heat, 159
 Miami Lake. *See* Park West, Miami Lake.
 Wynwood Art District, 220
Michigan
 Ann Arbor, 44
 Bay City, 44
 Bay Harbor, 214
 Berkley, 110, 219
 Detroit. *See* Detroit.
 East Lansing, 21
 Flint, 44
 Kewadin, 110
 Mackinac Island, 124
 Petoskey, 44
 Saginaw, 44
 Southfield. *See* Southfield.
Michigan, University of, 110
Michigan State University, 21-23, 144
Miles, Kevin, *196*, 252-253
Milkin, Michael, 98, *198*, 260-261
Miller, Gloria and Steve, 166-167
Miró, Joan, iii, 46, 89-90, 117, 209
 The Broder Collection, 285
 Park West Museum, *183*, 285

Molina, Albert, 140

"Modern Mona Lisas," (Markus), 222

Mokady, Moshe, 94

Monet, 79, 217, 230, 260

 Corbeille de fleurs (Monet), 297

 Monet: Framing Life, 2017 exhibit at the Detroit Institute of
 Arts, 296-297

Monroe, Marilyn, 238

Monthaven Arts & Cultural Center (Nashville), 117, 296, 303

Morandi, Giorgio, 246

Mouly, Maguy, 116

Mouly, Marcel, i, **115-117**, *187*, 209, 296, 300

Moving Canvas, 158

MSC Cruises, 133

Muhammad Ali Center (Louisville), 274

 See also Ali, Muhammad.

Murakami, 77, 79

Musée National Message Biblique (Nice), 120

Museum of Fine Arts (Boston), 83

Museum of Geometric & MADI Art (Dallas), 296

Museum of Modern Art (MoMA)

 Chagall exhibit (1946), 119

 Double Metamorphosis II (Agam), 65

 The Responsive Eye (Vasarely), 72

 Museum of Tolerance (Los Angeles), 296

Najar, David, 97-98, *188*, 236-237

Namath, Joe, 271

Nanimals (Lopez), 231

Napa Valley, 164, 166

NASA, ix, xv, 332

 Lewis Research Center, 23, 30

National Gallery of Canada, 88

Nechita, Alexandra, 263

Rosenthalis, Moshe, 94, 237
ROTC (Reserve Officers' Training Corps), 6
Rouault, Georges, 83
Rounded Flower Bed (Monet), 297
Royal Academy (London), 255
Royal Caribbean International (cruise line), 133, 305
Rubin, David S., 286
Russel, Charles, 43
Russia, 60, 109, 164, 300
 See also Soviet Union.
Rut, Tomasz, 265
Ruthsatz, Joanne, 241

Sachs, Michael, 53, 82
Saito, Kiyoshi, 77, 79
Salon des Realities Nouvelles, 64
Salon du Mai (1946 exhibit), 116
Les Saltimbanques (Picasso), 83
Samsung, 210
San Francisco, 53, 59
Sao Paulo Biennale, 64
Scaglione, Albert, *171-175, 178, 185-189, 191-198, 200-201, 294*
 art, introduction to, 13-15, *174*
 art, as a career, 35
 artists, qualities of successful careers of, 205-207
 collecting, the art of, 122-124
 commencement speech, Central Michigan University, xi-xv
 comments on by Peter Max, 58, 61
 educator, 22, 30, 39, 45, 134, 151-159, 291, 334
 eightieth birthday party, 124-125, *172*
 faith, ix, x, 120, 330-332
 "Four C's, The," xi-xv, 151, 207
 doctorate, Michigan State University, 23-27
 health scare, childhood, 10-11